THE COAL MINING INDUSTRY
OF SHEFFIELD AND NORTH EAST DERBYSHIRE

THE COAL MINING INDUSTRY
OF SHEFFIELD AND NORTH EAST DERBYSHIRE

Ken Wain

AMBERLEY

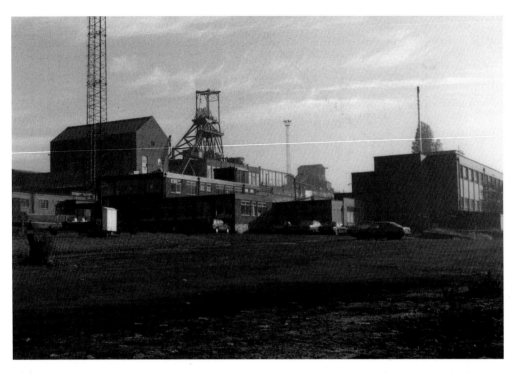

Above: Brookhouse Colliery. (*Alan Rowles*)

Cover image: Courtesy of Alan Hill.

First published 2014

Amberley Publishing
The Hill, Stroud
Gloucestershire, GL5 4EP

www.amberley-books.com

Copyright © Ken Wain 2014

The right of Ken Wain to be identified as the Author
of this work has been asserted in accordance with the
Copyrights, Designs and Patents Act 1988.

All rights reserved. No part of this book may be reprinted
or reproduced or utilised in any form or by any electronic,
mechanical or other means, now known or hereafter invented,
including photocopying and recording, or in any information
storage or retrieval system, without the permission in writing
from the Publishers.

British Library Cataloguing in Publication Data.
A catalogue record for this book is available from the British Library.

ISBN 978 1 4456 3963 5 (print)
ISBN 978 1 4456 3975 8 (ebook)

Typeset in 10pt on 12pt Sabon.
Typesetting and Origination by Amberley Publishing.
Printed in the UK.

Contents

Just a Little about My Background	7
Acknowledgements	8
Foreword	10
A History	11
How Much?	13
Shame and Exploitation	15
'Better Times by Order'	19
Looking back on Lads' Wages	21
A Sad Reflection: Sheffield and District	22
'Jobs for the Boys'	28
Dent Main Colliery (Birley Wood)	31
Other Collieries in the Woodhouse Area	33
Birley East Colliery	38
The Sheffield Coal Company and General Disputes Within the Industry	48
Gilbert Gould	54
Further Hardships	56
Fence Colliery	59
Fence Central Workshops and Stores: Woodhouse Mill	62
Orgreave Colliery	72
Orgreave Coke and Chemical Plant	78
Sheffield Nunnery Colliery	82
Handsworth Nunnery Colliery	87
Tinsley Park Colliery	92
Brightside Colliery	98
Aston/Beighton: Brookhouse Collieries	101
Brookhouse Colliery	104
North East Derbyshire Collieries	115
Perseverance Colliery, Killamarsh	115
The Sitwells North East Derbyshire Coal Masters and Ironfounders	123
J. & G. Wells Mining Co., Eckington	127
Hornthorpe Colliery	129
Norwood Colliery (Killamarsh)	131

West Kiveton Colliery	136
Steam	145
Chesterfield Area Collieries	152
Apperknowle and Unstone Collieries	152
Barlborough Colliery	160
Clowne Southgate Colliery	163
Chesterfield Area Collieries (North East Derbyshire)	167
Arkwright Colliery	167
High Moor Colliery	169
Underground Workers – Work Underground	171
Westhorpe Colliery	175
Renishaw Park Colliery	183
Tom Baker	188
The Markham Collieries at Duckmanton	190
Record Breakers	211
Orgreave Coke and Chemical Plant and the 1984/85 Miners' Strike	212
Bibliography	224

Just a Little about My Background

I was born in Killamarsh, North East Derbyshire, in 1941, and my family had strong connections with the mining industry.

I was educated at Killamarsh's primary and secondary modern schools, then took up employment as an apprentice electrician at Westhorpe Colliery in 1956.

I did my induction training at the NCB Bolsover Area Markham Training Centre, and my underground training at Grassmoor Colliery.

My technical training was done at Duckmanton Central Workshops and at the Chesterfield Technical College.

After finishing my apprenticeship, I continued working at Westhorpe Colliery and assisted at Highmoor Colliery, where the electrical installations were still ongoing.

I left Westhorpe and started work at the NCB Worksop Area Central Workshops, at Fence, repairing electrical switchgear and motors before becoming an electrical inspector. I then moved on to take over the job of electrical section supervisor.

When the workshops became national, I took on the job of electrical/mechanical maintenance supervisor for the whole workshop. When the establishment stopped working as an operating workshop and became the National Stores and Plant Centre, I retained the above post and also took on additional responsibility as the safety and training officer until my retirement.

Believe it or not, the idea for writing this book was conceived as early as 1974, during the miners' strike of that year; it took away a lot of the boredom during the strike and also taught me that I had taken on a much larger task than I had previously imagined possible.

To research an item like this while still working and bringing up a family was very difficult and time consuming to say the least.

To someone who was not computer-literate at the time, collecting, writing up and storing the verbal recollections of friends and those who have worked in the industry, 'when you eventually track them down', was a mammoth task.

Photographs are extremely difficult to find, but I must confess that many people have been very kind in making donations.

I hope you will enjoy reading the book. I have included information that will give you an insight into the mining industry in and around Sheffield, including the South Yorkshire and North East Derbyshire areas, but also discuss things that were little known of the industry, and stories within the local communities.

Acknowledgements

Mr K. G. Wain	Killamarsh	Ex-British Coal storekeeper
Mr D. R. Wain	Gleadless	Stream 7 Media
Mr J. Gwatkin	Denaby	Local historian/ex-colliery official
Ms. Maria Sikorski	Sheffield	Photographic donation
Mr S. Fox	Beighton	Local historian/photographer
Mr M. Jones	Killamarsh	Ex-British Coal/photographer
Mr T. W. Adair	Treeton	Ex-NUM official
Mr E. Mullins	Beighton	Fire services historian
Mr D. A. Goy	Treeton	Ex-British Coal official
Mr C. Higgins	Gleadless	Stained glass designer and historian
Mr A. Rowles	Wales Bar	Author and local historian
The Press Association	Nottingham	
Mr D. Thompson	Killamarsh	Local historian
Mr A. Walker	Handsworth	Ex-safety officer, Orgreave Colliery
Mr A. Peace	Barnsley	Photographic donation
Mr L. Widdowson	Woodhouse	Author and local historian
Mrs J. Siddons	Beighton	Author and local historian
Mr Brian Elliott	Doncaster	Author and local historian
Mr Peter Storey	Matlock	Head of Markham Vale Project
Mr A. Philpots	Swallownest	Photographic donation
Mr K. Holland	Mosborough	Photographer and local historian
Mr W. B. Clayton	Sheffield	Photographer and local historian
Mr Alan Hill	Birmingham	Author and mining historian
Sheffield Newspapers	Sheffield	Photographic donation
Mr R. Young	Wentworth	Author and local historian
Mr A. Nelson	Handsworth	Donation from L. E. Tall's Woodhouse
Mr C. Ulley	Sheffield	Photographic donation
NCB and British Coal Estates Department and scientific services.	Bretby, Staffs.	HQ Technical Dept, Bretby, Burton upon Trent

Rotherham Libraries Archives Department	Rotherham	
Elsecar Heritage Centre	Barnsley	
National Coal Mining Museum		Caphouse Colliery
Mr D. Mathews	Staveley	Photographic collection (mining)
Mr M. Eggenton	Langold	Local historian/photographer
Mr Peter Davis	Barnsley	Local historian. Photographic donation
Mr Benny Wilkinson	Conisbrough	Poet and ex-miner

Foreword

Coal, often referred to as 'the black diamond', has been one of the largest contributors to the economic stability of the city of Sheffield and its surrounding areas for hundreds of years.

During this time, the mining of coal has provided a wealth of employment for many thousands of people, not only in the mining fraternity, but also those people within the industrial and service providers' sections, without whose contribution the industry could not have operated.

In an ironic reversal of roles, the steel industry, Sheffield's other great benefactor and wealth provider, played its part in keeping the collieries equipped with the latest and best in steel technology. This allowed the machinery to cope with the heavy demands placed on it when extracting this life-giving necessity. Similarly, without the coal mines, the production of iron and steel could not have progressed.

This publication is intended to give the reader a glimpse into the industry during its heyday, though this is all it is; to go any further would need a lifetime's research to publish what would be an encyclopaedia of Sheffield's coal-mining industry.

Sheffield's two major industrial giants relied heavily upon each other throughout their existence, but sadly the collieries have all but gone and the steel industry is in serious decline, giving way to alternative fuels and manufacturing materials.

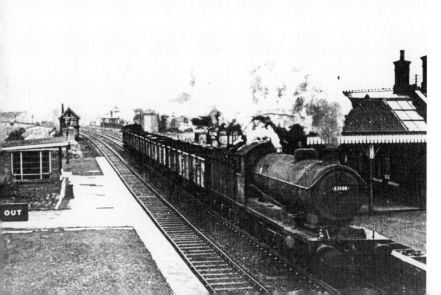

Coal train from Brookhouse Colliery, passing through Killamarsh LNER station towards Chesterfield, c. 1950. (*David Thompson*)

A History

Iron Age man invaded the Sheffield district in around 400 BC with his tools and weapons made from outcropped iron ore and coal, and was the forerunner of the distant beginnings of the iron and steel industry in Sheffield.

From the early days of charcoal burning to the coal-fired blast furnaces was a long haul! Archaeological sources confirm that the mining of coal, in one form or another, has been taking place in Sheffield and its district since well before the time of the Roman occupation, stretching way back into the Iron Age.

The great Midland coalfield, in which the Sheffield district pits are located, was laid down over 300 million years ago in the carboniferous period, and runs all the way from Huddersfield in the north to Nottingham in the south.

Much later, during the early part of the twelfth century, the Norman overlord Roger de Busli, who was by then the lord of the manor and had taken great areas of land in and around Sheffield, gave licence for the getting of coal. In Nottinghamshire, he gave the monks of Kirkstead Abbey the right to get coal and till the land in his control.

To the south-east of Sheffield, many bell pits in the Barlborough, Eckington, Killamarsh, Beighton, Woodhouse, and Handsworth areas were in operation at that time, and became very hazardous as a result of total abandonment after coal extraction had ceased.

Many people and animals were reported to have been injured, and some life was lost for many years to follow due to people falling into these uncapped and overgrown entrances.

An inquest was held in 1347 regarding Hugh Wadshelf, a shepherd who was drowned when he was looking for lost sheep and fell into a coal pit belonging to Roger, son of Gilbert de Beighton. The coroner's jury ordered that the said coal pit be filled in.

Pits are recorded as being in operation in the Gleadless area in 1515, and there are records that show a small pit near Sheffield producing 1,316 tons in 1580.

Robert Blount (Gentleman) obtained rights from the lord of the manor to get coals at 'Gleydleis' (Gleadless) in 1579. Timber supplies were depleted during the sixteenth century, which increased the need for coal. Records also show a colliery at Totley in 1615, and numerous pits in and around Unstone, to the south of Sheffield, in 1618, at the time of James I.

The year 1661 saw Sir John Frescheville installed as the lord of the manor of Eckington. He had coal mines in his possession, and John Wilson of Gleadless was recorded as working for him in the one at Basegreen in 1669.

He had other mines in 'Chinewoldmaresc' (Killamarsh) and Barlborough at this time, although the exact locations are unknown.

As a point of interest, records were formulated shortly after nationalisation of the pits in 1947, and show that there were no less than 442 abandoned mine workings in the immediate vicinity.

From this information, and not taking others into account, the Sheffield area must have been a virtual rabbit warren of mining activity.

It is clear from the size and type of these pits, usually bell pits or small drifts, and the number of people employed at each one, that the system used for the mining of coal was similar to that of allotment gardening, i.e. small lots of 1 acre or less, leased from the land-owning gentry, at a set price per acre, purely for the extraction of coal.

It was established that William Hibbert and partners were paying £5 per year for operating a coal delph in Beighton manor in 1726. Francis Atkin was paying £30 a year between 1744 and 1745 for a coal delph on Birley Moor. These were during the reigns of George I and George II.

In 1783, Samuel Staniforth, of Mosborough Hall, worked a pit at the top of Mosborough Moor, where he also had a soft coke oven, making coke for the Sheffield manufacturers and the local sicklesmiths.

The pit was abandoned due to water problems, and Samuel Staniforth died in 1812 and is buried in Eckington churchyard.

Norbriggs Colliery, between Killamarsh and Renishaw, is listed as being in operation in 1815, around the same time that a mining engineer by the name of Joseph Butler, from Killamarsh, had invented a way of dissipating firedamp gas accumulations by a series of controlled explosions.

Luke Worral from Mosborough, working in partnership with his friend Hodgson, sunk two pits in 1830, one at Beighton Hollow and one at Halfway. Hodgson's niece was killed in an accident at the Halfway pit just before Christmas 1837.

Worral was a shrewd businessman, and his workers were given very little hard cash, as they were forced to buy all their food and clothing from his shop. Vegetables, milk, and eggs etc. were all produced on his farm, giving him the monopoly in the local community.

How Much?

The price of coal in the cost of life and human endeavour has been shown to be very high throughout the complete cycle of mining history, and many of these deaths could have been avoided if more stringent regulation had been in place. Naked lights (candles) were the cause of thousands of gas explosions, resulting in the unnecessary loss of life of thousands of men and boys, particularly during the eighteenth and nineteenth centuries.

There was a long, long time between the era of hand-hewn coal and the later methods of gas detection with flame safety lamps, electronic automation, coal cutting and fault-sensing equipment.

Even though the introduction of high-technology systems, underground television monitoring of operations, and stringent safety regulations have improved the situation beyond recognition over the last few decades, great tragedies still occurred during this period.

This illustrates only too well the need for constant progress in the technological advancement and safety standards that protected these people, who gave their all in providing for the needs of others in a hostile environment that respects no man.

The miners of the eighteenth and early nineteenth centuries were quite rightly berated for their appalling behaviour towards the women and children who worked alongside them.

This is a stigma that stuck with them in later times, and even though women and children under the age of ten were prevented by law from working in the mines, and the miners changed their outlook on life and began to work through the Industrial Revolution with gradually changing working practices, they have often borne the brunt of ignorant society jokers, who would class them as lower mortals. To those who knew them, worked with them and lived in their communities, however, these people were indeed appreciated as the salt of the earth.

These men of the new era had strong principles and a camaraderie that could not be matched in any other profession.

They looked after each other in line with the old Yorkshire adage, 'There's nowt wrong wit reight folks.'

Eighteenth-century Sheffield became an important area for coal mining; the population in 1796 was 9,095, but by 1821 it had risen to 31,314.

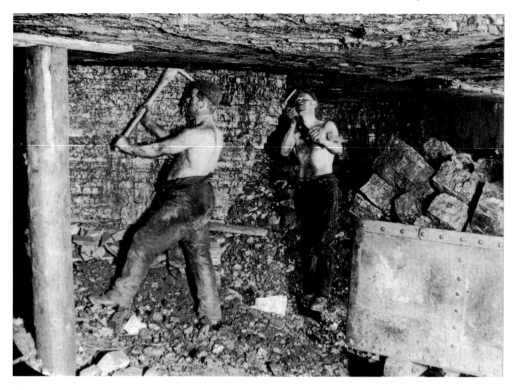

Hand hewing with only minimal roof support. (*NUM*)

By 1830 it had risen to approximately 100,000; many had come from rural farming areas to work in the pits, forsaking relatively good health and living conditions, only to find bad health and squalor in the hastily built so-called houses in which they existed.

It was reported at the time that in one yard alone the 'privy' was shared by nineteen families.

Because wheelbarrows could not get down the narrow passages between the houses to remove the waste and general refuse, it was allowed to heap up above the height of the houses, allowing leakage into the buildings!

It is almost unbelievable; the stench from this and the overcrowding of the houses was unbearable, and in 1832 an outbreak of cholera killed many hundreds of Sheffield's inhabitants.

The year 1861 saw almost a sixfold increase in population to 185,000 from the 1821 figure, due to the constant influx of workers into the mines, the iron and steel trades, and table blade manufacturers.

Shame and Exploitation

The coal masters of the eighteenth and nineteenth centuries were, with few exceptions, exactly that: the coal masters.

They were the staff-wielding masters who demanded respect and obedience; they were the ones who profited from the penny-pinching shortcuts on safety and mining methods, which very often resulted in tragedy for those who had to obey – if they were to utter words of protest or defiance, they might lose their jobs.

These were the people who had no shame in the way they subjected their workers to such conditions; they ignored the plight of the young boys and girls who worked alongside men and women, exposing themselves to all kinds of improper behaviour and relationships, in conditions that were hard to describe to the uninitiated. There were unsafe working practices, such as insufficient roof supports or in particular naked lights, which were often the cause of firedamp explosions that tore apart vast areas of underground workings, killing and maiming many hundreds of these poor souls on a daily basis throughout the British coal mines.

During the eighteenth and early nineteenth centuries, due mainly to the ignorance of the general populace about the miners and their lives, it was commonplace for people to make damning assumptions, despite knowing nothing about the situation.

The contemporaries of the day were soon investigating and writing reports on their so-called authoritative findings which could often be misconstrued by or mislead the masses. W. H. Pyne's encyclopaedia states that there are families who live underground, and only occasionally visit the regions of day. They have regular markets below, to which dealers descend to supply them with the articles of subsistence and clothing that they want!

William Cobbett visited a colliery in 1832, and said that the most surprising thing in the whole world was that thousands of men and thousands of horses continually live underground, and children are born there who seldom ever see the surface, though they live to a considerable age. Some of them start work at the age of four!

One can make up one's own mind as to the authoritativeness of these observations, but as will be seen later, when proper investigations into the employment of children in mines were conducted by the sub-commissioners in 1842, a good many of the stories painted a picture that was hard to believe.

This led to the law which prohibited girls and women, and boys under the age of ten, from working in the mines.

For many years in the seventeenth and eighteenth centuries, and in the early part of the nineteenth century, children as young as four toiled in the pits, with women, young girls and boys working naked down to the waist, which often led to abuse from some of the miners, who worked completely naked in the hot, humid conditions.

Richard Ayton, nineteenth-century moral standards critic, visited a pit in Whitehaven in 1813 and described how the mixing of the sexes below ground offered opportunities for sexual depravity:

> In consequence of the employment of women in the mines, the most abominable profligacy prevails among the people.
>
> One would scarcely have supposed that there would be any temptations to sin in these gloomy and loathsome caverns, but they are made the scenes of the most bestial debauchery.
>
> If a man and a woman meet in them, and are excited by passion at the moment, they indulge it, without pausing to enquire if it be father and daughter, or brother and sister, that are polluting themselves with incest.
>
> It is not a little offensive to see them changed into devils in their appearance, but it is afflicting indeed to witness the perversion that takes place in their moral character. They become a set of coarse, licentious wretches, scorning all kind of restraint, and yielding themselves up, with shameless audacity, to the most detestable sensuality. Their abominations are confined during the day to the dark recesses of the mines; but at night they are cast up from the pits like a pestilence; to contaminate the town.

Rape and illegitimacy were commonplace, with wives placing fatherhood of the children upon their husbands, who, because of the sheer poverty in which they lived, very often welcomed the arrival of new offspring as another new earner! Babies would frequently be taken down the pit by their mothers, sometimes on the day they were born, because the mine owner insisted that the mother should return to work immediately!

Miscarriage due to continued working during pregnancy was a fact of life, and life was cheap in those days of extreme poverty.

These poor women and children would work in terrible conditions for up to fourteen hours a day.

The miners themselves had to lie on the floor, often in acidic water, and hew down the coal with a pick, again by the light of a candle placed beside them on a lump of coal.

Later, when the miners were given Davy safety lamps, they would take off the lids covering the gauze, which prevented the gas from reaching the flame. It gave them a better light with which to work, but rendered the lamp useless and extremely dangerous.

The safety of these people was of little or no consequence to the mine owners, whose only concern was for the profit they could make. They would ignore these safety breaches for their own ends; labour was cheap and easily replaced.

They owned the mines, they owned the shops, and they very nearly owned the people. This can only be classed as slavery; an Act of Parliament banned slavery in 1833!

In 1842, J. C. Symons made a report to Parliament about the Yorkshire pits in which he included, 'A 40 year old miner admitted that he had worked a great deal where girls

Above left: Naked female face worker. (*Children's Employment Commission, 1842*)

Above right: Hewer working naked and wearing no boots. (*Children's Employment Commission, 1842*)

were employed in pits, saying, "I have had children by them myself, and have frequently had connexion with them in the pits."'

Nakedness among children and adolescents was of particular concern to the sub-commissioners:

A thirteen year old male witness stated, 'Our breeches are often torn between the legs with the chain.

The girls' breeches are torn as often as ours; they are torn many a time, and when they are going along we can see them all between the legs naked.'

When it is remembered that these girls work chiefly for men who are not their parents, that they go from 15 to 20 times a day into a dark chamber which is often 50 yards apart from any one, to a man working naked, or next to naked, it is not to be supposed but that where opportunity thus prevails sexual vices are of common occurrence. 'You have in the coal pits a nursery of vice which you will go far and wide above ground to equal.'

No brothel can beat it!

It was said that excessive statements like this were sensationalist, and unbecoming of the commissioners, creating some disbelief.

The abused women and children mentioned above lived in fear of their lives if ever they spoke of these things, which added to their continued misery.

They would regularly work for twelve to fourteen hours, six days a week, crawling in thick coal dust that runs like mercury when it is disturbed, or in foul-smelling rancid water, dragging tubs of coal, with leather harnesses around their waists and thick heavy chains chafing between their legs and fastened to the tubs, very often in roadways that were barely 3 feet high! Open sores and weeping ulcers were very common.

With little more than the light of a candle with which to see, these were the lucky ones. Other children, 'trappers', who did jobs such as pulling a door open when coal was being passed through from the workings, were classed as wasting a candle when they did not need to see, hence the saying 'not worth a light'. Such was the treatment of children in those times.

Leaving doors open could be catastrophic if proper ventilation was curtailed, as it caused build-up of inflammable gases, hence another saying bawled at the children: 'Put

wood in't hole' (close the door). It is said that the term 'door trapper', one who opens and closes doors on wedding and funeral cars, also derives from this activity.

> I don't know how long I have been in the pit. I go to Sunday School and I can read some.
> They teach me to write.
> Jesus Christ came on earth to save sinners. I don't know what death he died.
> I know I must pray to be saved.
>
> My name is Patrick Kiltride, I am eleven years old and I am a hurrier [tub puller].
> I have been in the pit about a year. I used to go begging before.
> I hurry along the main gate about 250 yards. It's level.
> Another boy hurries [pulls tubs] with me and I lather him sometimes. I sometimes get lathered myself.
> They wouldn't keep me if I went to school, but I'd rather go there than be in the pit. I can't read…

All this for a day off on Sunday, which usually gave very little chance for enjoyment, as they were generally exhausted and could only rest and sleep ready for the drudgery of the following day.

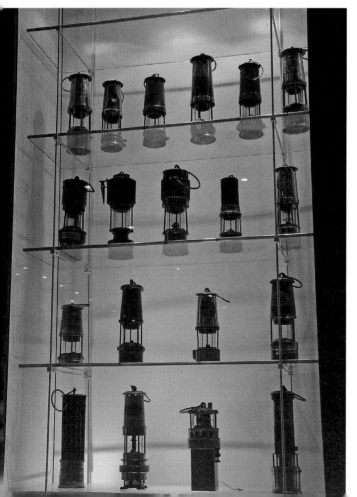

Selection of flame safety lamps at the National Coal Mining Museum. (*Ken Wain*)

'Better Times by Order'

It can be seen by the census of 1841 that there were 118,000 miners in Britain's pits, 2,350 being women!

With only four official one-day holidays per year, this could only be classed as slavery; it was altered to some extent in 1842, when the Royal Commission ordered the Government to pass laws prohibiting women, and children under the age of ten, from working underground, giving them back their lives.

The year 1842 also saw an improvement in the coal trade, and the coal masters granted a 10 per cent pay rise to avert a strike.

The first government inspector of mines was introduced in March 1843, when the 1842 Act became law.

Although some mine owners obeyed the law, many others did not, and instead allowed archaic working practices to continue for a number of years, until more government inspectors were employed to enforce the law. However, this was not until the early 1850s, and there were only twelve for the whole nation!

This was a considerable step forward, but the miners themselves were still working in unacceptable conditions, and loss of life was common, making the inspectors' work almost impossible. There were several reasons for this: the roof falling in due to insufficient supports, causing men to be crushed and buried under tons of rock and debris; explosions and fires caused by the ignition of gas while working with open flames, 'candles with which to see'; and, more generally, bad working practices causing all manner of serious and fatal injuries.

The Workmen's Compensation Act was introduced in 1843; it helped to alleviate some of the suffering caused by accidents while working in these conditions, but was only a feeble attempt to smooth the troubled waters. In 1851, nineteen people were killed per 1 million tons of coal raised from British mines.

The Government was now beginning to listen to the miners' plight, and the first Coal Mines Act was introduced in 1872; this was another meagre attempt that had little effect. It was not until fifteen years later that the 1887 Coal Mines Regulation Act came into force. This Act was comprehensive and wide-ranging, and was to govern the methods of working within the mines. Mine managers now had to obtain, by examination, a government certificate of competency.

A look at the following statistics shows that the Act did in fact have an impact, and things began to get better with a gradual drop in the death rate.

During the ten years from 1873 to 1882, the average yearly death rate per 1,000 persons from accidents under and above ground was 2.24, and per 1 million tons of coal raised it was 7.42. The following table gives the corresponding figures for the three succeeding decades.

Decade	Per 1,000 persons employed	Per million tons raised
1873–1882	2.24	7.42
1883–1892	1.81	5.65
1893–1902	1.39	4.70
1903–1912	1.33	4.76

This table shows a marked reduction in the death rate per 1,000 employed in the decade 1903–1912, compared to the rate between 1873 and 1882 of no less than 40.5 per cent!

National Accident Statistics 1880-1910

In the thirty years covering the end of the nineteenth century and the beginning of the twentieth, there were just over 1,300 men and boys killed in British coal mines every year, with an average of 4 killed and 571 injured every day!

That equates to 112 killed every month, and 14,476 injured.

By 1910, the number of those killed had risen to 1,808; 501 were killed in explosions, 658 as a result of being buried in roof falls, and a further 286 while working on underground road haulage systems.

Bad working practices and the lack of safety regulation were the main causes of this needless loss of life.

Looking back on Lads' Wages

1888. Working by day.
Age 13 1s 3d.
Age 14 1s 6d.
Age 15 1s 9d.
Age 16 2s 0d.
Age 17 2s 3d.
Age 18 2s 6d.
Age 19 2s 9d.
Age 20 3s 0d.

The Coal Trade Benevolent Association was founded in 1888 specifically to assist all the non-manual workers within the industry.

The Interpretation Act of 1889, brought about by the establishment of the Institution of Mining Engineers, would ensure safer working practices throughout the industry.

A large percentage of the workforce in the mining industry was made up on the sons and grandsons, who for centuries have been part of the industry by tradition.

A good many of these people and their forefathers suffered great humiliation and deprivation, and, when at work, lived in constant fear for their lives while providing something without which none of us would have survived. Coal mining was the foundation of the Industrial Revolution, which saw the country progress.

It is only over the last fifty years or so that the working conditions and safety standards have improved to any great extent, and allowed these members of society to enjoy the benefits of health and safety in employment that most others have taken for granted for many years.

Even at the beginning of the twentieth century, the first twenty years in the Sheffield and Barnsley areas alone show a catalogue of disaster that can only be described as carnage, and, as such, compares with no other occupation.

A Sad Reflection: Sheffield and District

23 Feb. 1904	Seven men killed when the cage winding rope broke at the Aldwarke Colliery near Rotherham.
1905	One man killed in a roof fall at Greaseborough Colliery near Rotherham.
9 Nov. 1906	One man killed at Bonds Main Colliery: Staveley Benjamin Booth, buried in Killamarsh churchyard.
23 April 1907	Three men killed and one man injured in a cage overwinding accident at Orgreave Colliery.
15 Nov. 1907	Seven men killed and six men injured in another cage overwinding accident at Barrow Colliery near Barnsley.
6 April 1908	Walter Bennett, the former Sheffield United and international footballer, was killed while working at Denaby Main Colliery.
1908	One man was killed at Holbrook Colliery near Halfway, Sheffield. The inquest into this accident was held in the Sidney Tavern at Mosborough.
31 March 1909	Three men killed in a shaft sinking accident at Maltby Colliery, and less than five months later one man was killed after falling down the shaft.
30 April 1909	Thirty men injured, two seriously, in a winding accident at Silverwood Colliery.
10 Nov. 1910	Two men killed underground at the Birley East Pit at Woodhouse.
11 July 1911	Three men killed in an underground explosion at Grimethorpe Colliery near Barnsley.
21 Aug. 1911	Three men killed in an explosion at Maltby Colliery near Rotherham.
12 Feb. 1912	Three men killed and six others badly injured and burned in an explosion at Bentley Colliery near Doncaster.
23 April 1907	Twelve men injured in a cage accident at Treeton Colliery, Sheffield.
6 July 1912	Three men killed in an explosion at Barnsley Main Colliery.
9 July 1912	Several major explosions at Cadeby Main Colliery, between Rotherham and Doncaster, killed eighty-eight men, including HM Inspector of Mines and his two assistants, along with the manager from Denaby Main Colliery. All the men working in

	one district, plus the entire rescue party, were killed while trying to save them, following a series of previous explosions. Three others died later.
7 Feb. 1913	Thirteen men killed underground at Rufford Pit in Nottinghamshire.
16 June 1913	Seven men and a young boy killed underground at Carr House Colliery near Rotherham.
30 May 1914	Eleven men killed and two badly injured at Newton Chambers' Wharncliffe Silkstone Pit near Barnsley.
6 April 1919	Six Men killed and seven injured in an explosion at Oxcroft drift mine.

This is a total of 144 dead, and 64 serious injuries.

This wholesale loss of human life took place within a 20-mile radius of Sheffield, a remarkable fact when compared with the whole of Great Britain during this same period of time: just fifteen years.

Two of Great Britain's most horrific pit tragedies happened during this time:

At Pretoria Colliery in Lancashire, on 21 December 1910, an explosion claimed the lives of 344 men and boys.
At Senghenydd Colliery, South Wales, on 14 October 1913, 439 were killed in an explosion.

The introduction of the Interpretation Act of 1889 heralded the start of regulation as to the safe working of the whole industry throughout its existence.

The Coal Mines (Weighing of Minerals) Act of 1905 was introduced to establish a system of accurate weighing of coal, to satisfy the miners that they were being paid correctly for the amount of coal mined, and was closely followed by the Workmen's Compensation Act of 1906, and the Notice of Accidents Act of the same year.

The Coal Mines Regulation Act was put in place in 1908, and was commonly known as the Eight Hours Act, because it limited the number of hours a miner could work in a day.

The Coal Mines Act 1911 set up the Mining Qualifications Board to ensure that people in responsible positions, and as such who would be wholly or partly responsible for the safe operation of the mines and the safety of those who worked within them, would be suitably qualified, and issued with first- and second-class certificates of competency, i.e. colliery managers, undermanagers, firemen, deputies and shot-firers.

This was to have a huge impact on the safety in mines, but it was only the beginning! Others were to follow:

Coal Mines (Minimum Wage Act) 1912.
Coal Mines Act General Regulations 1913.
Coal Mines Act 1914. Coal Mines Act 1919.
Mining Industry Act 1920. Mining Industry Act 1926.
Coal Mines Act 1930. Coal Mines Act 1931.
Mining Industry (Welfare Fund) Act 1931.
Coal Mines Act 1932.

Fully equipped medical centre. (NCB)

It was soon realised that these Acts were to be the means of better working practices and have an impact on the miners' working conditions, with the added bonus of increased production and profits.

The introduction of further Acts, which could well have been called welfare Acts, were clearly the way forward in ensuring by law that employees had a better crack of the whip, and, as a result of shorter hours and safer working practices, fatalities and accidents began to show a marked reduction over the years. Acts to ensure that people received the correct training to carry out their duties in a properly controlled way, and Acts which introduced statutory medical examinations to ensure, by regular monitoring, the good health of the workforce, were also brought in during the 1940s:

Mining Industry (Welfare Fund) 1934.
Abstract of Factories Act 1937.
The Coal Mines (Employment of Boys) Act 1937.
Coal Act 1938.
Mining Industry (Welfare Fund) Act 1939.
Coal Act 1943.
Workmen's Compensation Act 1943.
Coal Mining (Training and Medical Examination) Order 1944.
Coal Mining (Training and Medical Examination) Order 1945. No. 1 and No. 2.
Coal Mining (Training) General Regulations 1945.
Coal Industry Nationalisation Act 1946.
Industrial Injuries Act 1946.
The Mines and Quarries Act 1954.
Coal & Other Mines (Mechanics and Electricians Regulations) 1956.
The Protection of Eyes Regulations 1972.
The Health and Safety at Work Act 1974.
Reporting of Injuries, Diseases and Dangerous Occurrences Regulations (RIDDOR) 1985.
The Control of Substances Hazardous to Health Act (COSHH) 1988.

The Electricity at Work Regulations 1989.
Noise at Work Regulations 1989.

The effects of inhaling coal dust on miners' health have long been known.

The following extracts from *Coal Mining and the Miner*, 1919, by H. F. Bulman, and investigations conducted by Drs Haldane, Tatham, McMurray and Shufflebotham will give the reader a very interesting insight into medical thinking at the time!

They go on to conclude that

> Men working in dry and dusty coal mines inhale large quantities of dust without any bad effects ensuing. In fact, as has been shown, coal miners are singularly free from phthisis and lung diseases ... The physical effect of inhaling coal dust is an important question in relation to the health of miners.
>
> That the natural dust of coal mines, though containing sometimes considerable quantities of injurious dusts, can be inhaled without serious results is evident from many years of practical experience in Collieries.
>
> Dr Haldane's investigation has confirmed this conclusion. Experiments on animals show that some dusts act as scavengers and carry out the dangerous dusts with them.
>
> What proportion of the stimulating dusts must be present to secure immunity has not yet been determined.
>
> These experiments had to be postponed owing to the war, and further investigation is desirable.

Dr Tatham's investigation enabled him to conclude that coal miners could be looked upon as 'a very healthy body of men'!

What they didn't tell you was that, between 1866 and 1919, a miner was killed every six hours, seriously injured every two hours, and injured badly enough to need a week off work every two or three minutes (p. 37, *Mining Days in Abram*, F. Ridyard).

However, Dr Tatham's report only dealt with the death rate.

> As regards sickness and disease prevalent among miners, some information may be gathered from the returns made under the Workmen's Compensation Act 1906.
>
> Scheduled under this Act are twenty-five industrial diseases for which compensation has to be paid.
>
> The disease from which miners suffer especially is nystagmus.
>
> It was hardly known, or at any rate it was little heard of, before the coming of this Act, but during recent years its increase has been most remarkable.
>
> In 1908 the number of cases of it under the Act was 460, and in 1913 no fewer than 4,551, an increase of nearly 900 per cent in the six years.
>
> The causes and symptoms of this complaint are still a matter of discussion among medical authorities.
>
> The most general symptom is oscillation of the eyeballs.
>
> It seems to be mainly a nervous disorder, brought on by over strain and over fatigue, aggravated probably by the constrained attitude and also by the deficient light in which

miners often work.

It was stated not long ago by a medical man, Dr Samuel McMurray, ophthalmic surgeon to the Longton Hospital, Stoke-On-Trent, that approximately 20 per cent of all underground workers are found to have evidence of nystagmus, but only 0.29 per cent are incapacitated.

A mild attack may not incapacitate a man in any way.

The subject is fully dealt with by Dr Frank Shufflebottom in his 4 Milroy lecture (March 1914). He states that miners nystagmus is the most frequent of all occupational diseases.

It is now recognised in all the principal coal mining countries as a disease affecting the earning capacity of miners.

It is almost unknown in ironstone and metalliferous mines, and in naked light pits from which coal is obtained it is very much less frequent than in mines in which safety lamps are used.

It is worth noting too that in very large Collieries there has been a marked increase in the number of cases of nystagmus since the introduction of safety lamps.

Next to nystagmus, the occupational disease which causes the most disablement among miners is 'beat-knee', 'an acute inflammation in the subcutaneous tissues around the knee joint'. During 1913 there were 1,630 new cases of it, and 64 continued from the previous year.

These two diseases, together with 'beat-hand' and 'beat-elbow' are those which caused the most loss of work among coal miners.

During 1913 there were 7,478 cases of disablement by DISEASE in the mining industry, and £113,203 was paid by the way of compensation for them.

There were no FATAL cases due to the scheduled occupational diseases.

Due to accidents, there were 195,378 cases of disablement, for which £1,010,637 was paid by way of compensation, and 1,312 FATAL cases, for which £227,418 was paid to dependants.

This applies to the whole mining industry, Metal as well as Coal mining, but Coal mining constitutes within 2 to 3 per cent of the whole.

There has been a steady increase in the number of cases, and in the amount of compensation paid since the Act came into force.

Taking the 5 year period 1909–1913, the official returns under this [Workmen's Compensation] Act show that in the mining industry, while the number of persons employed has increased by 13 per cent, the number of disablement cases has risen by 26 per cent, and the total compensation paid, by 36 per cent.

NO DOUBT THE 'ACT' ENCOURAGES MALINGERING, but this cannot ALL be thus accounted for.

This sad curtailment and mutilation of human life and energy calls for the most earnest efforts of amelioration on the part of all concerned, including the medical profession. Health and strength are predominant factors in human well-being and efficiency.

From this time until the 1950s, when the coal faces became highly mechanised, but before the introduction of dust masks and dust-suppression equipment, the miners were virtually eating great volumes of coal dust, filling their lungs and contracting life-threatening illnesses such as bronchitis and pneumoconiosis, etc.

Approved SAFETY Equipment for ALL MINERS GENERAL WORKERS and ACETYLENE WELDERS

LARGE STOCKS ALWAYS ON HAND

MINERS' HELMETS, GLASSES AND GOGGLES, RESPIRATORS, GLOVES, MITTS, KNEE AND ELBOW PADS. HOME OFFICE APPROVED LEATHER BOOTS, ALL TYPES ANKLE, KNEE AND THIGH RUBBER BOOTS, CONVEYOR AND TRANSMISSION BELTING. VEE ROPE DRIVES AND PULLEYS. AIR HOSE, DELIVERY AND SUCTION WATER HOSE, &c., &c.

Let us quote to your requirements

R. & H. BARKES, LTD.
Clavering Place
NEWCASTLE-UPON-TYNE, 1
Branches: LONDON, GLASGOW, SUNDERLAND

DUST COLLECTION
at the source by plants

CYCLONE DUST Collecting Plants have been installed in some of the most important collieries in Great Britain.

They have proved extremely effective in ensuring greatly improved working conditions—a vital necessity in the present scheme of attracting many new workers to this all important industry.

Over 65 years of intensive research and experience of dust collecting problems in all classes of industry are at your service.

We invite your enquiries, which will have the immediate attention of our expert technical staff.

Full details gladly sent on request.
Please quote Ref. CTD/12.

MATTHEWS & YATES LTD
SWINTON (MANCHESTER) AND 20 BEDFORD ROW, LONDON, W.C.1
Telephones: SWInton 2273 (4 lines) CHAncery 7823 (3 lines)
GLASGOW LEEDS BIRMINGHAM CARDIFF

Modern-day miners are equipped with all the relevant safety equipment.

THIS COLLIERY IS NOW MANAGED BY THE NATIONAL COAL BOARD ON BEHALF OF THE PEOPLE

JANUARY 1ST 1947

The sign that was erected outside each colliery on vesting day, 1 January 1947, following the Coal Industry Nationalisation Act, 1946.

'Jobs for the Boys'

The Coal Industry Nationalisation Act 1946 brought the nation's 958 coal mines and 323 small licensed mines under the jurisdiction of the Labour Government in January 1947.

UK production at this time was 147 million tons, with a manpower contingency of 711,000 men.

It cost the nation £165 million in compensation for the original owners and almost £79 million for former royalty owners, and along with it the British Labour Prime Minister, Clement Attlee, set up an uncanny system of 'jobs for the boys', more befitting Winston Churchill, with whom he was in coalition during the war years. Needless to say, Attlee was the deputy prime minister at the time. The Chairman of the National Coal Board was Viscount Hyndley, GBE. The Deputy Chairman was Sir Arthur Street, GCB, KBE, CMG, CIE, MC.

The coalfields were split up into eight divisions, each with its own chairman:

Scottish Division, Chairman the Earl of Balfour.
Northern Division, Chairman E. H. D. Skinner.
North Eastern Division, Chairman Major-General Sir Noel G. Holmes KBE, CB, MC.
North Western Division, Chairman J. A. Webb CBE.
East Midland Division, Chairman Sir Hubert Houldsworth KC, DSc.
West Midland Division, Chairman the Rt Hon. Ben Smith KBE.
South Western Division, Chairman G. E. Aeron-Thomas OBEDL, JP.
South Eastern Division, Chairman Rear-Admiral (S) H. R. M. Woodhouse, CB, OBE, RN (Retd).

All these men had deputies, of whom a good many were of a similar standing.

I think that most of these people would have had great difficulty knowing the difference between a pick and a shovel, but the Prime Minister obviously thought that they were the right men for the job.

In 1951, the new Conservative Government acknowledged that nationalisation was here to stay; the new Government minister of fuel and power, Geoffrey Lloyd, gave assurances to the House that once they accepted nationalisation they wouldn't be able to sit around looking through neutral or semi-hostile eyes, much less mess around with it. What a difference thirty-three years can make!

'Jobs for the Boys'

Other small mine owners were operating in and around the Sheffield area; some are listed below:

Berry Moor Thorgoland, Sheffield.
Armitage Works Company Ltd.

Deepcar Henholmes, Deepcar, Sheffield.
C. Bramhall.

Myers Lane Oughtibridge, Sheffield.
T. Brook & Sons.

Bracken Moore Deepcar, Sheffield.
Chambers Brothers, Effingham, Sheffield.

Gregory, Reddish & Company Ltd Deepcar, Sheffield.
Clough

Callywhite Lane Dronfield.

Handley Collieries Ltd Apperknowle, Sheffield.

Leewood Colliery Ltd (private opencast) 336 Main Road, Sheffield.

T. Wragg Worral Moor, Loxley, Sheffield.

Sharps Sicklebrook Colliery Coal Aston, Sheffield.

Tinker Brothers Ltd Hazelhead, Sheffield.

Mrs M. Jackson.

Pickford Holland & Co. Little Matlock, Sheffield.

Tinker Brothers Ltd Hazelhead, Sheffield.

Although most collieries were nationalised by 1947, the NCB issued operating licences to several small mine owners in the Sheffield area to continue in production.

The following were still in production in 1949:

North Eastern Division

Cliff Bridge Colliery Company Ltd (F. Fox), Thurgoland, Sheffield.

Guyder Bottom Colliery Company Ltd, Hoylanswaine, Penistone, Sheffield.
Hollin Dyke Colliery Company Ltd, Bird Lane, Thurgoland, Sheffield.
Swallownest Brick Company, Swallownest, Sheffield.
Thimblewood Colliery Company Ltd, Bird Lane, Thurgoland, Sheffield.
Wortley Colliery Company, Wortley, Sheffield.

East Midlands Division

Dent Main Colliery (1924) Ltd, Birley Wood Farm, Gleadless, Sheffield. Colliery situated on Birley Moor Road.

Dent Main Colliery (Birley Wood)

Granted operating license by NCB in 1947.

Dent Main Colliery was opened in 1924 and had three directors, Colin and Albert Pemberton and Brian Hutchinson.

It was situated on Birley Moor Road, between Frecheville and Mosborough.

The site is now occupied by the Birley garden centre.

The adit (entrance) to the drift was approximately 100 yards from the main road, and the drift dipped to a gradient of 1 in 3.3 into the workings of the Parkgate coal seam.

The Coalmining History Resource Centre states that there were twenty-seven men working underground and eleven on the surface in 1945; the manager at this time was J. H. Heslop.

The pit was gas-free so the colliers were allowed to use acetylene lamps as working lights.

There were no mechanical means of cutting the coal; holes were drilled into the coal face at intervals along its length, shots were fired which brought down the coal and it was then worked by pick and shovel and loaded into the tubs, which were of 10-cwt capacity.

Pit ponies were used in the roadways to transport materials to the workings from the pit bottom, the average height of the roadways being only 5 feet. The ponies were also used to haul the full coal tubs from the workings up to the bottom of the drift, where they were then attached to a haulage rope to be hauled up the drift with a petrol-engined winch.

On reaching the surface the tubs were detached from the haulage rope and derailed by one man using a long pole, tipping the coal onto the screening belt, where he then joined two other men in sorting the coal until the next tub reached the surface.

Dent Main was one of the last pits in the Sheffield area to use pit ponies; they were well looked after and regularly taken to Hackenthorpe village to be re-shoed.

The pit was known locally as Diamond Row Pit due to a row of miners' cottages that were built topside the colliery entrance and had diamond-design leaded windows.

The pit worked in wet conditions, and orange-coloured 'ochre water' was continually pumped out due to iron deposits in the workings.

The colliery was successful, and supplied its coal to the steelworks in Sheffield, the main hauliers being Robinsons of Sheffield. Local coal dealers, M. Heath, Jones of Intake and Keeton & Richardson, were also used for nearby small businesses and household coal sales.

The colliery had two 7-ton lorries, which took coal to Blackburn Meadows power station in Sheffield.

Mr Brian Hutchinson was the sole remaining director when the pit closed in the early 1970s. He was the one who drew up the plans for working the districts in all areas of the mine. Great credit is due to him, as the only instrument available to him at this time was a handheld compass.

The map and the compass are the only remaining artefacts from the colliery, and are now in the safe hands of his daughter, Mrs Margaret Bennett, who gave me permission to reproduce the map, a close-up of the drift and some of the workings for all to see.

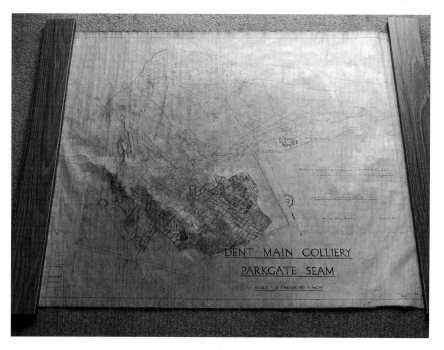

Colliery workings, 1956.

M. Heath's coal lorries operating from Dent Main.

Other Collieries in the Woodhouse Area

In 1700, Messrs Birks and Oldale of Woodhouse began a partnership and invested in a colliery at the top of Furnace Lane.

Some 150 years later, William Herrings' men broke through into the old workings and found the remains of old wooden corves, pickaxe handles and hammer shafts, the heads having rusted away.

P. France & Sons started pits during the 1700s at engine houses towards the bottom of Furnace Lane. The area between Handsworth, Hackenthorpe, Normanton Springs and Treeton must have been particularly rich in coal, given the number of pits that started up in the area during the eighteenth century.

High Hazels had a small drift mine, and a pit of unknown origin is recorded as being in Richmond in 1700.

In the same district, Samuel Shepley, John Stacye and Alex Fenton also had pits.

Dore House Colliery started operations in 1795, but ceased production after only five years, due to what seemed at the time to be almost unsolvable underground transportation problems.

The colliery was reopened some twenty years later by R. Sorby, and continued to work successfully until the early 1870s.

From 1805, Nixon, Littlewood & Co. worked a colliery at Handsworth, under lease from the Duke of Norfolk for a period of fifteen years, until Messrs Holy, Wilson, Dunn and Jeffcock took over the lease for several more years.

In the early 1850s, G. Habershon opened up the Junction Colliery near the Woodhouse Junction railway station. It had three shallow shafts, the lower of which was used to draw coal from the workings. A tramway was run between the lower shaft head and the railway station for the quick and easy disposal of coal, which was first drawn from the shaft by a horse-operated rope-and-pulley system called a Jenny Wheel; the coal was then transferred into tubs to be transported to the station.

It seems that bad working practices, including insufficient roof supports etc., caused water to rush into the workings, which led to the abandonment of the mine in 1870.

A second Junction Colliery, operated by Fox & Co., worked across the road (Long Storrs Lane) between 1862 and 1870.

Other collieries known to be working in the Woodhouse area in the late eighteenth and early nineteenth centuries include the following:

Dore House Colliery, 1795
Owned by the Dore House Colliery Co., opened in 1795 and quickly abandoned, but reopened by R. Sorby, and still working in 1848.

Woodhouse Mill Colliery, c. 1850.
Belonged to the Habershons, who had been mine owners since before 1838.

Coalbrook Colliery, c. 1845
Owned by P. France from Woodhouse.

Junction Colliery
Owned by the Habershons. Was working in 1857, but had closed by 1870 due to flooding.

Junction Colliery 2
Operated by Messrs Fox & Co., and worked for eight years from 1862 to 1870.

Industrial Colliery
Owned by Industrial Coal & Iron Co. Worked on the same site, but lack of funds caused its closure in 1876.

Woodhouse Colliery
Jointly owned by Jos and John Hibbard, Frank Tofield and the rector of Handsworth, the Revd John Hands. This colliery was worked by four different operators during its six years of life:

1862 W. Herring and Bradley.
1863/4 Richards.
1865/6 Lachin.
1867/8 Horsfield.

The pit was reopened in 1894. The record of its closure is not available.

Stubbin Lane Colliery
Was opened in 1875 by T. W. Rhodes. It was a small undertaking situated in Shirecliffe Wood; it only worked for two years and was abandoned in 1877.

There were further colliery workings during the twentieth century, making this South Eastern district of Sheffield a great wealth of mining activity, evidence of which was uncovered by recent opencast mining operations in the area.

Mining activity in this area seemed to slacken off towards the end of the nineteenth

century, probably due to the larger Birley pits being opened. Those pits worked the deeper seam coals, which attracted colliers with more regular work and a better pay structure, until 1926, when the Bramley Hall Estate opened several drifts into shallow seams of Barnsley coal, only 18 feet below the surface, and, during the strike of that year and for a good few years to follow, extracted coal from an area that had been worked some years before.

Joseph Hewlett opened up another pit near to the old Stubbin Lane Colliery. Although it was very productive in its very short life, it had to close after only one year due to severe water problems.

J. G. Worthy & Partners were to open up the pit again in 1932, and ran it for another four years until they had to close it because continuing water problems were pulling on their financial resources to such an extent that they were forced into liquidation.

In 1830, during the great turnout, general unrest was rife, and rioting started up throughout the whole neighbourhood.

A troop of foot soldiers was drafted into Woodhouse Village at 2.00 a.m. to help to quell the rioters.

Some of the striking miners' wives were so incensed by the use of blackleg labour and the deployment of soldiers that they stripped the clothing from several of them and left them for the villagers to ridicule.

Sporadic fighting carried on throughout the night until the following morning, when the Riot Act was read out under the village cross, beside the Cross Daggers Inn.

Four women, one of whom was heavily pregnant, were duly arrested for their actions towards the blacklegs; they were formally charged and imprisoned. The child was born later, within the prison confines, and stayed with the mother until her eventual release.

The disruption continued for several more weeks, and the soldiers stayed in attendance until things became more subdued and gradually returned to normality.

It was during the miners' strike of 1844 that P. France's men, who had little affection for the management due to appalling conditions, long hours of work and abysmal pay, ran amok on the colliery surface.

They had to be restrained from blowing up the colliery's boilers, and from attempting to throw the Frances' eldest son down the pit shaft!

Because of the disturbances at France's Coalbrook Colliery, and Habershon's at Woodhouse Mill, which ended in disharmony among a lot of the workforce, the People's Colliery was opened near Birley Spa Lane by Messrs Taylor & Co. on Daniel Ward's property in 1844. It was still in operation after three years of working, but no records can be found as to when it was closed.

White's Directory of 1914 shows that the business interests in the village were greatly reliant on the mining industry, keeping the whole community in work.

The following is an extract from White's *District of Sheffield Directory of Woodhouse 1914*, and shows the reliance of local businesses on the coal mining industry.

George Anderson
Corfe Repairer
48 Sheffield Road

William John Atkin
Coal Merchant
37 Station Road

Edward Brindley Jnr
Miners' Tools Dealer
31 Tannery Street

T. Burnett & Co Ltd
Wagon Repairers
Woodhouse Junction

John Fairbanks
Foreman Shunter
1 Junction Road

Fred Freeman
Rolling Stock Controller for Great Central Railway
75 Station Road

Harrison & Camm Ltd
Wagon Repairers
Woodhouse Junction

Matthew Heeley
Cart Owner
14 Market Street

Hollis & Dale
Boot makers
Market Street

Hurst Nelson & Co. Ltd
Wagon Builders
Woodhouse Junction

Paul Jackson
Secretary Yorks Miners' Association
(Birley Branch No. 2)
7 Revill Lane

Vivian Kendall
Boot Maker
2 Chapel Street

Lincoln Wagon & Engine Co. Ltd
Woodhouse Junction

Charles Liversidge
Cart Owner
11 Station Road

For the entertainment of the local populace
The People's Electric Theatre & Picture Palace
Proprietor Mr Fred D. Albert
Station Road

William Swift Reynolds
Blacksmith
39 Station Road

W. H. Santhouse & Sons
Coal Dealers
72 Vicar Lane

Alfred J. Gainsford
Secretary to Sheffield Coal Company
Birley Collieries Ltd

Samuel Stevens
Wagon Builder
Woodhouse Junction

Septimus Taylor
Cart Owner
23 Victoria Road

Joseph Turner
Joiner
Vicar Lane

William Turner
Carting Contractors
67 Station Road

Harry Whittaker
Boot Maker
3 Beighton Road

William Rice
Haycroft Colliery Clerk
69 Worksop Road
Woodhouse Mill

Birley East Colliery

In 1887, the Sheffield Coal Company moved into an area of Woodhouse known locally as 'Sally Clarks', and sank a shaft to a depth of 729 feet into the Silkstone seam.

It was completed in 1888 and was to become the downcast shaft. Approximately 30 yards away, a second shaft was sunk to a depth of 718 feet and was to be the upcast shaft. Both were 14-foot-9-inch diameter.

The Silkstone seam was very productive and provided the colliery with approximately 45 per cent of its lifetime's output, until the beginning of the First World War, when advances were made into the Thorncliffe and Parkgate seams; these were connected by a drift, which was the main artery for coals from both seams to the pit bottom.

Birley East pit was to become the largest deep mine in the area at that time, and provided employment for men from miles around. Although it was always dogged with water problems, it was mainly controlled, and produced large amounts of good-quality, saleable coal.

The management and employees worked as a team, and there was very little upheaval through disputes, apart from the national stoppages that troubled the whole industry over the years.

The safety record at the pit was very good overall, but, as with all the pits in the industry, nothing was plain sailing and its record was marred by three serious incidents within a thirty-year span.

The first happened in 1898, when a full tub of coal jumped off the rails and ran into a sixteen-year-old boy, crushing him to death. He had apparently been working between eleven and twelve hours' overtime. The Midlands Area Chief Mines Inspector, Mr A. H. Stokes, criticised the practice of using boys to do overtime. The Coal Mines Regulation Act, which would have limited his hours of work to eight, was not introduced for another ten years.

On 25 January 1904 at 2.30 p.m., a major fire developed in the engine room, which was very quickly consumed. It spread rapidly to the dynamo room and downcast shaft; the dynamos were destroyed in the process. The woodwork in the shaft was ignited, and smoke and flames were spreading down the shaft. The fire started as the day shift and afternoon shift were turning over; some men had already descended into the pit to start the afternoon shift while others from the day shift were still in the pit waiting to be brought to the surface. It was feared that all the 1,050 men might be trapped underground, and relatives began assembling on the pit top, but fortunately their fears were suppressed by the management, who gave them assurances that everyone was safe. The Sheffield fire brigade sent a horse-drawn steamer, which was soon on the scene, and after a while the fire was sufficiently under control to allow the men to be wound to the surface. The fire brigade remained at the colliery overnight damping down, and left the pit at 9 a.m. the following

day. The pit was closed for two weeks and suffered damage to the tune of over £10,000.

Birley East Colliery, along with most other pits in the area, had a large contingent of pit ponies. The ponies were used for many and varied tasks, and they all had their own handlers, known as pony drivers, to whom they were very faithful. They were hitched on to flat-bottomed wagons known as trams, on which were loaded supplies such as pit props, pipes, and girders, etc., for transportation to various parts of the pit. They were also used for pulling full or empty tubs of coal either from or to the coal face or to the pit bottom for winding out of the pit. The pony drivers had good relationships with their animals, and teamwork always paid off! Most ponies had an uncanny sense of impending danger, and would stop in their tracks to warn their drivers of anything abnormal. It has been said on many occasions that ponies froze to the ground and refused to move, and that if they had proceeded any further they would have been buried under a fall of roof. Having said this, there were some drivers working on bonus who would ill-treat their pony by kicking or beating it; this resulted in the pony kicking back, and serious injuries could result on both sides. The Coal Mines Act of 1911 made rules for the protection of animals in coal mines.

S. Widdowson was a member of the Birley branch of the Yorkshire Miners' Association. When the National Union of Mineworkers was formed, he became a lifelong member of the Yorkshire Area and was eventually awarded the medal for long membership before his retirement.

13 December 1934 saw six men buried by an estimated 80 tons of coal in a roof fall that was the result of water seeping through faults in the overhead strata, and insufficient roof supports in the prevailing conditions. All six men were extricated, but three of them succumbed.

The three men who died were named as Harold Reaney, aged twenty-seven, Ernest Redfearn, aged twenty-seven, and Arthur Pearson, aged thirty-three.

Ironically, John Priest was killed on 23 October 1943 by a shock wave reported as being the result of shot firing, on the colliery's last day of working.

Eight men were badly burned, and four of these died from their injuries, in an explosion that occurred on Saturday 23 February 1924 as a result of a shot firing accident, when an accumulation of firedamp gas was ignited.

HM Chief Inspector of Mines, Mr Henry Walker CBE, concluded that the shot firer had not tested for gas before he fired the shot!

Shot firing accidents accounted for a large percentage of gas explosions, and were usually the result of sheer negligence on behalf of the shot firer; many of them were found guilty of manslaughter and imprisoned.

All shot firers and colliery officials have to have training to test for gas with a flame safety lamp, and are examined and issued with a certificate of competence. They must also have a periodic retest by the colliery manager.

Copious amounts of top-quality coal were extracted from the colliery, which stayed at the forefront of modern technology and innovation, although it was constantly dogged with water problems. The Silkstone seam was officially abandoned in 1934 for this reason.

The colliery ceased coal production on 25 November 1943.

On 2 December 1943, the Rt Hon. Ernest Bevin, Minister of Labour and National Service, stated in the House of Commons that thousands of young men aged between

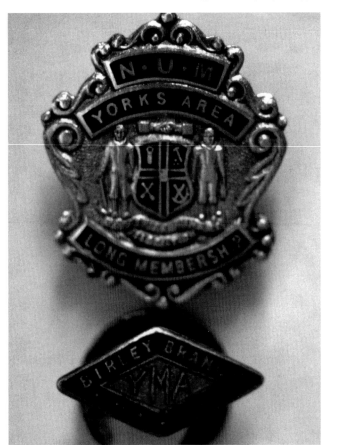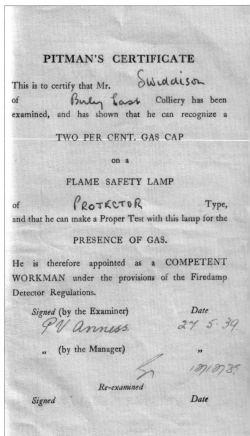

Above left: (Len Widdowson)

Above right: The name is spelt wrongly on this certificate. (Len Widdowson)

eighteen and twenty-five, on becoming available for call-up, would be selected by ballot and conscripted into the coal mining industry as a compulsory alternative to service in the armed forces. These conscripts were referred to among the local miners as 'Bevin boys'.

They were being freshly recruited into the mining industry to help with the extra output required during the war years, and due to Birley East Colliery just closing, it was chosen as a fully equipped training establishment for their needs between 1943 and 10 June 1948. The coal mines (training) general regulations were implemented in 1945.

Most of the surface equipment, including the shunting engines, was transferred to Brookhouse Colliery, and in 1950, an electric winder, which had been manufactured at the old Waleswood Colliery Estates department, was erected in the headstocks to retrieve valuable equipment from the underground workings. The operation carried on for approximately two years until the exercise became too expensive.

The Birley Colliery branch line closed in 1950, and the demolition of the surface buildings commenced.

The washery buildings were the subject of much media attention, as it took at least three attempts before they were finally blown up with a fair amount of dynamite!

The shafts were filled in with rubble transported in from Sheffield city centre from another local landmark, the recently demolished Classic Cinema, and the remainder was from the nearby Brookhouse Colliery's spoil heap.

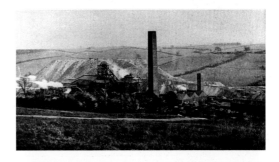

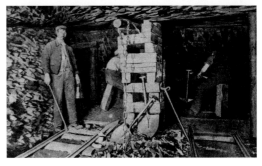

At the coal face prior to the First World War. (*Both photographs on this page courtesy of Alan Rowles*)

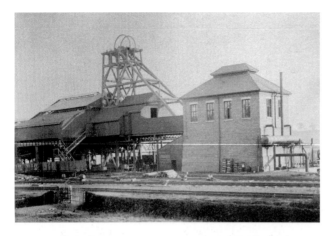

A very early photograph, possibly from 1885, showing the uncompleted building of what was to be the downcast shaft installation. (*Alan Rowles*)

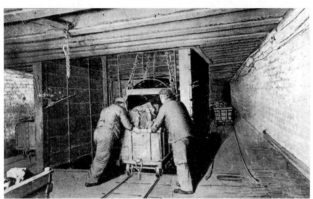

Onsetters loading full tubs onto the pit cage to be hauled to the surface. (*Alan Rowles*)

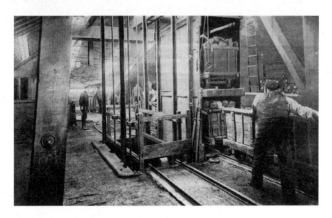

The pit top banks man unloading the full tubs and shoving on two empties to be wound down the shaft. (*Alan Rowles*)

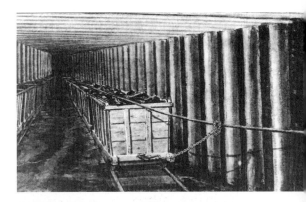

Coal tubs being hauled along a main roadway from a coalface in the Parkgate seam. (*Alan Rowles*)

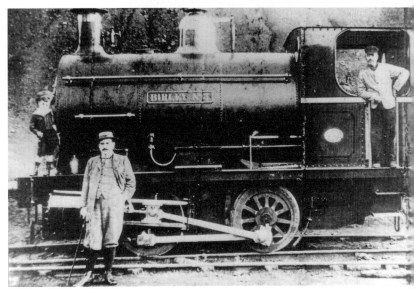

Mr Gainsford, Director of the Sheffield Coal Company, taking delivery of a new shunting engine, No. 972, in 1903. The engine went on to work at Birley West Colliery until it ceased production in 1908; then the engine was found work at the coking facility until 1925. No. 972 was transferred to the company's Beighton Colliery for a short time, until it was passed over to Brookhouse Colliery for the remainder of its working life. It was scrapped in 1940. (*Alan Rowles*)

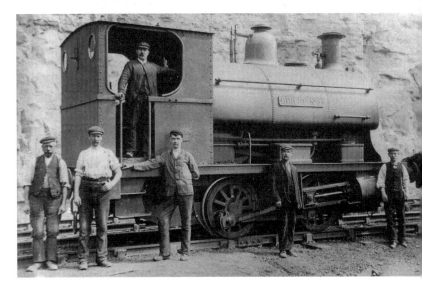

Birley West shunting team posing beside their engine, *Birley No. 3*, c. 1905. (*Alan Rowles*)

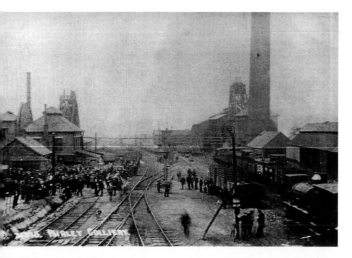

Pay day, Birley East Pit yard, *c.* 1900. (*Alan Rowles*)

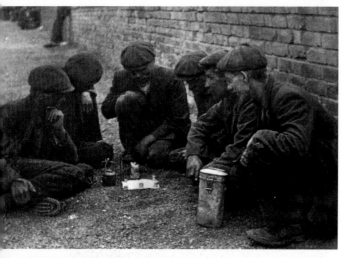

Butty man sharing out the team's wages, *c.* 1900. (*Ben Clayton*)

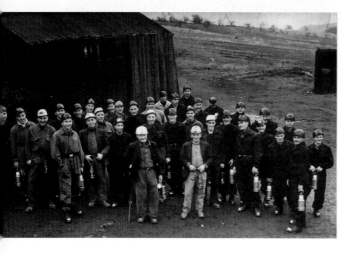

Bevin Boys and their instructors shown at East Birley Colliery training centre. (*Alan Rowles*)

Prefabricated buildings, which were part of the training centre. These buildings stood the test of time and were still in use up to 1990, eventually being demolished in 1998. (*Alan Rowles*)

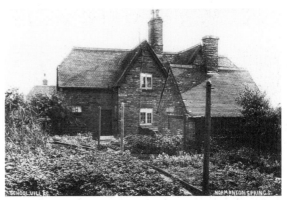

The imposing, semi-detatched stone houses at Normanton Springs, built by the Sheffield Coal Company around 1855 for the manager and undermanager at nearby Birley West Colliery.

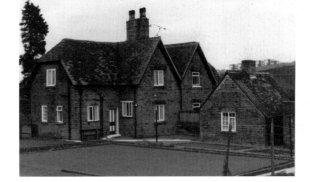

This photograph was taken 100 years later. Note the maisonettes above the outhouse. (*Alan Rowles*)

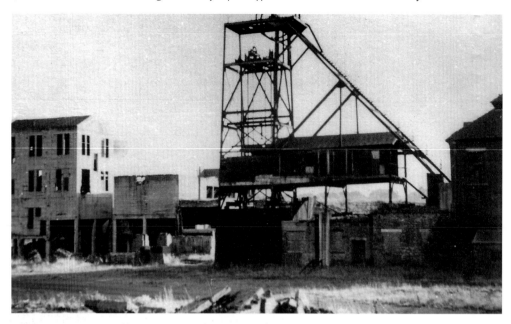

A photograph showing the electric winding mechanism on the steelwork below the winding wheel.

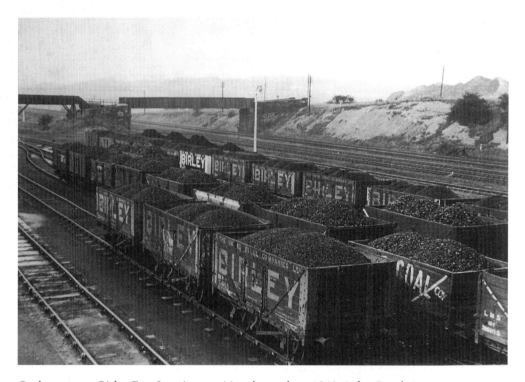

Coal wagons at Birley East Junction awaiting despatch, c. 1940. (*Alan Rowles*)

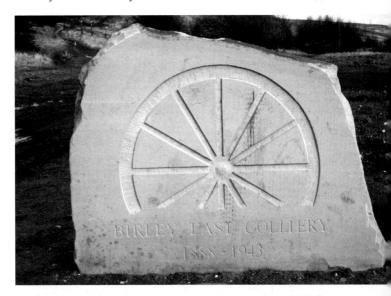

Birley East Colliery commemorative stone plaque, above, and shaft caps minus plaques, right. (*Len Widdowson*)

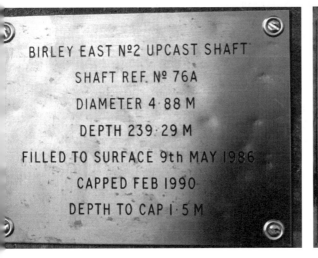

BIRLEY EAST Nº2 UPCAST SHAFT
SHAFT REF. Nº 76A
DIAMETER 4·88 M
DEPTH 239·29 M
FILLED TO SURFACE 9th MAY 1986
CAPPED FEB 1990
DEPTH TO CAP 1·5 M

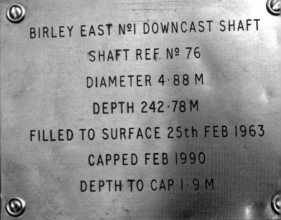

BIRLEY EAST Nº1 DOWNCAST SHAFT
SHAFT REF. Nº 76
DIAMETER 4·88 M
DEPTH 242·78 M
FILLED TO SURFACE 25th FEB 1963
CAPPED FEB 1990
DEPTH TO CAP 1·9 M

The Sheffield Coal Company and General Disputes Within the Industry

Jeffcock, Dunn & Co. joined forces with Messrs Houndsfield-Wilson Coal Company, Bartholomew, W. Littlewood, J. Jeffcock and J. & E. Sorby of Attercliffe in setting up the Sheffield Coal Company in 1805.

It was made a limited company, with a capital outlay of £90,000.

The company offices were in the Corn Exchange in Sheffield. It must be borne in mind, however, that at this time the company members were operating collieries in the Handsworth, Woodhouse, Birley, Intake and Hollinsend areas of Sheffield to great effect.

The Birley collieries made a gross operating profit of £81,734 3s 10d in 1915, a net profit of £63,984 13s 11d.

Railway lines were laid to the Birley Vale Colliery in 1855, and coupled to the Manchester, Sheffield & Lincolnshire railway compay's main line at Woodhouse Junction.

This new method of coal transportation was an immediate success, and led the company, which had details of further coal reserves, to sink the Birley West Colliery in 1871.

The Birley Vale and Woodthorpe collieries had doubled their output to in excess of 150,000 tons per annum by 1874, and in 1876 the colliers came out on strike to fight a reduction in their wage demand.

The year 1876 also saw six men killed in an explosion at the Birley Planting pit.

In October 1879, the Sheffield Coal Company's pits went on strike for a bigger share of the profits; this created much hardship, not only among the miners' families but in the community at large, particularly as it was at Christmastime.

The strike was doomed to fail from the outset, because some of the miners decided to carry on working while others were locked out; this created bad blood and hard feelings among those on strike.

Eventually, fighting broke out and things quickly deteriorated to such an extent that one man was shot at on returning home from work. Fortunately, a man was apprehended and the gun confiscated.

A house in Woodhouse that was being used by other working miners had a bomb planted in it by the striking miners; it was seriously damaged as a result of the explosion, but thankfully there were no injuries.

However, by the 1880s, production had increased dramatically, and over the next decade the miners had received three pay awards, which brought their average weekly earnings to £1 10s per week.

The Birley East Colliery was opened in 1888, and in the same year there was a strike for an increase of 10 per cent in their wages, which was accepted by most of the colliery owners.

By 1892, the Birley Vale collieries were producing just over 2,500 tons per day! New company offices were found in Cairns Chambers, Church Street, Sheffield.

Although the company were doing well with their exports, there was a nationwide slump in the general coal trade, and the colliery managers decided to respond by announcing a 25 per cent reduction in pay. This was to be implemented with immediate effect throughout the coalfield.

The miners found this a difficult pill to swallow, and on 2 August 1893 they came out on strike and yet again plunged the industry into further turmoil to try to protect their wages.

The miners were driven by sheer desperation, and their anger was roused; their actions soon turned into outright lawlessness and wanton damage. This turned out to be one of the bloodiest encounters within the industry at this time. Localised fighting turned into widespread civil unrest and serious rioting, as a result of which criminal damage amounting to tens of thousands of pounds took place.

Holbrook Colliery at Killamarsh bore the brunt of some of the more serious altercations, which resulted in badly damaged coke oven equipment and colliery offices.

Hauliers were threatened with their lives if attempts were made to move coal stocks. Coal wagons were derailed at Hornthorpe Colliery near Eckington, the contents being tipped on the ground and on the main railway line, which could have resulted in fatalities, as an oncoming express train was due at the time. The actions of a quick-thinking signalman narrowly averted the tragedy.

The Army was called in to establish law and order, and some of the miners were shot, several being killed!

Lord Rosebery intervened by forming a conciliation board, which held the original rates of pay and promised a better deal at a later date. The strike ended on 19 October. Contracts were set up to sell coal nationally to several of the major gas companies, and local domestic merchants were also able to buy coal from the land sale office on Birley Moor Road, and at Beighton Colliery.

In 1915, the Birley collieries made a gross operating profit of £81,734 3s 10d. After interest and dividends were paid to shareholders, this meant a net profit of £63, 984 13s 11d! These are the people who were demanding a 25 per cent reduction in pay!

Birley West Colliery closed in 1908, but continued to produce coke until 1925.

DIABOLICAL ATTEMPT TO BLOW UP A HOUSE AT HANDSWORTH WOODHOUSE.

During Tuesday night a diabolical attempt was made to blow up a house situate in Victoria road, Handsworth Woodhouse, and occupied by a miner, Wallis Taylor, employed by the Sheffield Coal Company at Birley Collieries. It appears that Taylor and his father-in-law, a man named Whittaker, have continued working at the above colliery during the dispute, and this has caused a considerable amount of ill-feeling towards them amongst the men locked out. They have, however continued at work, and this week Taylor has taken in, as lodgers several men who were working at the same colliery. They all retired to rest as usual on Tuesday evening, when at half-past twelve o'clock they were alarmed by a loud explosion in the house. The window of the back bedroom in which the men were sleeping was blown out, and the staircase door was found to have been moved out of its place. The staircase also showed signs of the effects of the explosion. Upon examination of the lower room, the remains of a tin bottle were found, which no doubt had contained the explosive material. The can, it is estimated, would hold about two pounds of gunpowder, and it is believed it was placed in the kitchen through the window, with a fuse attached, which would allow the perpetrators sufficient time before it reached the powder to get away. The most remarkable thing about the occurrence is that the bed room has suffered most, although the can was placed either in the kitchen or perhaps upon the staircase. Happily, however, no one was injured. The police are on the look-out, and are using every endeavour to track the guilty parties, and also to prevent a recurrence of the outrage.

OUTRAGE BY NON-UNIONIST MINERS AT WOODHOUSE.
SHOOTING AT LOCKED-OUT MINERS.

On Tuesday evening, a miner named William Ellis, living at Woodhouse, was, with his son, proceeding along the highway leading from Normanton Spring to Woodhouse, and when a short distance from Normanton they passed two men who were returning from work at the Birley Collieries. Ellis (who is one of the men locked out) looked at them, and one of them said, "Tha'll know us agean when tha sees us," and upon passing them a few yards a shot was fired, and Ellis heard a ball whiz past close to him. He gave information to the police, and the man was apprehended by Police-sergeant Watson, and lodged in the Police Station, Woodhouse. The revolver was found which is a six-chambered one. The chambers were, however, not loaded, as three of them were fired off at the time by the prisoner's companion.

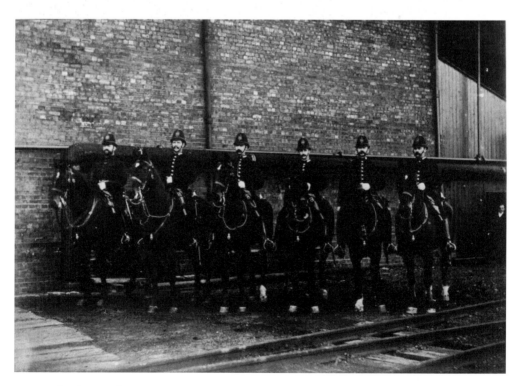

Mounted police on duty at Birley East Colliery during the 1893 strike. (*Alan Rowles*)

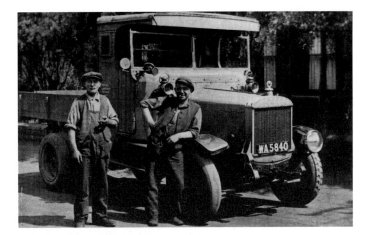

Messrs Maw and Watson with their coal wagon on Vicar Lane, Woodhouse, *c.* 1928. Note the bald tyres! (*Alan Rowles*)

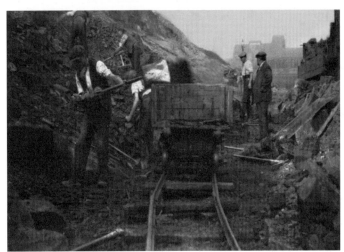

Robert Fleming's brickyard and quarry operated on the site of Birley West Colliery, at the bottom of Linley Lane. Colliery buildings can be seen in the background. (*Norman Fleming*)

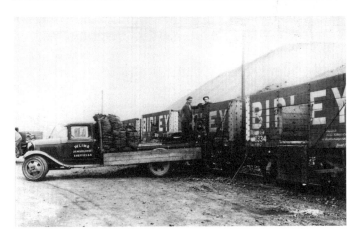

Sheffield coal merchants, Limbs from Hillsborough and Holmes from nearby Hollinsend (on the next page), collect their supplies from the land sale office at Birley West Colliery on 31 March 1938. (*Alan Rowles*)

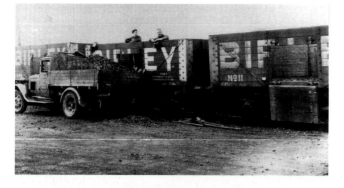

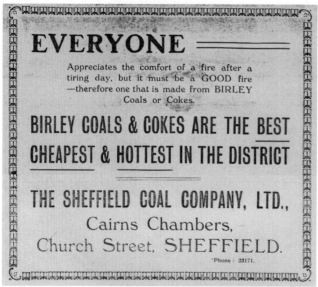

(Alan Rowles)

After the 1926 General Strike and the 1929 economic downturn, the city of Sheffield decided, after consultation with the trade unions and the Chamber of Commerce, to advertise the city on a national and international basis. To that end, they decided to have a 'Sheffield Week' every year. It lasted until the start of the Second World War. (Ken Wain)

The coal man was once a regular sight throughout the country, but is now sadly a dying breed, mainly supplying those who once worked in the industry with their concessionary fuel allowance, plus a few private customers. (*Ken Wain*)

Gilbert Gould

It was a great surprise to the local mining community when Gilbert Gould and some of his family members decided to lease a plot of land from the Duke of Norfolk and open up two drifts on Gleadless Common, to the south of Sheffield. After a period of time, however, Gilbert and his men came across a 6-foot seam of good-quality Silkstone coal after going in about 150 yards at a gradient of approximately 1 in 3.

It was soon realised that they had broken into some old workings, which were believed to be from the late 1700s.

The coal was hauled up the drifts in three tubs using a small steam-operated winding engine.

Ironically, the production of coal coincided with the miners' strike of 1921, and the small family concern not only proved its worth with the family but with the local community as a whole!

During the 1926 miners' strike, the colliery owner decided to continue with production, but the mining union opposed the sale of the coal on this occasion, and crowds gathered at the pit to prevent the movement of the coal.

Eventually the union decided that it could be moved, and the police were called to ensure its removal was unhindered. The pits only continued for another two years and were closed when they became uneconomical in 1928.

...be searching local newspapers, school and hospitals records and family papers. If you have any records of your family members in the war - stories, pictures medals, post war achievements, do let us know. If you are new to the village we are still interested in your family stories and souvenirs.

If you would like to help with this project or have questions, please get in touch:

Carole at 01296 748538 carole.e.fryer@btinternet.com

Judith at 01296 749080 judithmcarthur377@gmail.com

If you would like to join the History Group ring Joan on 01296 748538

1947 and went there

1923 Agent Hayland Scheph
Coal and coke co Ltd
1940 joint agent then Holbrook e?
J.S. Wells Ltd. Eshugt. echoyte?
1933 Agent Hayes A Monroad
 and renanced rhonda westhome.

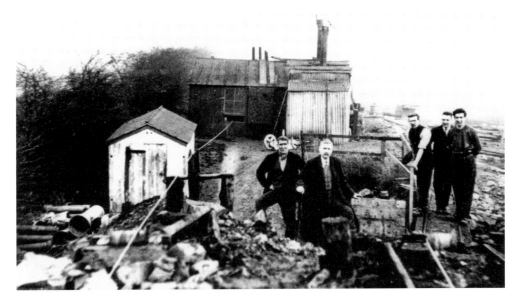

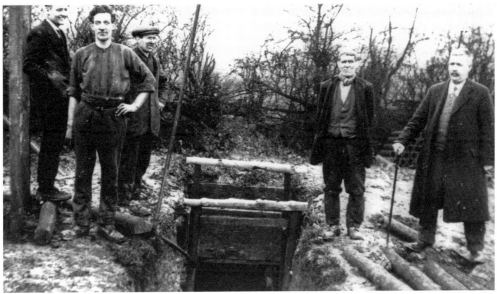

Above: Gilbert Gould's drift mines on Gleadless Common, *c.* 1900. (*S. Fox*)

Further Hardships

The Government took control of the administration of the mines during the First World War, due to the importance of coal to the war effort and the national economy, and so things were held stable over this period.

However, Lord Rosebery's promises never materialised, and the miners made a further attempt by coming out again in 1919, for a short period, to no avail.

The Government relinquished control of the mines in 1921, and their owners immediately let it be known that massive wage cuts would be implemented on April Fool's Day of that year!

The miners responded by calling a national lockout.

After only two weeks, it was realised that the transport and rail workers would not join them in their dispute, and so they stood alone.

Inevitably, after three months of isolation and with no movement from the owners, they had no option but to back down and return to work, accepting the lower wages that were on offer. Ironically, the coal trade picked up again, and exports began to blossom, which led to a good four years of economic stability.

Unfortunately, this was to be short-lived due to the importation of much cheaper European deep-mined coal, and also of American outcropped coal, which flooded the world markets and left the British producers high and dry.

The pits' profits dwindled, and the owners yet again demanded lower pay and longer working hours, supposedly to help promote the sale of British coal.

This was a paper exercise to save the pits, but no consideration was given to the workforce, who were yet again being used as pawns in a political game of chess; it was working them to exhaustion while giving them a meagre existence, which led to poor health and near destitution.

Serious slumps in the coal trade were by no means uncommon, and this often resulted in managers drastically cutting miners' pay.

Despite the knowledge that terrible hardship would follow, the men often had no option but to strike. Thankfully the villagers rallied around, donating what they could, forming distress funds and, as can be seen in the bottom right picture on the previous page, at Keyworth House in Tannery Street, Woodhouse, in 1912, providing soup kitchens.

Because of the ever worsening situation among the mining communities, local people took to driving their own drifts or sinking small shafts wherever there was thought to be

coal, either for their own use or for the opportunity of selling a few tons to enable them to buy food and clothing for their families. Gleadless colliers sank a shaft on Kirkby Road, in Taylors Field, to a depth of 30 feet, and found a 4-foot-6-inch seam of good Silkstone coal.

The pit was called 'Mangle Main' because the winding rope, which was attached by a hook to a large bucket to lift the coal up from the pit bottom, was fastened to the wooden roller of an old iron-framed mangle on the surface, and the handle was turned to lift up the bucket! Such was the poverty at the time that make do and mend ruled the day; access was via steep home-made wooden ladders! The pit was a godsend and saw them through the strike.

I can well remember my wife's uncle, Mr Horace Coe, telling me that he used to fetch coal from the pit for stoking up the boilers at Seagraves Nurseries, where he was a gardener.

Charity Main pit was opened at the same time in Fidlers Field, opposite the 'New Inn'.

As the name implies, coal was mined by local people, who were allowed 1 cwt a day for themselves but were paid nothing, and all the profits from sales were used to feed local miners and their families during the strike. Another drift was opened up at the top of Hurlfield Hill, near the 'Toll Bar'; this was operated by a Mr Wakelin and another man who kept it open during the strike, after which it was no longer viable.

Further outcropping took place throughout Sheffield and in Woodhouse Mill, Birley Fields, Handsworth, Darnall, Tinsley, Totley, Greystones, Ringinglow, and indeed in all other local mining areas, including the Rotherham, Worksop, Chesterfield and Barnsley districts. Whole communities would turn out to get coal.

One of the miners' leaders was reported as saying, 'This is a yo-yo situation that cannot carry on; we can't go up and down like this forever. One day the yarn will break, and it's already wearing very thin.'

The seriousness of the situation was soon realised, and the trade unions were already preparing to come out with the miners if requested.

The Government realised this and very quickly came up with a subsidy of more than £20 million to smooth the troubled waters, so to speak, until it set up a Royal Commission to investigate the situation.

The Commission duly reported in March 1926, but to no one's surprise it recommended the owners demand lower wages, with a package of reorganisation and a promise of better conditions at a later date.

The owners immediately refused any talk of reorganisation, and the miners refused to accept the owners' demands, which led to a stalemate situation; the 1926 lockout began on 1 May.

Prime Minister Stanley Baldwin pleaded with the miners to return to work, but he was ignored, and the General Strike was called by the trade union movement; it ran from 4 to 12 May, and caused nationwide disruption.

Although the miners were now without savings and reliant on the local communities for handouts of food and clothing, they remained resolute for seven months, but many had now begun to take up the Prime Minister's promise of a fair deal for a return to work. By the end of November, most of the pits were back to normal working, even though it was generally felt that the recently introduced Trades Dispute Act was little more than a lever to further restrict trade union activity, and to force them back to work.

The 1926 national miners' strike brought great hardship to the miners and their families; it was to go on for seven months, and distress committees were set up to help them survive throughout this period. More than 32,000 meals were issued at this time, along with other essentials such as free clothing, footwear and medical facilities.

The Endowed School in Waterslacks Lane at Woodhouse was used as a distribution centre for the above mentioned services, for which these people waited patiently, the children clutching their own food bowls.

The miners were yet again returning to work with no more than they had in the first place, and the establishment were back in charge.

A good many of the nation's coal masters classed their workforce as no more than slaves, whom they used to gather them great wealth and recognition among the upper echelons of society.

However, there were those who recognised the true worth of their workers, and in turn they became their benefactors.

Homes were built in many mining communities, at great cost to the owners, for the use of their employees.

Schools were constructed for the education of their children, and chapels were built to cater for their religious needs.

Thomas Dunn of the Jeffcock Dunn & Co. Coal Company, who died in 1871 aged seventy, left money for the Birley school to be built in Normanton Springs, adjacent to the two houses that had previously been built by the company for the managers of the Birley West Colliery.

The school was opened in 1872, and a commemorative plaque was installed in Gleadless church in memory of this man of benevolence, who was much revered both by his workforce and within the company itself.

Above right and below left: (Alan Rowles)
Below right: Trade union officials overseeing miners voting in the 1926 strike in Sheffield. (Ken Wain)

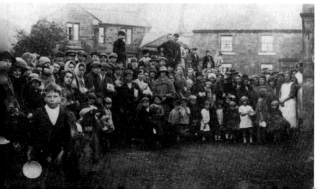 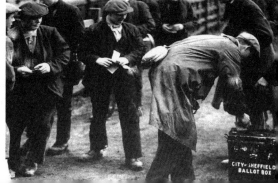

Fence Colliery

The Sheffield Colliery Company, under the directorship of Robert Dunn, sank Fence Colliery at Woodhouse Mill in 1842.

The colliery had two shafts, which were taken to a depth of 350 yards into the Flockton seam. No. 1 downcast air shaft was used for man riding and coal winding, and No. 2. upcast shaft was used for pumping water from the workings, and as a return airway. Further developments were made into the High Hazels and Swallowood seams, and a few years later a third shaft was sunk into the Top Hards seam at a depth of 154 yards.

The colliery was served by the Rotherham/Masborough to Derby railway, which had opened two years previously in May 1840.

It was linked to the pit yard by means of a tramway using horse-drawn tubs.

Due to general colliery expansion and the influx of miners from other areas, the colliery company built several miners' cottages and a house for the manager opposite the pit gates, on Falconer Lane.

Further cottages were built topside the colliery on Fence Hill, towards Swallownest; the community was now well established and the enterprise began to flourish.

The Sheffield Colliery Company decided to concentrate its efforts on its Hollinsend and Birley Vale sites, and sold the colliery to the newly formed Fence Colliery Company only twenty years later in 1862.

After only two years, in December 1864, a firedamp explosion ripped through the colliery, killing George Ward and the three Goodall brothers. The mines inspector, Mr Dickenson, said that the explosion was caused by an inrush of gas, which exploded because of the naked lights that the colliers were allowed to use at that time. The man in charge of testing for gas with a Davy lamp had not done so on this day, and was censured for his carelessness. The coroner advised that Davy lamps should be used in every mine.

Sir Humphrey Davy's Flame Safety Lamp was invented in 1815 and first introduced at Hebburn Colliery in 1816.

When the explosion occurred, only one Flame Safety Lamp was in use at the colliery, showing the laxity of the owners at this time. This was general practice throughout the industry and led to the unnecessary deaths of many hundreds of men and boys.

Shortly after this, the company built Fence Methodist church, at a cost of £400. The previous places of worship were the carpenter's shop and then the colliery offices, the services being conducted by the acting Sunday school superintendent, Mr L. Bates, the

colliery manager. The church was given free coal and only charged a peppercorn rent of one shilling per year.

By 1865, the pit was producing 250 tons per day, but shortly after the figures were released, a man was killed by a fall of roof due to bad working practices and insufficient roof supports. He was found to be dead when the rescuers reached him.

A further investment of £300,000 in 1870 secured the purchase of nearby Orgreave Colliery from the Sorby family. The purchase of Orgreave Colliery proved to be a sound investment, with a production figure of 20,000 tons in that year.

However, not content, the company sank another colliery at Treeton in 1875, and coupled them together via underground roadways, to facilitate better ventilation and easier means of escape in the event of an emergency.

The Aston cum Aughton School Board erected a day school in 1877 for the miners' children, and in 1883 the colliery's output peaked at around 108,000 tons. This was short-lived, however, because the production costs outstripped the colliery's short-term profits, and, coupled with problems within the pit that demanded immediate financing, the costs became prohibitive, leading to the pit's temporary closure.

Mr John Jaffray, a Birmingham businessman, along with several of his colleagues and business associates, came up with a rescue package. They formed a limited company, and with a capital outlay of only £20,000 began to work the colliery yet again, bringing it back into profitability. This was the first phase of what was to be the Rothervale Colliery Company.

The year 1870 saw Fence's best house coal selling at 14s 6d per ton.

In a major cost-cutting exercise, coal was last wound from Fence colliery in 1887, after which the coal was transported underground to be wound from Treeton Colliery. The coal seams were finally exhausted in 1902, after which time the Fence shafts were used solely for the purpose of pumping out the excessive ingress of water from the Treeton Colliery workings. In 1929, the colliery company installed water and electricity in the church, and finally, in 1935, the No. 1 and No. 2 shafts were plugged. The pumping was continued via the No. 3 Shaft until late 1957, when it was also plugged and the colliery buildings demolished, ending its life of only sixty years.

The colliery site was then used by the NCB for the storage of mining equipment until the site was cleared in 1959 to allow the excavations for the foundations of the NCB's new Fence Workshops to commence. While the excavations were being carried out, it was found that there were another five shafts on the site, and that opencast workings were also found in abundance. One of the shafts was found to be only 12 m from the side of the A57 Worksop Road!

Fence Colliery

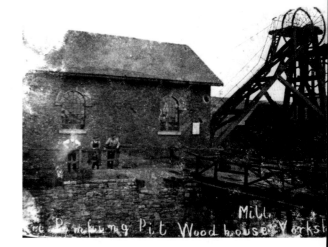

Fence Colliery, c. 1880. (Reg Edgeley)

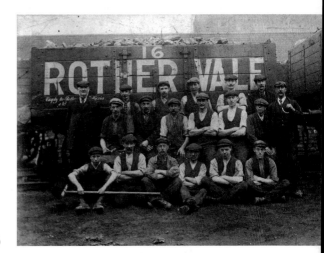

(Alan Rowles)

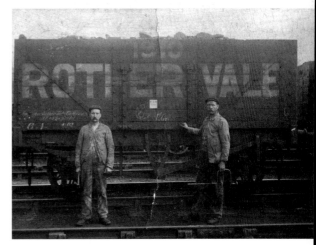

(Alan Rowles)

Fence Central Workshops and Stores: Woodhouse Mill

The idea behind an area central workshops and stores was to provide an excellent electrical and mechanical engineering service, with the backup of a repair and manufacturing facility, and a fully stocked stores, to enable a speedy and efficient repair and overhaul service. They catered for the technical needs of all the collieries in the area, by keeping their mechanised plant in tip-top working order.

The collieries within the Worksop No. 1 Area at that time were:

Orgreave
Shireoaks
Steeley
Thurcroft
Treeton
Brookhouse
Dinnington Main
Firbeck Main
Handsworth
Kiveton Park

Eventually the industry was 'Rationalised' by British Coal, and the workshops within the industry became national workshops. Each specialised in specific skill categories to enable them to offer a more efficient service to all the nation's mines, including a complete colliery 'on site' backup with skilled craftsmen, thus competing with manufacturers of mining equipment, who, because of declining sales in new equipment, were tendering more and more for the repair work, and had the advantage of readily available spares and manufacturing technology.

Collieries soon realised the advantages of using the site teams, and began to reap extra savings and speedier, more efficient repairs, which made for much better planning and achievement of production targets.

Inevitably, after the 1984 miners' strike and during the next decade of pit closures, the workshops' closure plan sped up.

Fence National Workshops closed as an operating unit in 1988, and became the National Plant Centre for the British Coal Corporation, which was formed in 1989, until its closure on 30 November 1995.

When the British Coal Corporation eventually left the site, it lay idle for several years until Laycast took over the tenure in 1998.

Laycast went on to develop a £15 million state-of-the-art casting facility, with all the latest technological equipment and know-how to make it a world leader at the time. The company initially prospered, with several lucrative contracts for specialised castings throughout the world. Sadly, trade began to decline, and the company left the site in 2007, after only nine years.

The buildings were demolished by July 2008, and the site was cleared. Opencast mining was carried out to retrieve coal, which was relatively widespread and near to the surface, to make way for a new industrial estate.

The NCB No. 1 Worksop Area Fence Central Workshops and Stores opened as an operational unit on 1 March 1961. (*Ken Wain*)

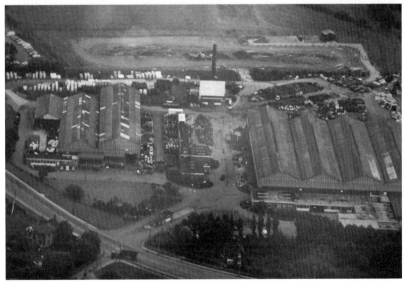

Aerial photo taken in 1975. (*NCB*)

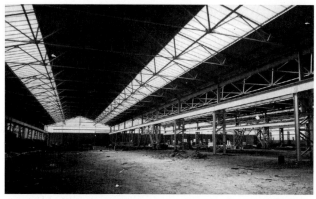

Fence Central Workshops, Worksop No. 1 Area, under construction, c. 1959. (NCB)

Coal and stone loaders department, c. 1986.

Fence Central Workshops and Stores: Woodhouse Mill

Trailing cable repair department.

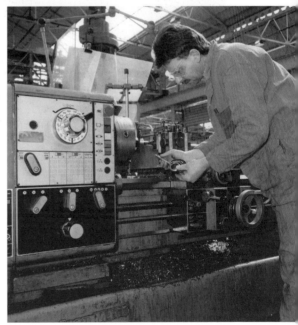

Machine shop.

Pump testing.

Cable repairs.

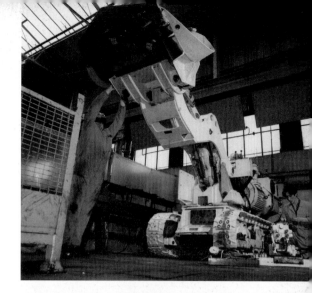

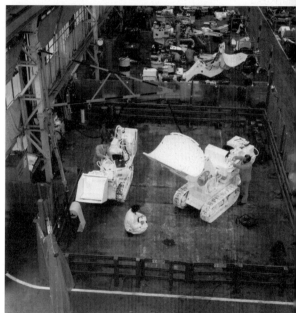

Power loader repairs.

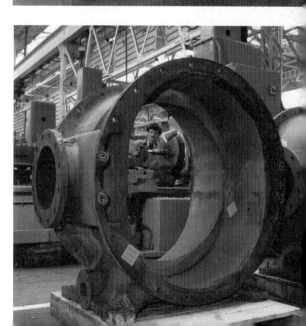

Pump repairs.

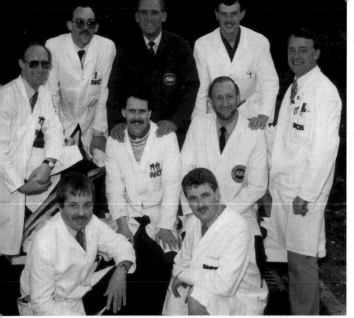

Supervisory staff, 1987.

Electronic equipment repairs.

Fence Central Workshops and Stores: Woodhouse Mill

Before and after, 1959–1994. The end of an era. (*Ken Wain*)

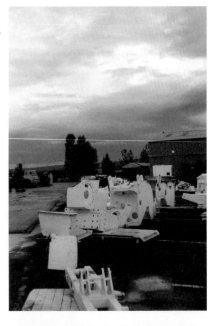

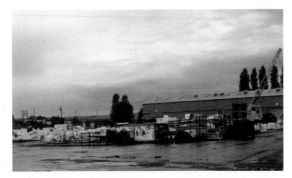

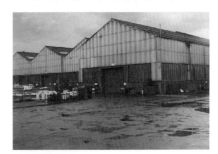

(Ken Wain)

Scenes that are hard to swallow. (*Ken Wain*)

Total devastation. (*Ken Wain*)

Friends and good times remembered. (*Ken Wain*)

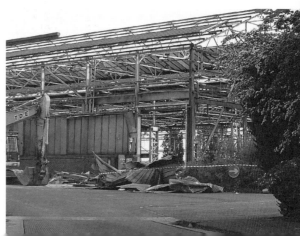

Time marches on and waits for no one. (*Ken Wain*)

Orgreave Colliery

In 1851, Richard Sorby of Treeton sank Orgreave Colliery to a depth of 132 yards into the Barnsley seam on the site of the old Dore House Colliery, which worked from 1795 to 1851.

Orgreave Colliery started producing coal in 1860.

It was taken over by the Fence Colliery Company in 1870, and, one year later, was brought to a standstill to allow major redevelopment work to proceed into the High Hazels seam, but this only had limited success.

The Fence Colliery Company was annulled in 1874, and the new Rothervale Collieries Ltd was formed, the head office being in Sheffield at 17 Haymarket Chambers.

Production at this time was running at some 30,000 tons per year, and by 1883 it had risen to 132,000 tons per year, providing the home markets with top-quality gas, household, and manufacturing coal.

The year 1887 saw the commencement of an exercise to deepen the shafts into the Silkstone seam, which took about three years to complete, the shafts passing through the Haigh Moor seam at 202 yards, the Flockton seam at 328 yards and the Parkgate seam at 386 yards until finally reaching the Silkstone seam at 404 yards. The railways purchased Parkgate coal for its steam-raising qualities. The colliery was connected underground in the Swallowood seam to Treeton Colliery, so that seven seams were now being worked.

The colliery was protected by the military during the 1883 strike, due to threats of damage to equipment, although this never materialised.

Three men died and one was injured in an over-winding accident; the production at this time was 132,727 tons per year.

The year 1909 saw the introduction of the old-age pension for those over the age of seventy.

Walter Gill was born in 1910 and lived at Gleadless. His father was a miner and worked at Orgreave Colliery along with other family members; they all worked together to strip out a certain area of coal each day. They used to take the coal off in layers, and when the seam was tapering out to 6 inches they laid on their sides and pulled the coal out with a pick.

When Walter was fourteen, he went to join his father at Orgreave. He left school on the Friday, and on the Monday morning he was up at 4 a.m. and walked to the pit, which

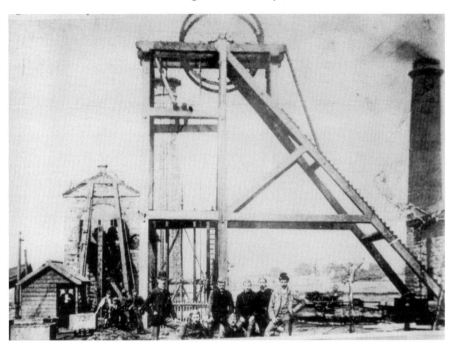

Orgreave Colliery, 1864. (*Ben Clayton*)

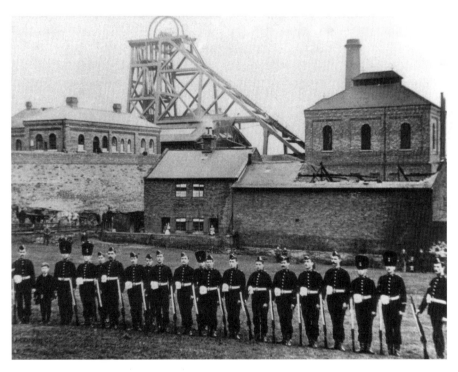

The military guarding Orgreave Colliery during the 1893 dispute, showing damage inflicted on the colliery buildings. Note the proud 'New Recruit' to the left of the picture. (*Ben Clayton*)

was 3 miles and an hour's walk. He would then go down the pit and walk another 1½ miles to his work. He was a 'haulage lad', clipping tubs on to the haulage rope, which pulled the tubs to the workings or back to the pit bottom. He was paid 4s 6d per day for 7½ hours' work.

By 1913, over 1 million men and boys were employed in the industry; of this number, 1,753 were killed!

This was at a time when the national output was 287,114,000 tons, and 90 million tons were exported.

By 1923 the colliery was producing 834,000 tons per year.

By the 1940s, Orgreave Colliery was working the Parkgate, Flockton, High Hazels and Silkstone seams, and in 1949 the colliery was producing coking coal and household and steam coals, and employing a workforce of 1,484 men under the management of Mr B. Blackburn.

Because of prevailing problems with constant dirt bands and poor roof conditions in the Flockton, Parkgate and Silkstone seams, the NCB put into place a major development scheme, which included opening up further reserves in the Swallowood seam, along with a new ventilation fan to help with gas accumulations in the Flockton and Silkstone seams. Skip winding was installed, and new colliery offices were built.

Work progressed in all the seams until the Parkgate and Silkstone seams were exhausted in 1962 and 1965 respectively.

By the 1970s a major percentage of the colliery's output was used by the Orgreave coke and chemical plant. At the time of the 1974 miners' strike, the pit was producing an annual 500,000 tons with 1,000 men, but geological conditions were getting progressively worse, the Swallowood workings being the only viable workable seam, and the colliery was eventually closed in October 1981; the underground connection with Treeton was sealed.

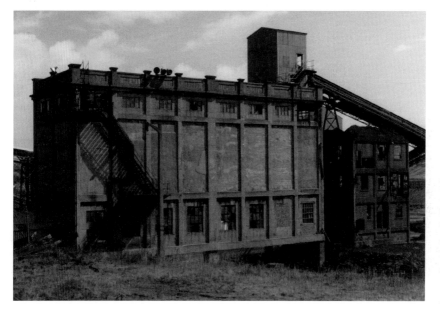

Orgreave washery and screens, which were kept open until Treeton closed. (*Alan Rowles*)

Orgreave Colliery

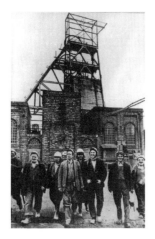

(Ben Clayton)

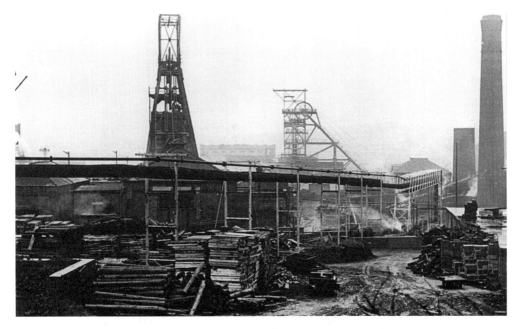

Record breakers. (*Ben Clayton*)

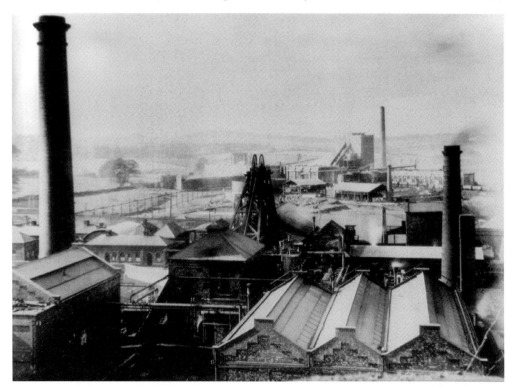

Orgreave Colliery, 1930. (*Ben Clayton*)

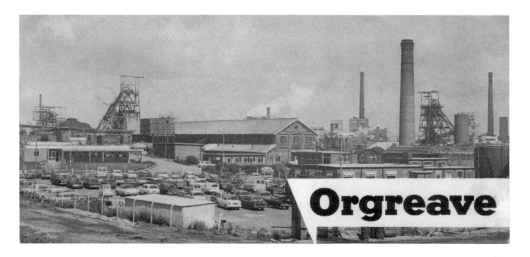

Just before closure, 1981. (*NCB*)

Orgreave Coke and Chemical Plant

Rothervale Collieries Ltd opened the Orgreave coke and chemical plant in 1918, and shortly after this the United Steel Company took over Rothervale Collieries Ltd, which ensured a ready market for the colliery's coal and coke products.

The chemical plant was producing tar, benzole, ammonia products and gas, among many others.

The whole plant was to be taken over after the nationalisation of the collieries in 1947; the British Steel Corporation ran it until its closure in 1990.

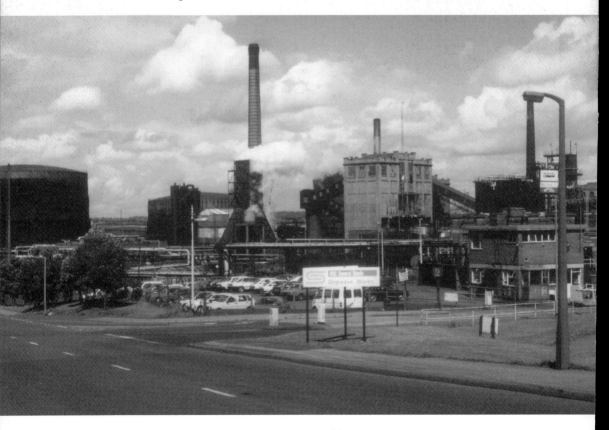

Orgreave coke and chemical plant in 1975. (*Len Widdowson*)

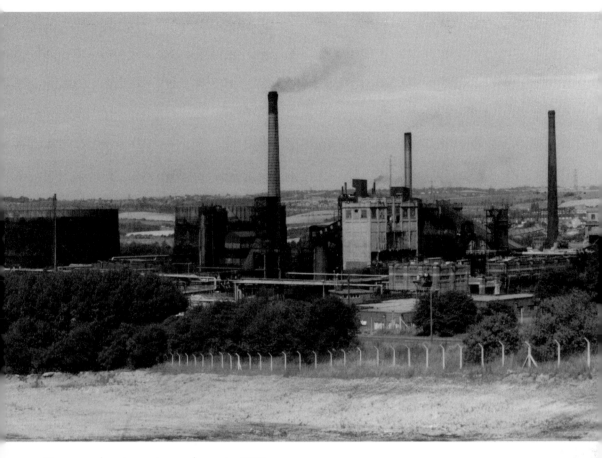

Orgreave plant just prior to closure in 1990.

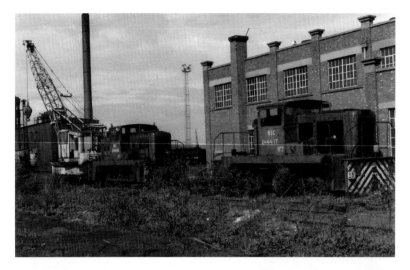

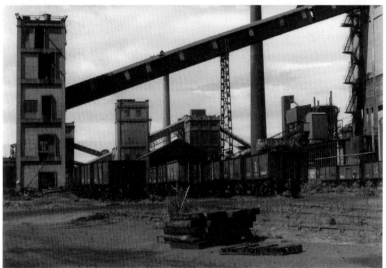

These pages: Orgreave coke and chemical plant lying derelict after closure in 1990, marking the end of an era of serving the local collieries and iron- and steel-making industries. (*Alan Rowles*)

Orgreave Coke and Chemical Plant

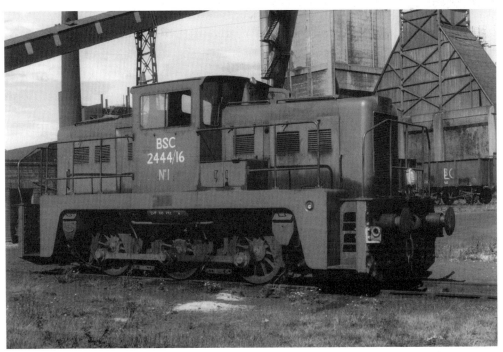

Sheffield Nunnery Colliery

The Duke of Norfolk sank a pair of shafts to a depth of 265 yards into the Silkstone seam in the early 1860s, a couple of miles from the city centre, near what is now the new Supertram park and ride car park on the Sheffield Parkway.

After only a decade of working, the duke decided to hand over the operation to a group of businessmen who were to be known as the Nunnery Colliery Company.

In November 1894, the Coal Owners Federation, acting on behalf of Nunnery Colliery, brought about a summons in the Sheffield police court against forty-eight men for absenting themselves from work without permission, claiming ten shillings' damages from each of them. The stipendiary magistrate held that no specific damage could be proven in the case of four of the defendants because they were available but could not work due to the fact that other men were not working between them and the pit mouth (banks men). Due to this, all the cases against the men who were not banks men were withdrawn, and each of the banks men had to pay ten shillings.

The colliery was responsible for producing almost half of all the household coal consumed in the city, and it was also producing more than 200 tons of coke a day for the local steel makers at the beginning of the 1900s.

The Coal Exchange was established in Sheffield on 11 May 1910.

Water seepage into the colliery workings was such that one of the shafts was divided into two, one half for coal winding and one half for pumping out the water! It was once claimed that the production of water was nearing 50 per cent of coal production at the pit!

By the turn of the century the pit was also producing Parkgate coal, increasing the output to around 1,700 tons per day; this was reached at 180 yards, and at around the same time the company invested into the building of a brickworks, which was capable of manufacturing ½ million bricks a month. The raw materials were extracted from the colliery.

Tragedy struck at about 2.30 p.m. on the afternoon of 3 December 1923, when, according to the colliery undermanager John Thomas Bradwell, ninety men and thirty boys were travelling to their place of work down an incline of approximately 1 in 5 in a train of forty-four tubs. The haulage rope broke, sending the tubs, each containing three or four men and boys, careering down the incline and smashing into each other at an estimated 60 mph. Some of the tubs derailed, and bodies were thrown from the tubs

and strewn all over the roadway with horrific injuries. The impact caused all their lamps to be extinguished, leaving them terrified and in complete darkness, screaming from the pain of their injuries, with some dying around them.

The pit yard began to fill with friends and relatives of the men as news of the tragedy spread. Extra men were deployed to join the rescue squad along with local doctors, to bring the men out of the pit and take the injured to the Royal Hospital in a fleet of ambulances which had been summoned to the scene.

It was feared that as many as forty could have been killed, but as the hours passed by it was thankfully realised that the death toll was much less than had been originally thought; seven men had died, along with forty-six injured – fifteen suffered serious injuries, the other thirty-one were walking wounded.

The seven men who died were named as William Thomas Birch, aged fifty-three, Charles Needham, aged sixty, Charles Bowden, aged sixty-two, Charles White, aged thirty-seven, Bernard Newton, aged eighteen, John Henry Turner, aged forty, and his son Thomas Walter Turner, aged twenty-one.

John Henry Turner and his son Thomas Walter Turner were buried in the same grave at Sheffield City Road cemetery on 8 December that year.

By 1935, Sheffield was consuming 515,000 tons of coal per year, with the Nunnery Colliery turning 2,000 tons per week at its peak.

A friend of mine told me that an old neighbour of his, Mr Tommy Rollins, who worked at the pit during the Second World War when the German bombing of London began, told him that military vehicles came to the pit and brought valuable museum pieces and art treasures, including stained-glass windows from Westminster Abbey, that were stored underground until the end of the war. It appears that these pieces of our national heritage were somehow forgotten about, never retrieved and now lay locked in the bowels of the earth! Tommy's son Arthur was an electrician at the pit, and was electrocuted while working on a piece of electrical equipment.

On Saturday 4 December, a snowy day in 1937, a group of eighty Notts Mining Association students visited the colliery and were greeted by the Colliery Manager, Mr A. Shaw. After a brief introduction they were each given a lamp and wound down the downcast shaft in five pulls of the cage, the cage's capacity being sixteen riders at a time. They were given a conducted tour of the mine workings in the Parkgate seam after travelling almost 2 miles in roadways that were barely 4 feet 6 inches in height, giving then a true perspective of what it was like walking to work in the mine. They visited the Parkgate seam coalface and watched as the machine operator cut coal with a Siskol Coal Cutting Machine; they also saw the miners hand-fill the coal into tubs that held 10 cwt of coal each. After walking back to the pit bottom, they were wound back to the surface, where they washed and were given refreshments before leaving the colliery for their journey home.

It seems that Nunnery Colliery was a firm favourite for the underground storage of valuable works of art, and in particular stained-glass windows.

The 101-year-old Cecil Higgins, from Gleadless, recalls that he was working as a stained-glass window designer for Robertson & Russell, a company based in Carver Street, Sheffield. In 1940, the company was contacted by Sheffield Cathedral and asked

to remove the stained-glass windows from the cathedral and the churches within the diocese, which stretched out as far as Hull.

Cecil and a team of four men were given the task of removing these stained-glass windows and storing them underground for protection during Hitler's bombing raids. They spent a full year removing the windows from the two Sheffield cathedrals: the Church of England Sheffield Cathedral, and the Roman Catholic St Marie's Cathedral.

Because this was such a mammoth task, and some of the churches were in more isolated areas, which were less prone to be affected by bombing raids, Cecil had to make the unenviable decisions on which churches took priority for window removal, and some obviously had to be left.

The windows were meticulously wrapped and crated up, and drawings of the window designs were put into airtight metal tubes for safekeeping in the crates before transportation down the pit.

Because of Cecil's background, the job was in safe hands.

They were taken down the pit and shown where to leave the crates, on either side of a disused roadway. They saw that further along the roadway there was a large dip in the floor of the road which was holding water, but were told by the two men who were accompanying them that it was their job to ensure that the water was pumped out of the pit to supply the nearby by-products plant.

Almost immediately after the job was completed, Cecil was called up, and spent the next six years in the Army. When Cecil was demobbed in 1946, he had barely had time to readjust to civilian life when he was sent for by Robertson & Russell and asked to retrieve the glass from Nunnery Colliery, and to reassemble and refit the windows in the respective cathedrals and churches. Up to this time these windows had been boarded up, and the powers that be were now all shouting for them to be reinstated!

The men returned to the colliery to retrieve the windows, but found that the crates had rotted and they were buried in mud, due to severe flooding at the mine during the war years; so much for keeping the pumps running. They were able to retrieve a lot of the glass, but the metal tubes containing the drawings for the window designs were tragically missing.

Fortunately, they were able to reconstruct a lot of the windows from memory, and after a good three years they were soon finishing the job of complete restoration – no mean feat considering the conditions they were working in.

The pit went on to work satisfactorily up to Nationalisation in 1947, when the NCB decided that coal reserves would be difficult to retrieve via the Nunnery Colliery because of transportation costs from the far reaches of the pit, and so it decided to cut its losses and use its other colliery at Handsworth to continue to work the existing reserves, and to expand into new areas to exploit the Haigh Moor and Flockton coal seams.

The colliery finally closed in 1953, after equipment was salvaged from the roadways.

The London treasures were never mentioned, presumed lost! I wonder if anyone found anything of value during the salvaging operation? In an HSE document dated June 2012, it states that some of our deep mines are being used for other purposes, e.g. waste disposal, and storage of documents, valuable artefacts and military equipment. Let's hope that these don't get lost!

When Nunnery Colliery officially closed in 1953, 1,000 men were employed there, and most of them continued to work at the Handsworth Nunnery Colliery.

Mr Roy Young, a schoolmaster in the Rotherham area, was a keen local historian, and along with others decided it would be a good idea to do an archaeological dig on the site of the old Nunnery Colliery due to its near proximity to the old Sheffield Nunnery.

The colliery manager, Mr L. R. Cooke, gave them permission to work on the site for just one week; they worked without any success, until some young boys who were watching them approached them saying, 'Is this what you are looking for mister?' One of them was holding what looked like a Roman drinking vessel. When asked where they had found it, they put it on the ground and ran off, never to be seen again! The dig was abandoned.

Miners arriving back at the Sheffield Nunnery Colliery after the 1926 strike. (*Ben Clayton*)

The vessel that was left behind by the boys. It is approximately 7 inches in diameter, and about 9 inches high, with a wall thickness of 5/16 inch, and looks to be made from some kind of red clay. Who knows what else would have been found had the boys given the location of the find? It is now the proud possession of Mr Roy Young. (*Ken Wain*)

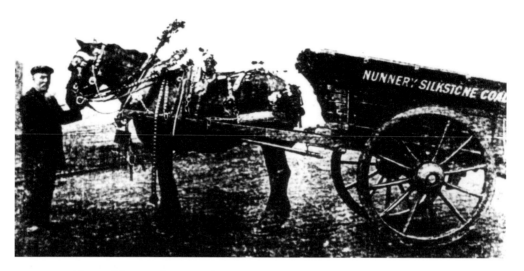

Nunnery coal cart delivering house coal, c. 1920. (*Ben Clayton*)

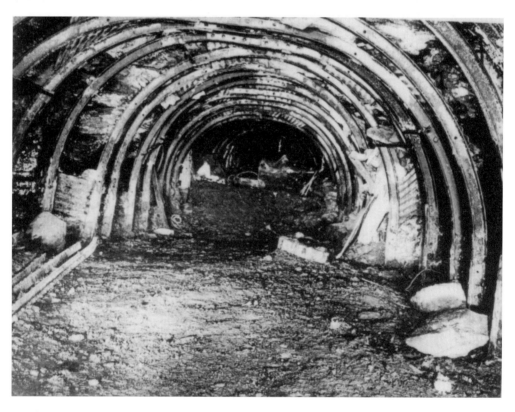

Roadway rapidly deteriorating after equipment had been salvaged. (*Ben Clayton*)

Handsworth Nunnery Colliery

The Nunnery Colliery Company started to sink the Handsworth shafts in 1901. Two years later, they completed the sinking, reaching the Silkstone seam at a depth of 410 yards. The Barnsley seam was passed through at 206 feet and the Swallowood seam was located at 406 feet. The Lidgett seam was at 561 feet, Claycross marine band at 755 feet, Sitwell at 776 feet, Fenton at 842 feet, Parkgate at 954, and the Thorncliffe was split at 989 feet and 1,008 feet.

The different types of coal put the colliery at a distinct advantage to many others because they could produce house coal, steam coal, coking coal, gas coal and manufacturing coal.

There was a slump in the coal trade in 1912, which resulted in the colliery owners slashing the miners' wages, even though they knew that it would only be short-lived. This caused much bitterness towards the owners, and hardship led to near destitution among the miners, who relied heavily upon their relatives and the local communities to ensure that they had enough food for their families, and shoes and clothing for the children. The coal trade picked up and the miners returned to work, but with no advantage.

In 1918, the Rothervale Colliery Company had a coke and by-products plant built at Orgreave.

Although the colliery, along with many others, saw further unrest, they installed what was at the time an ultra-modern American system of coke ovens, and they were soon producing thousands of tons of coke for the steel industries in and around the Sheffield and Rotherham districts.

The colliery set up its own by-products plant, and was soon manufacturing large amounts of tar, naphthalene, and ammonia sulphate. The tar was used on the local roads, which were now being laid at a good rate, and coal gas was being supplied to the local gas company in Sheffield. The two plants worked side by side in perfect harmony, as there was sufficient demand for their products to keep them both in good work.

In 1947, after Nationalisation, the NCB retained the plant at Handsworth and ran it until the colliery closed.

By 1949 the colliery was employing 1,484 men, and the pit was in its heyday.

The mechanisation of the pit in 1965 gave hope for the long-term prospects of the pit, with the installation of Dosco and Trepanner coal cutters, but it was not to be, as the colliery was closed only one year later, in October 1966, due to coal reserves being worked out. It seems strange to spend all that money for only one year.

The Orgreave plant was handed over to the British Steel Corporation in 1948, and continued to work with coal supplied by several South Yorkshire collieries until its eventual closure in 1990.

When the plant was demolished, the site became one of the opencast executive's major reclamation sites, and included the old Waverley mine.

After the open casting was completed, a large-scale industrial development started in the northern section and is now well under way, with all the access roads, electricity supplies, street lighting, etc., nearing completion. Sizeable manufacturing units, including a large one for the American aerospace company Boeing, are now in full production.

UK Coal sold some of its holdings on the old Waverley site to Rolls-Royce, who are planning a similar project to include three plants on the park in 2012, creating hundreds of jobs. Work is already under way on a residential development on the Waverley site.

Power requirements are provided for the site by giant wind turbines.

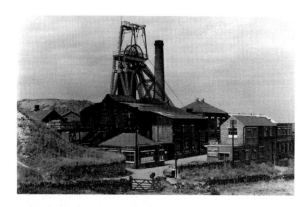

(*Ben Clayton*)

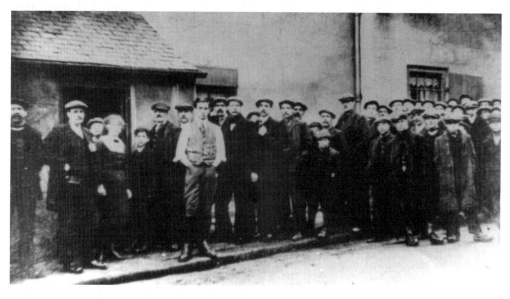

Handsworth Colliery miners pose for the camera as they queue for their strike pay outside the Cross Keys pub in 1912. (*Ben Clayton*)

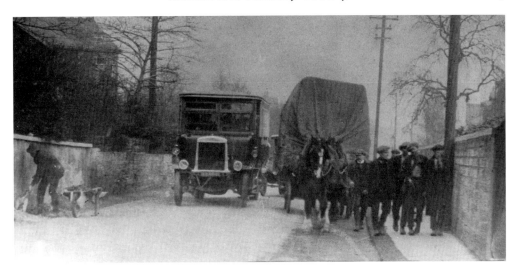

A busy scene on Handsworth Road showing colliers on their way home from the pit, alongside a horse and cart and the No. 11 bus, c. 1920. (*Ben Clayton*)

The spoil heap and remains of the headgear set in concrete, still waiting for removal from the site in 2012. (*Ken Wain*)

Surface worker Bill Holmes attending the pit ponies. In total, 73,000 horses and ponies were working underground and on the surface during the nineteenth century and the first half of the twentieth century. (*Ben Clayton*)

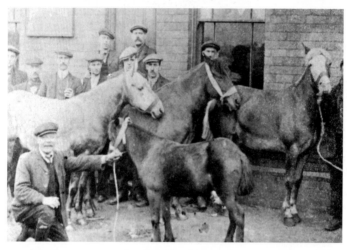

When the mines were nationalised in 1947, there were still 21,000 ponies working underground. By 1952, this had dropped to 15,500, and by 1973 it was 490. (*Ben Clayton*)

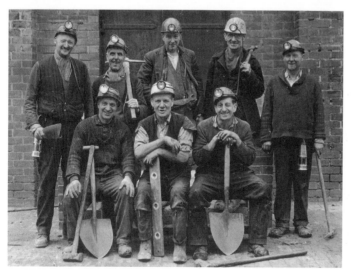

The year 1967 saw some of the last workers at the pit posing for the camera in front of the pit bank fan air doors. Top row: Frank Tompkins, Horace Flinders, Jonny Doughty, Cis Durret and Joe Allen (onsetter). Bottom row: Sam Sidall, Jack Baker and Cyril Hartley. (*Ben Clayton*)

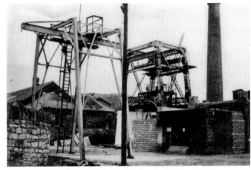
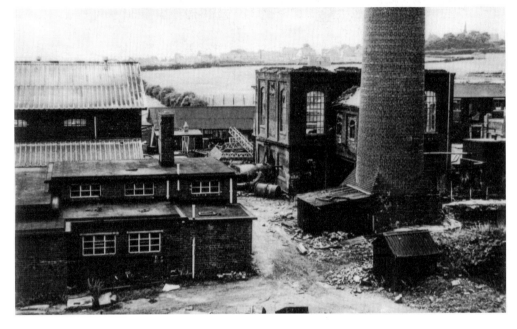
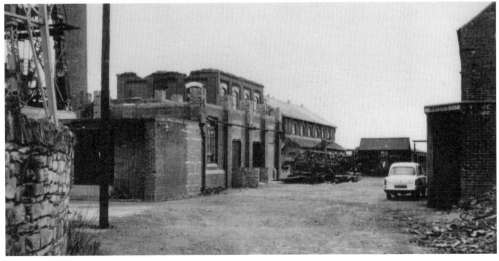

The end of an era. These photographs show demolition work under way at Handsworth Nunnery in 1968. (*Ben Clayton*)

Tinsley Park Colliery

Before the sinking of the shafts into the deep coal seams, Earl Fitzwilliam opened up a bell pit in 1819. The earl and the Duke of Norfolk were the main contributors to the financing of the Greenland arm of the Sheffield Canal, by which means it was connected to the River Don. Two wharves were constructed in Sheffield at a later date, and served the colliery for the transportation of coal to various destinations.

A network of wagon ways was constructed to take the coal from this pit and others in the area to the canal, for distribution to the local ironworks for coke making.

Booth & Co. owned the Parkgate ironworks in Attercliffe, and in 1833 they were listed in the *White's Directory* of that year as the owners of the pit.

The son of Benjamin Huntsman, the inventor of crucible steel, bought out the ironworks in the same year. It was proven to be a sound business; the family went on to lease land from Earl Fitzwilliam to sink a coal mine approximately 3 miles from Sheffield city centre, at Tinsley Park Colliery, which had a royalty take of approximately 1,000 acres. He started operations in 1852 by extracting coal from the High Hazels and Barnsley seams; the colliery was soon producing around 4,000 tons of steam coal and house coal per week.

During the 1869 miners' strike, a serious fire was raging underground at the company's 217-yard-deep West Retford pit in the 4-foot-6-inch-thick Barnsley seam. Originally it was thought that the pit would be brought back into production very quickly, but the strike lasted for almost two years and caused much damage. The pit was at this time turning 2,400 tons per week excluding Sundays, so this long-term industrial action amounted to a great loss. Two miners died as a result of inhaling noxious fumes; their bodies were not found for almost twenty years.

The colliery was closed during the period of the strike, but soon recovered and went on to work coal in the High Hazels, Parkgate, Silkstone, Wathwood, Thin Coal and Haigh Moor seams.

The Duke of Portland opened up a small railway line in 1900 between Treeton and Brightside, known as the Sheffield District Railway. It had a branch line over 1 mile long, which served Tinsley Park Colliery and took the coal onto the Lancashire, Derbyshire, & East Coast Railway.

The railway companies purchased over 60 per cent of the coal for its steam-raising qualities; the remainder was sold nationally as a good quality house coal.

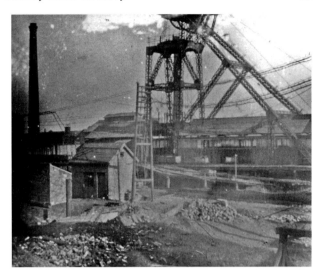

Tinsley Park Colliery, c. 1914.
(Ben Clayton)

The Huntsman family sold the four collieries to the Tinsley Park Colliery Company, ensuring money was made available to develop the lease. This materialised very quickly, and the company invested in a bank of thirty-eight coke ovens, which were soon to come on line and supply the local iron and steel makers.

Three 450-hp mixed-pressure steam turbines were installed, the steam being supplied by a bank of nine boilers. These were supplemented by two gas engines, one 450 hp and the other 600 hp, the gas being supplied from the pits by product plant.

Electricity was soon to flow on the surface and underground, and powered all the collieries' machinery.

A new steel headgear was also erected around this time, wooden-framed headgear being made illegal in 1911.

The pits were now doing very well with sales of coal and by-products, and were served by the Sheffield & District Railway Company's branch line, allowing several other companies access to the collieries.

In June 1902, a further shaft was sunk to a depth of 465 yards into the Parkgate seam, followed by another in 1909, which was dropped into the Silkstone seam at 550 yards.

By 1910 these two seams gave a joint production figure of some 9,000 tons per week, and the colliery owned in excess of 700 railway wagons. The colliery was at this time employing 2,075 men.

The pit went on to survive the three strikes of 1912, 1921 and 1926 without any major problems, and in 1927 the manpower had dropped to 2,000, with 1,580 working underground and 416 on the surface.

The Sheffield Junior Chamber of Commerce visited the colliery on 7 July 1931. One of the visitors compiled an interesting list of technical data about the colliery plant and the coal workings:

> Both the shafts are 15 feet in diameter and are served by steam winding engines which develop 1400 hp using a steel wire rope with a tensile strength of 100 tons per square inch.

During the cage's descent it reaches speeds of 35–40 mph.

The ventilation of the mine is achieved by a 250 hp fan which draws air through the mine workings and exhausts it via the upcast shaft at a rate of 200,000 cubic feet per minute.

Electrical pumps are placed at strategic points in the mine and pump out 500,000 gallons of water per day.

There are 51 coke ovens 33 feet long and 20 inches wide and 7 feet 6 inches high, 8 ovens 33 feet long and 14 inches wide and 7 feet 6 inches high.

Each one holds on average 8½ tons of coal, the coal being carbonised in 12 hours.

The approximate yield from each oven is:- 6 tons of Best Coke. 27 gallons of Crude benzole. 85½ gallons of Crude Tar. 225 lbs of Sulphate of Ammonia and surplus Gas for Town use.

The Silkstone seam is the deepest and is valuable for coke and gas making.

The roof exerts great pressure due to its depth and requires steel arch girders to support it.

The Parkgate seam is 87 yards above the Silkstone; it is a hard coal which is a good house coal and also used for steam raising and coke making.

The roof is 60 foot thick hard sandstone and needs no support.

The Swallowood seam is very soft and has a band of dirt running through it which has to be cut out.

The roof is also very soft and weak and the wooden roof supports are 'swallowed' up.

The colliery continued working until 1943, when it recorded considerable losses and was closed.

On 20 July 1936, surface labourer Henry Mellor was hit by an LMS engine pulling a brake van in the colliery sidings. Henry stepped out of his cabin by the line side and into the path of the engine, and was killed. It was thought that he did not hear the engine because he was deaf in one ear.

Colliery pit head baths, showing the locker room for clean and dirty clothing. (NCB)

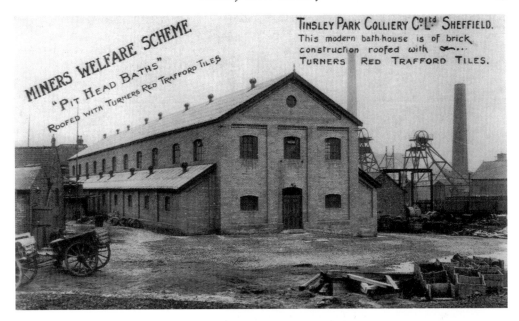

The company built houses for the miners, along with a colliery institute, and provided considerable sporting facilities, including cricket and football pitches and a bowling green. (*Cliff Ulley*)

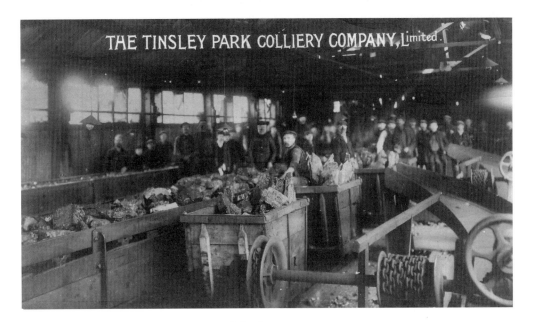

Tinsley Park Colliery screens, *c.* 1920. (*Cliff Ulley*)

Colliery pit head baths, showing the locker room for clean and dirty clothing, and communal showers with hot and cold water. (*Ken Wain*)

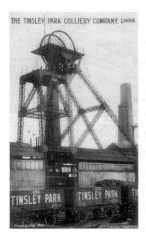 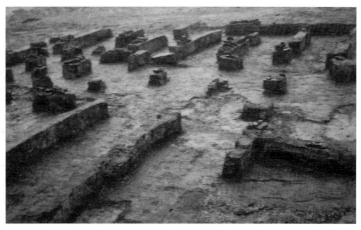

Above left: In 1936, the Tinsley Colliery Company took over Kilnhurst Colliery, then in 1939 they bought out the J. & G. Wells company at Eckington.

Above right: Exposed pillar and stall workings in the old Winter seam at Tinsley Park Colliery, found during outcropping excavations.

A 6-foot seam of Parkgate coal at Tinsley Park Colliery. (*Cliff Ulley*)

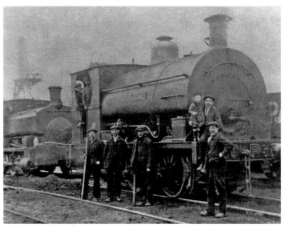

Shunting engines and crew at Tinsley Park Colliery, *c.* 1920. Note the little girl posing for the photograph on the engine – there was no Health and Safety Act then! (*Sheffield Newspapers*)

Brightside Colliery

The 1860s saw some of Sheffield's deep mines being sunk into the seams of steam coal. Unwin & Shaw's Brightside Colliery, which was close to Brightside railway station, was one of these, boasting two shafts sunk into the Parkgate coal seam at a depth of 200 yards. No 1 Shaft was operational from 1855 to 1871; No 2 Shaft was worked from 1868 to 1886.

The Parkgate seam of coal was renowned for being a particularly hard, compact coal, usually wanting little in the way of extensive roof supports, and was for this reason also relatively free from gas seepage.

Having said this, it was always in the interests of the miners' safety that this should not lead to complacency, and that all areas within the mine should be treated with respect, even though they had a good ventilation system in the form of a return air upcast shaft to take away the foul air.

The mine managers chose to allow the miners to work with naked lights in the belief that the pit was gas-free.

By 1865, the No. 1 colliery was doing well, and at that time was employing upwards of 500 men and boys.

At 6.30 a.m. on Monday 25 October of that year, the day shift, consisting of 300 men and boys, descended the pit to start their shift, and at approximately 7.30 a.m. a violent explosion was heard near to the main roadway. A large inrush of deadly firedamp gas forced its way through a fissure in the coalface, and was ignited by a naked light being used by Francis Milburn.

He was badly burned, and the force of the blast thrust him up to a pillar, which fractured his skull, killing him outright. The blast passed ferociously through the workings, striking George Parker and his fourteen-year-old son George Parker Jnr. They doth died later that day from horrendous burns and injuries.

We all too often read stories like this, and again these accidents were down to sheer neglect on the part of the mine managers and the miners themselves, and the blasé attitude of the managers in allowing downright dangerous working methods to prevail, with the miners forsaking safety lamps for the better but lethal light of the candle.

At the inquest, the coroner commented that the recklessness of the colliers, which led them to lay aside the safety lamps, was the cause of this and hundreds of other explosions, and as usual laid no blame at the door of the managers.

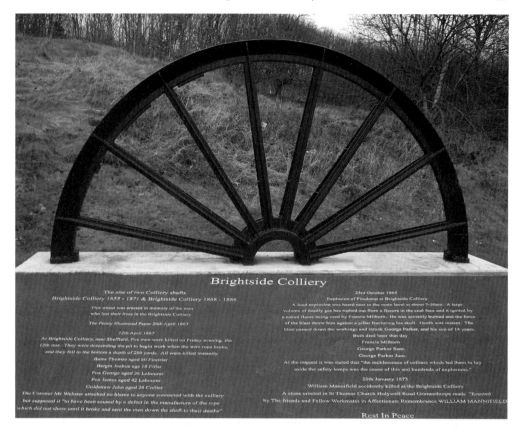

Only two years later, on 12 April 1867, Thomas Bates, Joshua Bergin, George Fox, James Fox and John Gouldstraw walked onto the pit bank and boarded the cage to be lowered down to the pit workings. The engine driver started to lower the cage, and it had only travelled a few feet when the steel winding rope severed and the cage, with the men inside, fell at an alarming rate to the bottom of the 200-yard-deep shaft.

The engine driver said he felt the weight of the cage fall off the engine when it went in to free fall, instantly killing the occupants. Even though it was inconceivable that there would be any survivors after such an occurrence, local surgeon Mr Morton of Brightside was summoned to the scene, and immediately went with a rescue party into the pit bottom, via a drift which was driven at the time of the sinking of the shafts.

On arrival in the pit bottom they found that both the cage in which the men were travelling and the one which was being wound up the shaft at the same time were smashed into hundreds of pieces. The rope and the iron bars from which the cage was manufactured were twisted into every conceivable way, all being tangled together.

That being the case, the state of the bodies of these unfortunate men can easily be imagined. All of them were horribly mutilated, some worse than others; the whole of Bergin's head was cut off from the trunk, with the exception of the lower jaw and the base of the skull.

Thomas Bates had one of his arms cut clean off, and the limbs of all of the men were fractured, and their bodies mutilated, the surgeon saying that in every case death would have been instantaneous.

The rescuers at once set to to remove the bodies from the tangled wreckage to be taken from the pit, and till a late hour were engaged in fixing another cage to wind them to the surface.

On Saturday, the coroner, John Webster, opened an inquest at the Bridge Inn, Brightside, and took details as to the identities of the deceased; he then adjourned the inquest until Wednesday to allow the Government inspector time to do an on-the-spot investigation.

When the inquest was restarted, a suggestion was made that the engineman had caused the accident by running the rope slack, allowing the cage to overstrain the rope with a severe jerk when it began to descend.

Conflicting evidence showed that the rope strands had been spliced almost together, the outer strands having become somewhat worn. The jury came to the conclusion that this defect in manufacture contributed to the breakage of the rope, and added to their verdict of accidental death.

A recommendation was made that the manufacturers of the rope, Messrs Shaw & Sons, should be made aware of the defect and take necessary steps to rectify the situation. No mention was made regarding whether the rope was regularly examined as to its suitability for use, or whether the rope manufacturers were culpable due to faulty manufacture. The mine managers yet again breathed a sigh of relief, the Victorian coroners' courts being forever biased.

A third accident at the No. 2 pit killed William Mannifield at Brightside Colliery on 20 January 1873. A stone was erected in St Thomas church, Holywell Road, Grimethorpe, and reads, 'Erected by the friends and fellow workmates in affectionate remembrance WILLIAM MANNIFIELD.'

Brightside Colliery was only a distant memory in Sheffield's mining history until the City Councillor for Brightside, MP Peter Price, decided to research it.

Peter was an active member of the Sheffield North East Community Assembly, and it was voiced at one of their meetings that it would be a good idea to remember the sacrifices that the local miners paid within the local community by erecting a memorial in the form of half a colliery winding wheel, with a plaque inscribed with their names.

The motion was passed, and Sheffield City Council purchased and installed the memorial opposite the old colliery entrance on Hollywell Road, the total cost being £4,000 from the Community Assemblies Fund.

Most of the local residents saw this as a wonderful gesture of remembrance to those brave men who gave their lives for the local community. The city council scrapped the community assemblies in 2013, due to central government cuts.

Aston/Beighton: Brookhouse Collieries

The old Aston Colliery, known locally as North Staveley Pit, was sunk by the Staveley Iron & Steel Company into the Barnsley seam in 1864 at 211 yards deep. A ventilation shaft was sunk to the same depth some 60 yards away.

In 1866, the colliery owners built seven rows of terraced houses for the miners and their families, and a school for 100 children, which became a National School in 1875.

The population in 1861 was 991, and due to mining operations in the area it had risen to 1,667 by 1871.

A chapel was built in 1879, and tennis courts, a bowling green, a recreation ground for the children and a pavilion for the miners to play indoor games were put in place.

In 1908, tragedy struck when the colliery was hit by an outbreak of typhoid, which took the lives of several young men aged between eighteen and twenty.

The High Hazels seam was tapped in 1912, just after the miners' strike, and worked alongside the Barnsley seam until 1930.

The pit was officially closed in 1932, and the site was secured by the Sheffield Coal Company; the No. 1 shaft was filled and capped.

No. 2 shaft was widened and taken to a depth of 436 yards in 1902, and this was to become Beighton Colliery.

Coal was eventually drawn in 1903 from the Silkstone seam; the colliery was coupled underground to the company's Birley East Colliery at Woodhouse to provide for good ventilation at Beighton, as well as a secondary means of escape from either colliery if need be.

Primarily because of the distance between the two collieries, ventilation left a lot to be desired, and an air blowing fan was installed, which increased the air intake dramatically.

Beighton had thirty pit ponies working underground, and several on the surface in the stock yard.

The pit had a good production record, with few or no accidents in its lifetime, and raised 480 tubs of coal every hour.

The colliery stopped the winding of coal on 9 March 1942, when Brookhouse took over from it.

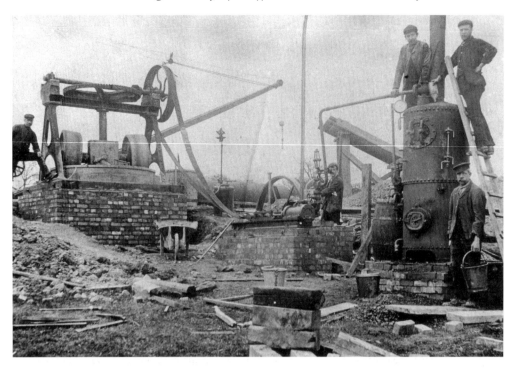

Shaft sinkers at Beighton Colliery, 1902. The chap to the right of the picture, holding the bucket, is Mr T. E. Fox, a site labourer. (S. Fox)

Beighton Colliery. (S. Fox)

Beighton Colliery, the coking plant and the Railway Inn during the flood of 1920. (*Ben Clayton*)

Brookhouse Colliery

In 1929, the colliery company decided to sink another shaft, Brookhouse, to ease the ventilation problem and exploit the Thorncliffe seam.

This was completed in 1930 by converting the blowing fan into an exhaust fan, using the Beighton shaft as the upcast shaft, as was its function for the Aston Colliery, and the Brookhouse shaft became the downcast shaft.

Even with all the costs involved, the owners decided to keep the colliery 'ticking over' because of the general decline in trade and the economy at the time. However, in 1937 the company was taken over by the United Steel Company.

Four years of hard work at a time when the country was plunged into the Second World War put the colliery at the top of the league at the time; it was envied nationwide for having the best mining technology and coal preparation equipment in the country.

All the colliery's output was now wound from the Brookhouse shaft and represented a great contribution to the nation's war effort in providing coal for domestic use, steam locos, gas production and a sizeable on-site coking operation for the steel-making industries engaged in the manufacture of munitions and armour plate for tanks and battleships. Alongside this was a highly productive by-products plant.

Following the war, the colliery was nationalised in 1947 and became part of the NCB's North Eastern Division, Worksop No. 1 Area. In 1949, the manager was Mr R. M. Clive, who had a manpower contingent of 2,042 men producing coking, gas, household and steam coals.

After successfully using Mavor and Coulson Samson coal cutters for several years in the 1950s, the colliery eventually installed Anderson Boyes 125-hp Trepanners, which made a vast improvement and upped the production.

Pithead baths and a fully equipped medical centre were opened in 1951, on Saturday 24 November, by W. E. Jones Esq., OBEJP, Vice President of the National Union of Mineworkers, and General Secretary of the Yorkshire Area of the National Union of Mineworkers, who was supported by Tom Smith Esq, CBE, Labour Director of the North Eastern Division National Coal Board.

T. A. Bennett, Esq., MBE, Secretary of the Miners' Welfare Commission, formally handed over the title deeds of the baths to C. Smith, Esq., who accepted them on behalf of the Management Committee of the Brookhouse Colliery Pit Head Baths.

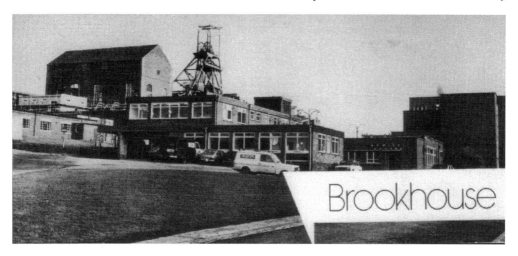

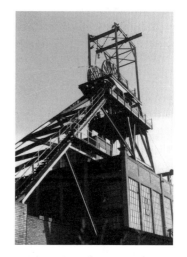

Above: (NCB)

Right: (Alan Rowles)

Below: Shaft sinkers at Brookhouse Colliery, 1929. The shaft sinkers included Martin Garraty, the Devine brothers, M. O. Hara, J. Callaghan, A. Ambler and J. Turtle, an engineer. (*Mrs J. Siddons*)

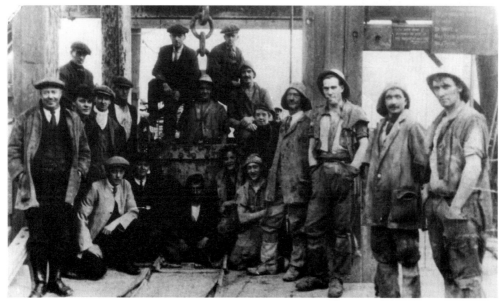

The new facilities came into use the following day at the commencement of the night shift.

Harold Dring from Swallownest drove the 'paddy-mail' engine, which hauled the miners to and from their work at the coalface.

Because of the time spent waiting in the engine house, he used his talent as an amateur artist to decorate the walls of the engine house with anything from landscapes to scantily dressed ladies.

Harold was only eighteen years of age when his father died, which meant that he had to go down the pit to support his family.

He won prizes for his work at school, and an art college offered him a place, but he couldn't afford to take it up.

Sadly, his work is now sealed underground where no one can see it!

The Sheffield Coal Company decided, in 1924, that because they had three collieries in the area – Birley East, Aston, and Beighton – and a good proportion of the workforce was travelling from Sheffield and the outlying areas to work at their pits, they would build housing for the miners and would call it the 'Garden City' Scheme.

Progress was soon made, and the houses were to the latest specification at the time. Each had a spacious living room and kitchen, with indoor toilets and a separate bathroom. They all had three bedrooms and a garden plot.

A good many of the miners who heard of the scheme showed an interest and made applications to the Sheffield Coal Company to work in their local collieries. A lot of these men were set on, and secured homes in the 'Garden City'.

The pit's accident record was marred on 4 March 1958, when, at approximately 6.30 a.m., thirty-six men were reportedly injured due to an over-winding accident of the pit cage while descending the 1,285-foot-deep Brookhouse No. 1 downcast shaft, due to excessive speed and a faulty braking system on the winding apparatus.

The cage was travelling at approximately one and a half times its normal speed when it hit the pit bottom sump at the Silkstone seam opening.

The electric winding engine was manufactured by GEC and installed in 1929, but was only used infrequently up to 1942 as a means of egress from the old Beighton Colliery until Brookhouse was reorganised to raise a projected output of 15,000 tons per week.

At the time of the accident, there were forty-seven men in the cage; seventeen of these sustained a fractured femur, five sustained a fractured tibia and six sustained fractures of other bones. The rest received other injuries.

Only one hour before this, 260 night-shift men and 507 day-shift men had safely traversed the shaft to and from work.

The front page of the *Sheffield Star* on that day shows Mr Harold Doncaster being stretchered out of the pit in great pain from the trauma of the accident.

Some of the men were never able to work again; others, after varying lengths of hospital treatment, recuperation and convalescence, were given employment on the colliery surface doing light work.

Seven of the men – Harold Doncaster, Patrick Jones, Ronald Cooper, Harry Turner, Arnold Keye, Arnold Clarke and Douglas Totty – were found work at nearby Fence Central Workshops.

Skip winding was brought to the colliery in the late 1960s to facilitate increasing output, and, although the pit went on to exploit further coal reserves, it was closed shortly after the miners' strike in October 1985.

Some forty-six years later, in October 2004, a plaque was erected in commemoration of these men, who suffered pain and humiliation in the quest for the nation's need for coal.

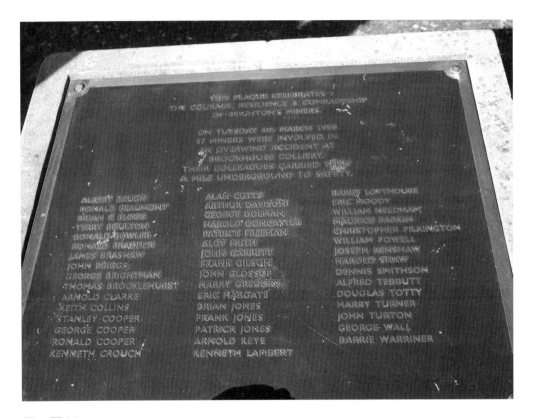

(Ken Wain)

(Ken Wain)

OPENING CEREMONY

Chairman :
C. SMITH, Esq.
AGENT BROOKHOUSE AND THURCROFT UNITS
NATIONAL COAL BOARD

•

T. A. BENNETT, Esq., M.B.E., Secretary of the Miners' Welfare
Commission, will formally hand over the Title Deeds
of the Baths to

C. SMITH, Esq.

who will accept these on behalf of the Trustees and
Management Committee of the Brookhouse
Colliery Pit Head Baths.

•

Opening Ceremony by
W. E. JONES, Esq., O.B.E., J.P.,
VICE-PRESIDENT OF THE NATIONAL UNION OF MINEWORKERS
GENERAL SECRETARY, YORKSHIRE AREA, NATIONAL UNION
OF MINEWORKERS

Supported by
TOM SMITH, Esq. C.B.E.,
LABOUR DIRECTOR OF THE NORTH EASTERN DIVISION
NATIONAL COAL BOARD

Above right: Weigh ticket for gas coal from Brookhouse to Eastern Gas Co. (*Ben Clayton*)

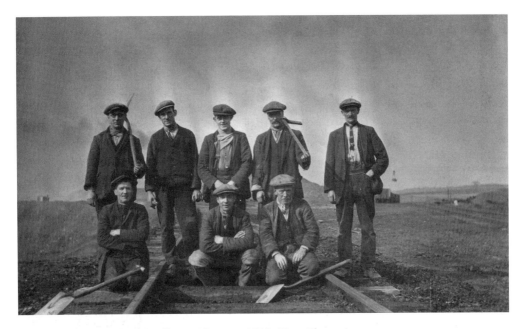

Plate layers laying out the colliery sidings, *c.* 1930. (*Ben Clayton*)

Brookhouse steam winder and level indicator. (*Ben Clayton*)

Above left: The Sheffield Coal Company's shunting engine, *Orient*, was transferred after the closure of Birley East Colliery to work at Brookhouse; she is shown here in 1956. She was withdrawn from service in 1957 and burnt up on site. (*Alan Rowles*)

Above right: Newly refurbished loco *WDG* taking a load of coking coal to the coke ovens, 15 October 1961. (*Mike Eggenton*)

Underground art gallery. (*Sheffield Newspapers*)

(Mrs Julie Siddons)

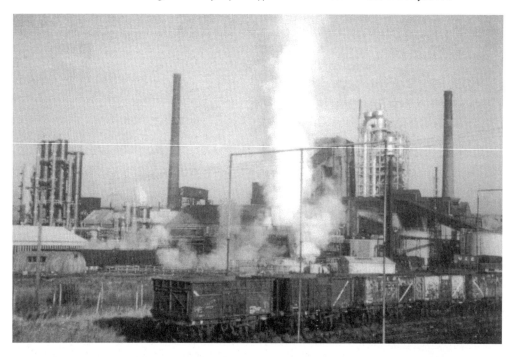

Brookhouse coke ovens and by-products plant, c. 1960. (*Mrs Julie Siddons*)

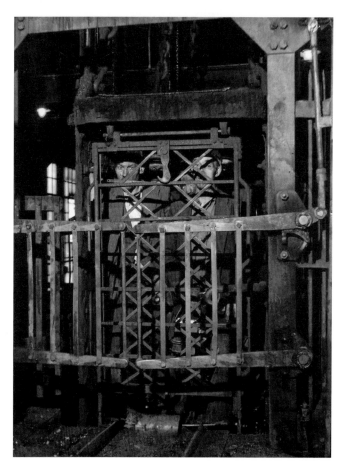

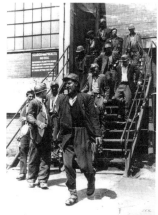

These two photographs were taken in the 1950s. The one on the left shows the men returning to the surface after a hard day's work in the pit; the above picture shows the men leaving the pit bank and walking down the steps on their way across the yard to the baths. (*Mrs Julie Siddons*)

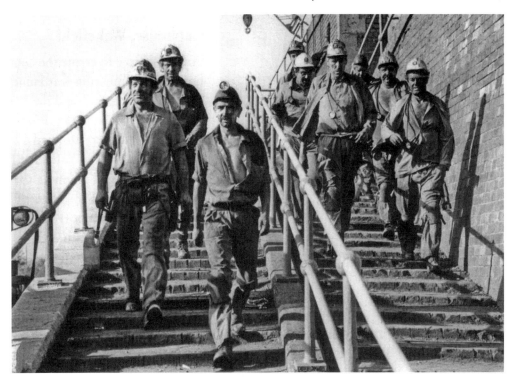

Men leaving the pit bank on their last shift in October 1985. (*Derbyshire Times*)

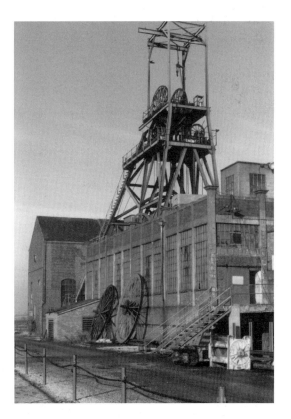

(*Alan Rowles*)

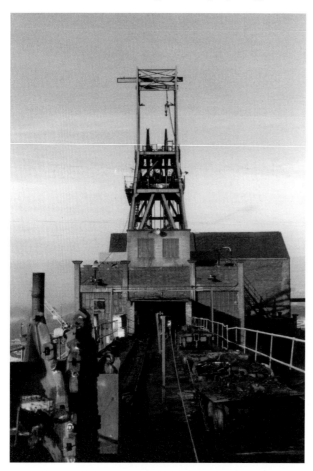

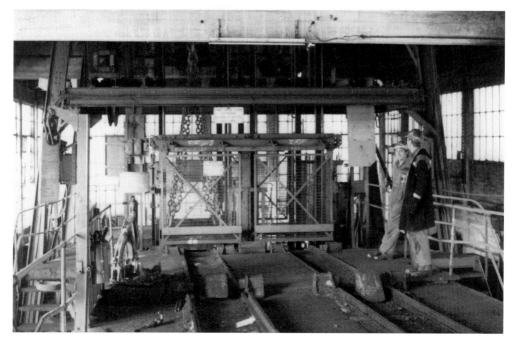

Left and below: A photograph of Brookhouse Colliery, taken at the time of closure in April 1986. (*Alan Rowles*)

NORTH EAST DERBYSHIRE COLLIERIES

Perseverance Colliery, Killamarsh

George III was on the throne by the time Turner Ward's Perseverance pit of Nethermore Lane at Killamarsh was in operation in 1785, eight years after the completion of the Chesterfield to Stockwith Canal, which was only 38 feet away from the pit shaft. The year 1789 saw 42,379 tons of coal transported by horse-drawn barges. Scant records of this time imply that there were twenty-three employees at this pit, one of the larger ones in the area at this time!

They consisted of a mixture of ten men, four women and two girls underground, and one man and six women on the surface. Ten years later the manpower had doubled, and the pit prospered.

On 6 January 1858, four men perished when the rope attached to the bucket they were being wound down in snapped, and the bucket plummeted to the bottom of the shaft.

The accident occurred on the Wednesday, and an inquest was held on the Thursday by the coroner, Mr Busby. At the inquest it was heard that

> At about ten o'clock on the Tuesday night, Sarah Wheelhouse resident of Nethermoor Lane and relative of Turner Ward, had seen a substantial fire beneath the rope but could not see if the rope was on fire or not.
>
> She thought that it would have damaged the rope and as a consequence of this that the men would not have been allowed to descend into the mine.
>
> She said that she immediately went to tell Turner Ward about the fire. Apparently the fire had been lit to thaw out the frost from about the rope.
>
> John Whittam, coal miner, had been told by a person by the name of Twiggs about the fire and was asked to have a look at the rope.
>
> He did so and could see no material injury, but it was dusk at the time. They fetched the engine lamp and examined the rope again. 'I could not see that it was much burnt,' he said.
>
> William Truswell, the winding engine man then let down several men and boys into the pit.
>
> Luke Mallender said that he had seen the fire and that a great deal of water was required to extinguish it. He did not take particular notice of the rope but he could see that the fire had been around it.
>
> An empty cage was afterwards let down the pit with the rope.

Turner Ward who was there at the time told him to tell a person called John Sheppard that William Truswell was to examine the rope before the men went down the pit in the morning.

He told Sheppard of it when he came, saying that there had been a fire about the rope. The rope was in the pit at the time, so he drew it up so that Sheppard might examine it.

It was dark at the time so they used the engine lamp to examine the rope.

Sheppard said that he believed the fire HAD to some extent damaged the rope.

When Truswell arrived, Sheppard did tell him and he went to the pit bank, he found Charles Mallender the under steward of the pit examining the rope, he said to him 'Well Charles, there has been a fire'.

He replied, 'Yes'; and while they were standing there John Whittam came up and asked if the rope was badly burnt; They told him that they thought not, so he examined it himself and said 'It is not burnt badly, it will not hurt us'. Charles Mallender said he would go down the pit, which he did, along with three boys.

He did not send any loaded cage into the pit on the morning of the accident before any men went down.

At six o'clock in the morning, 24 men had been wound down the shaft safely.

Charles Mallender, the underground steward said that he saw Truswell run empty cages up and down the shaft on two occasions before the men went down but he had not seen a loaded cage sent down. He was the first in the pit. On drawing the rope he thought that it had not been seriously injured; Truswell agreed and said the rope was relatively new when fitted and had only been in use for three months.

Twenty four men and boys were wound into the pit in cages of four or five at a time.

The deceased had previously refused to be wound into the pit until they were assured by the engineer that all was well, but the cage had only descended about ten yards when the rope broke and it fell about sixty yards to the bottom of the shaft killing the Senior brothers outright.

They were named as William Senior, aged 28, John, aged 20, and Francis, aged 18. They left behind a brother Edward who learned of the accident on his way to the pit after buying powder and candles from Turner Wards Shop. They also left an aged mother who relied on them for her upkeep and wellbeing.

Richard Turton died before he could be brought out from the pit.

George Mettam, another engine tender who was lodging in the same house as Truswell, said that, on the morning of the accident, Truswell told him that the rope was not fit to let down the men. While letting the men down, he felt as though his heart was in his mouth.

Turner Ward, along with many other mine owners of the time, was a force to be reckoned with, and ruled with an iron rod. What he said was law, and woe betide anyone who had the audacity to question his decisions or make any contrary remarks. They did so in peril of losing their jobs. A slip of the tongue in the wrong place could easily end up with the loss of a job and could cause undue hardship.

Revd Francis James Metcalfe, who was the rector of the parish at this time and was much revered by all and sundry, was often called in to smooth the troubled waters at such times.

The mine owners not only owned the mines but very often, as in the case of Turner Ward, also owned the local shops, and a good many would pay their miners with tokens for buying goods at their shops – very little money changed hands. This practice was called the truck system, and carried on for many years until it was eventually outlawed when the Truck Act came into being in 1831.

Turner Ward was not only a local tyrant; he was also a shrewd businessman and owned the local brickworks, which were only a stone's throw away from the pit, and it was said that when the pit closed and the pit chimney was blown up in December 1895, the bricks were taken down the village and used to build three houses on Sheffield Road rather than use new bricks!

The pit shaft was filled in on 24 November 1909 after a public outcry due to its danger to the community. These smaller pits were typical of the day and continued in operation well into the 1900s. Most were operated as family concerns and could be classed as the local cottage industries.

Many of these pits opened and closed in relatively short periods of time, often due to being worked out quickly or as a result of insurmountable technical problems such as uncontrollable ingress of water, and serious strata faults, which meant the abandonment of the pit.

There are records that show that some of the drift mines did in fact reopen at later dates, due to better techniques having evolved, or simply due to an increased local demand for coal.

Turner Ward said that the Government Inspector of Mines, Mr Hedley, certified special rules for the pit some eighteen months previous, and that the rules were circulated to every employee at the pit.

Turner Wards truck shops on Kirkcroft Lane. (*M. Sikorski*)

He said that he had read out these rules to Twiggs and Truswell on several occasions, and told them that they must be obeyed at all times or they would be punished, but he could not remember whether he had actually given each of them a copy!

He said that he did not hear of the fire or the accident until he got up shortly after six o'clock on Wednesday morning:

> I immediately went down and saw the rope; the engine man and banks man were not justified in letting down the men.
>
> They ought to have waited while daylight, and examined the rope carefully. If they had done so, it was so badly burnt that they would not have ventured to let down either cages or men. Twiggs and Truswell were the persons responsible for letting down the men.

The Government Inspector of Mines, Mr John Hedley, informed the coroner that four men would weigh from 5 to 6 cwt.

If the rope had been tested, by running a loaded cage up and down twice, before the men went down on the morning of the accident, it would have broken the rope in passing over the pulley.

After he had examined the rope, he said it was very much charred on the outside, the tar was nearly all dried out of it and the hemp was quite brittle from the heat.

If the rope had been tested by running a loaded cage up and down the pit, either the rope must have broken in two or the fracture would have been so great as to make it clear to any man that it was dangerous to use.

The coroner, Mr Busby, in his summing-up, looked very carefully at the evidence and commented upon it as he proceeded, and the jury returned a verdict of manslaughter against William Truswell. Truswell was committed to Derby assizes for trial.

Joseph Batty, collier and parish constable, said that on Thursday the 7th, when he was taking Truswell into custody on the charge of manslaughter, Truswell said to him on the way to the lock-up,

> I knew the rope was not right.
>
> I called Charles Mallender the under ground steward to one side and said to him 'I know the rope is not right, but we must not tell these men, or they will not go down.'
>
> Mr Ward pays me a good wage (24s 0d a week), and I don't want to lose that. I know we don't act up to the rules, but if I don't do it then somebody else will.

Now, some 154 years later, the great-great-granddaughter of the infamous Turner Ward tells me her grandfather told her that hearsay had it that Turner Ward knew well before the accident that the rope was worn and needed changing!

To save money, he had the rope coated with tar to make it last longer, thus endangering life. It was also said that because of certain members of the workforce who were privy to this information, and the fact that after the accident the information was passed around the community, whenever Turner Ward walked the streets he was taunted with the cries of 'murderer murderer', but he was a free man, hopefully living with a guilty conscience.

It seems that there is little documentary evidence about Killamarsh and Barlborough, but it is interesting to see reference to the villages in Pigot & Co.'s commercial directory for Derbyshire of 1835, in which it states that there are extensive mines of coal and ironstone in the area.

The coal masters at that time were listed as

Appleby, Walker & Co., Renishaw.
John Philip Forrest, Barlborough.
William Webster, Barlborough.
George Wells, Eckington.
Luke Worral, Mosborough.

The following were listed as mine owners in Killamarsh between 1841 and 1895, but there was very little detail as to the locations of their mines.

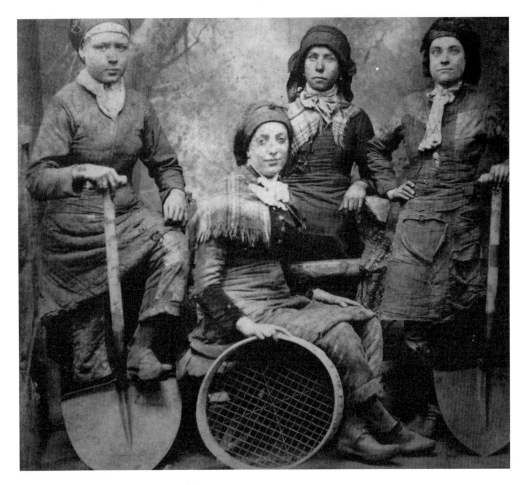

Female surface workers typical of this era. (NCM)

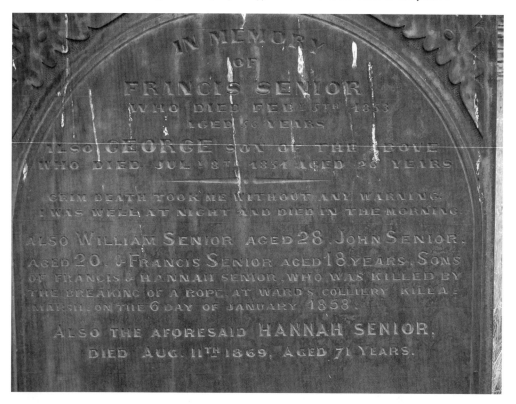

(Ken Wain)

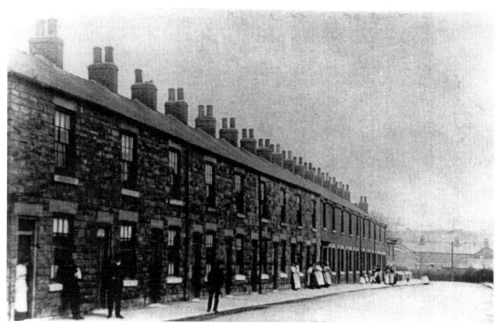

Miners' cottages, Sheffield Road, Killamarsh, early 1920s. (*David Thompson*)

Remains of Turner Ward's Colliery on Nethermoor Lane at Killamarsh, found during excavations for a new housing development in 1976. The shaft was only 38 feet from the Chesterfield–Stockwith Canal! The scale of the excavation can be judged by the size of the two house bricks in the bottom centre of photograph. (*Vin Hopkinson*)

Francis Ward 1841.
William Ward 1841–52.
Francis Senior 1841–52.
Joseph Worral 1843.
Samuel Ward 1845–52.
John and Thomas Shirtcliffe 1845.
Skevington Dickinson 1845–6.
Jonathan Batty & Co. 1856–60.
Thomas Webster and Joseph Batty 1856.
Thomas Webster 1856–72.
Mr G. Earle 1886. He leased 90 acres of land from the Duke of Portland at Nethermoor, and sank a shallow shaft to 45 yards into a seam of coal that was 5 feet 6 inches thick.

He subsequently re-leased the land to Mr G. Hunter, who was a certified manager from Bishop Auckland, for £60 per acre, and 100 men were set on.

In 1868, a small pit, run by Harry Pope, is listed as being in operation near the Chesterfield Canal at Norwood, by the side of the Yorkshire Tar Distillers chemical works. The coal was raised by a horse and jenny wheel, then taken out by local horse-

and-cart owner Fred Adams, who sold it for 1s a bag. The pit failed, due to selling coal too cheaply and the workings being flooded. The railway company, which had a branch line to the Yorkshire Tar Distillers, refused to pay for the coal that ran under their lines, so in retribution Harry Pope had the coal taken from under the lines, which subsequently collapsed due to subsidence; the outcome of this action was not recorded. Other pits were listed for T. G. Richardson in 1894, and Thomas Jackson in 1895. The above information was supplied from the archives of Vincent Hopkinson, Killamarsh local historian.

The national output of coal in 1870 was a massive 110 million tons, with 296,000 men and boys!

In 1881, there were some 731 inhabitants in the parish of Barlborough, which would lead one to believe that most of the working populace would be engaged in the mining of coal, due to the number of coal owners at that time.

Other entries include references to coal mining in Staveley, Brampton, and Clowne, to name but a few in the near vicinity of Sheffield.

In 1843, Joseph Worral sunk a pit at Norwood Bank, Killamarsh, and ran it single-handedly until its closure in 1910; it was reopened only three years later, and they were producing an average of 150 tons per week, run by eight men who were members of the same family.

They drew coal from a 60-foot-deep shaft by means of a single horse-operated 'Jenny Wheel,' and the pit stayed in the same family for its entire working life of 100 years.

The pit was closed in 1943, at about the same time as the Sheepbridge Company's Norwood Colliery, and J. & G. Well's Holbrook Colliery. Worral and Hodgson's pits at Beighton Hollows and Halfway were also closed at this time.

Killamarsh seems to be better documented in later times, when proper records began at the time of the sinking of the shafts into the steam coals, which were needed for shipping and for the rapidly expanding railway system.

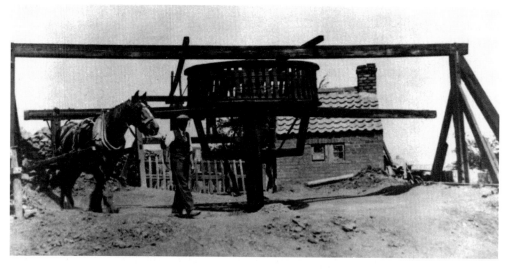

J. Worral, 1939. (*David Thompson*)

The Sitwells
North East Derbyshire
Coal Masters and Ironfounders

The Sitwell family have, in some way or another, been known to be in existence in the area from the fourteenth century.

Early records show that Robert Sytwell, resident of Staveley Netherthorpe, and one of the forefathers of the Sitwell family of coal masters and iron founders of Renishaw Hall, was leasing a coal mine at Eckington Marsh with a William Greaves as long ago as 1570, for which they were paying a yearly rent of 40s.

George Sitwell was known to be paying the sum of £20 a year in mineral rights as early as 1601, in the reign of Elizabeth I; the company's ironworks at Foxbrook and Slitting Mill were in operation well before 1650, and supplied all the local nail makers, and scythe and sickle makers at Eckington, Killamarsh, Mosborough, Troway, Birley Hay and Ridgeway in the Moss Valley. By 1700 the company was making more iron nails than anyone else in the world. The ironworks were eventually sold in 1792.

Ridgeway was the central hub of the scythe and sickle manufacturing industry around Sheffield. Gales & Martin's directory of Sheffield's and adjacent villages' manufacturing, of 1787, shows that thirty-one sicklesmiths were listed at the time, of whom 80 per cent were within a 3-mile radius of Ridgeway!

Water from the Moss Valley powered the giant waterwheels, which operated the tilt hammers for forging and the gritstone wheels for grinding the scythe and sickle blades at Birley Hay. It was the only water-powered forge in the Moss Valley.

Charcoal was used for forging and waterwheels for grinding in most other locations until the early 1920s. The Birley Hay unit prospered for many years, exporting its products worldwide.

Over the years it suffered from prohibitive maintenance costs, and a fractured axle shaft on one of the waterwheels led to the owners, T. & G. Hutton, closing the forge in 1938 and moving all its production to the more efficient steam-powered unit at the top end of Ridgeway village. The Phoenix Works, on High Lane, had been in the family since the latter part of the 1700s.

Coal for fuelling the steam boilers and workshop equipment was readily available from Vardy's Highlane Colliery, situated across the road from the works!

The miners worked hard and, when they could, they played hard, with an emphasis on alcohol consumption. In 1879, Lady Ida Sitwell opened the Eckington coffee house in an effort to lure the miners away from the evils of drink. It was said that the Sitwells'

miners were given tokens to spend at the coffee house as part of their wages, but this had little or no effect and was doomed to failure from the beginning.

Some twenty-five years later, *Kelly's Directory* of 1904 states that there were no fewer than nine retailers of beer at the time, and this with a population of only 13,000.

It was shortly after the 1893 riots at Hornthorpe Pit that Lady Ida Sitwell had a drive built through Eckington Woods in the Moss Valley, which went past the Plumbley Colliery, better known as 'Seldom Seen' because of its location in the depths of the woods.

J. & G. Wells purchased the colliery from the Sitwells, and paid 1s per ton of coal in mining rights. The colliery itself had a relatively trouble-free existence apart from regular water problems. It was connected underground with Hornthorpe Colliery and with Black's Renishaw station pit, which was also purchased by the J. & G. Wells company.

Tragedy struck at the Plumbley Colliery on 16 March 1895, when three children were skating on the colliery pond. The ice broke, and all three children were consumed by the icy waters, along with Alfie Williamson, a fireman at the pit, who made a valiant attempt to save them.

The Sitwells progressed to be one of the most prominent coal master families in the Eckington and Renishaw district, right up to Nationalisation in 1947. This means the family was involved in the coal industry for some 367 years, which must surely rate as a record in mining history.

A single rail line, built at the same time as the main Midland line, was laid across Killamarsh meadows, and ran from the colliery, through Eckington village to Renishaw station to convey the coal wagons to the Midland Railway main line. This line was later used by local people wishing to travel between Eckington and Renishaw station on payment of 1 penny! Penny Engine Lane, down which the Penny Line ran, still exists in Eckington village.

To the rear of Eckington church, at the bottom of Gashouse Lane, by the side of Ladybank Wood, a drift was taken down at a steep incline into a seam of Parkgate coal. It was called Mossbrook Colliery, and the Penny Line ran alongside it. The *Guide to the Coalfields*, published by the *Colliery Guardian*, makes reference to Mossbrook Colliery Ltd, with its office in Rockingham Street, Sheffield. The colliery employed twelve men underground and two on the surface, commencing work in 1955. By 1968 and for the following two years, there was a general decline in business, which meant that the manpower had to be reduced to only three men underground and two on the surface. However, business improved, and by 1970 five were working underground and three on the surface. Eight full tubs of coal at a time were hauled up the drift by a 25-hp haulage engine and pushed into a tippler, which loaded the coal on to an elevator that deposited it into a bunker for loading into a delivery lorry.

The colliery was taken over by the Doe Lea Colliery Ltd in 1972 but closed in December 1979.

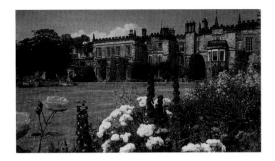

The Sitwells' Renishaw Hall.

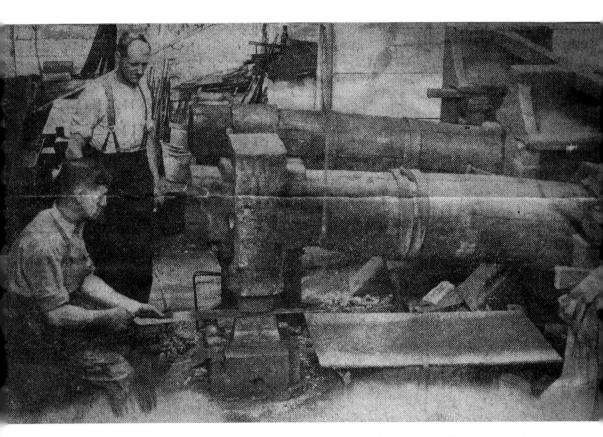

The Birley Hay. Tilt hammers are shown here forging a scythe blade, 1935. (*Sheffield Telegraph*)

(*Ken Wain*)

Highlane Silkstone Colliery, Ridgeway, was opened in 1880 by Andrew Vardy, who was joined by his son Henry as the colliery manager twenty years later. He eventually took over the pit until its closure in 1928, two years after the General Strike of 1926. The pit was directly across the road from the Phoenix Works, and provided the works with all the coal required for its steam boilers and equipment (*Twentieth-Century Ridgeway Remembered*, J. Hambleton). (*Frank Fisher*)

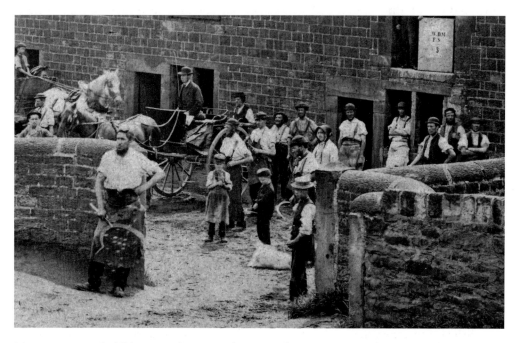

Men, women and children are shown working together at Hutton's Phoenix Works, Highlane, Ridgeway, *c.* 1900. (*Tony Rippon*)

J. & G. Wells Mining Co., Eckington

In the early 1830s, George Wells of Southgate, Eckington, opened up a gin pit (a pit where the coal tubs are hauled up the pit shaft by a steam-powered engine). Two others were soon to follow, and within four years he had built coke ovens and was operating a new engine pit, thanks to a rapid expansion programme. He had just bought Sale's & Bibb's Moorhole pit at the top of Mosborough Moor for £2,500.

It was in July 1833 that George Wells' was sold by John Shirt Jennings of Beighton (farmer). The sale included all the coal beds, seams and veins belonging to him and situated at Killamarsh, approximately 18 acres, for the sum of £200. The deeds of conveyance costs were shared.

When George Wells died in 1835, his sons took over the business, and with their newfound wealth they sank the Moorhole bottom-side mine at the top of Mosborough Moor.

In 1838, his sons, namely George and Joseph, who worked independently, but then consolidated and were later to be known as the J. & G. Wells Company, were also operating gin pits and coke ovens in and around the Eckington district, and went on to be one of the biggest mining names in the country.

One of the family homes, Hohenlinden, was transformed into an elderly residents' home on Southgate in Eckington, and is now known as The Grange children's nursery and family support unit, which reflects the importance of the family within the community.

In 1867, a chap by the name of William Sewell, who was reported to have walked from Worksop to Halfway village, between Killamarsh and Eckington, at the age of sixteen, was soon to find employment in the local pits. He worked hard, and among his other attributes he became chairman of the Miners' Association.

One of his biggest claims to fame among the local workforce was that he recognised genuine need, and once persuaded the directors of the J. & G. Wells company to donate a pony to a former miner who was disabled in the pit, to allow him to make a living.

A row of houses were built later in Halfway village, and the road was named Sewell Road in his honour. This was next door to Eckington Grammar School, now demolished, and across the road from the existing Morrisons supermarket. George Wells died in 1871, and his brother Joseph died only two years later. Joseph had previously had a splendid house, Elmwood, built next door to Eckington Hall as a gift for his daughter.

The J. & G. Wells company was taken over in 1944 by the Rothervale Collieries Group until Nationalisation in 1947. Among their possessions at this time were collieries at Westhorpe in Killamarsh, and at Renishaw Park. They had previously owned Hornthorpe Colliery at Eckington, Plumbley Colliery at Eckington, Moorhole collieries and Westwell Colliery at Mosborough, Holbrook Colliery, Norwood Colliery, and the Renishaw Station Pit, which they had taken over from Blacks.

The family were very close-knit and had a chapel built, in memory of their two brothers, which they gave to the people of Eckington. Over the years, the congregations got smaller, and due to this and rising running costs the chapel was closed. It was eventually sold and used as a factory unit until it was demolished in 1970.

The family made a large financial contribution towards the building of St Mark's church in Mosborough, and the last of the Wells family to live at Elmwood was Margaret Wells, who paid for the installation of electricity in the church; she died in 1977.

The Grange, on Southgate, Eckington, formerly Hohenlinden, the home of George Wells. Now, it is a children's nursery and family support unit run by Derbyshire County Council, and, ironically, is partly funded by the Coalfields Regeneration Scheme. (*Ken Wain*)

Hornthorpe Colliery

Hornthorpe Colliery was sunk by the J. & G. Wells Coal Company in 1871/2, at a depth of 633 feet into a 4-foot-10-inch-thick seam of good Silkstone coal, and was soon producing top-quality household and gas coal.

Hornthorpe, Plumbley, and Renishaw Station Pit, belonging to J. & G. Wells, were connected underground.

The colliery employed 440 men underground and 96 men on the surface at this time.

In February 1888, two boys were caught stealing coal from the colliery; P. C. Holmes of Eckington said he saw them carrying three stones of coal. The boys, named as James Marples and William Bowers, were each fined 7s 6d, or on failure of payment seven days in jail.

Just after Christmas 1889, the surface workers at the pit, along with those of Holbrook Colliery and Renishaw Park Colliery, were given an advance on pay to the tune of threepence per day for men and twopence per day for boys. It would come into force on New Year's Day, and was welcomed by all. This followed a similar advance given on 1 July in the previous year.

The national strike of 1893 caused a great deal of upheaval at Hornthorpe and Holbrook collieries. Buildings were severely damaged at Holbrook, and hundreds of strikers besieged the non-union men in the engine house, bombarding them with all manner of missiles until troops and police reinforcements arrived from Chesterfield, Dronfield and Sheffield to quell the rioters. On 28 August hundreds of miners marched on Hornthorpe Colliery, hell-bent on causing maximum damage.

Two wagons loaded with slack were sent hurtling down the railway line from the pit towards the main line, demolishing three sets of level crossing gates before coming to rest and blocking the main line. An excursion train, followed by the Scotch express, was miraculously prevented from running into the area by the actions of a quick-thinking signalman.

Both pits were soon brought back to work after the strike, and continued to produce household coal, but at Hornthorpe it was for a relatively short period of time, as on 5 March 1921 the general manager of J. & G. Wells Ltd, Mr Greensmith, announced that the lease for the colliery would expire on 25 March, and that the company intended to give up possession of Hornthorpe pit.

Even though Hornthorpe was only fifty years old, he said that it was old and that, although the output was currently around 1,400 tons per week, the water ingress was serious and the pumps were running continually to keep the workings clear and to safeguard neighbouring pits. The men would be employed at J. & G. Wells' other pits. Sir George Sitwell said that there was apparently no prospect of the colliery working after the expiry of the lease.

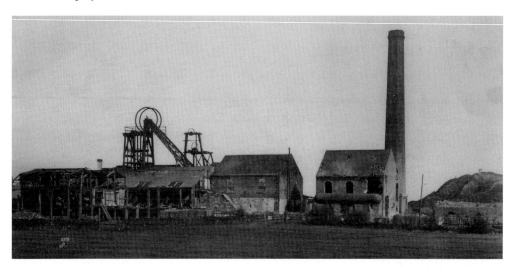

A rare photo of Hornthorpe Colliery, Eckington. Not a lot is documented about the colliery. It is seen here in a derelict state, waiting for demolition after its closure in 1921. (*Dave Mathews*)

Norwood Colliery (Killamarsh)

The sinking of Norwood Colliery was started in 1865 by the Sheepbridge Iron & Steel Co.

Miners from all over the country came to Killamarsh to find work at the new colliery, and coal was reached three years later at a depth of 510 feet to the Top Hard seam. I am proud to say that the shaft sinking was undertaken by my great-great-grandfather Mr Elijah Wain, the master sinker, and his team, who completed the task without any fatality or serious injury.

The following is an extract from *The Colliery Guardian* of 1867, which refers to the sinking of the shaft:

Norwood Colliery, Killamarsh –
On Saturday last, a very substantial supper was provided for the workmen at the above Colliery by the Sheepbridge Coal and Iron Company, in commemoration of having reached Coal there, at a depth of about 170 yards. Upwards of 80 sat down, and a very pleasant and agreeable evening was spent by all present.

Among the company were the Rev E. H. Smith, incumbent of Killamarsh, and several Killamarsh gentlemen. Mr Longbottom, Manager at the Colliery, was called to the chair, and after the cloth was drawn, briefly opened the proceedings by referring to the remarkable and almost unexampled success that had attended the sinking of these shafts, the coal having been reached without a single accident of any kind.

He considered this for a matter of congratulation and thankfulness, as they had difficulties to contend with in the earlier part in the sinking which required great skill and judgement from the management, and also great endurance and exertion to overcome.

He paid a high tribute to the Master Sinker, Mr Wain, for the tact and energy he had shown in the undertaking, and congratulated all on the amicable way they had worked together, and on the good feeling that had prevailed throughout.

The Chairman then proposed 'Continued success to the Norwood Colliery, and Prosperity to the Sheepbridge Coal and Iron Company,' which was drunk with great enthusiasm.

Mr Smith next proposed the health of William Fowler Esq, Whittington Hall, Company, which was rapturously drunk with musical honours, and with three times three cheers, and one over, and the same honours for Mrs Fowler and family.

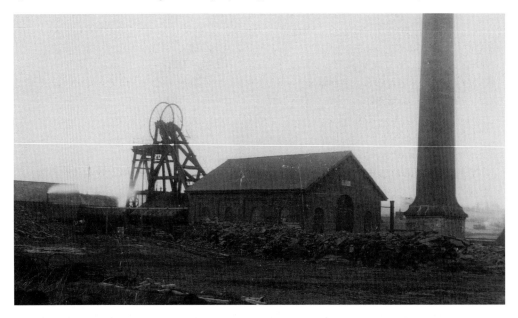

(David Thompson)

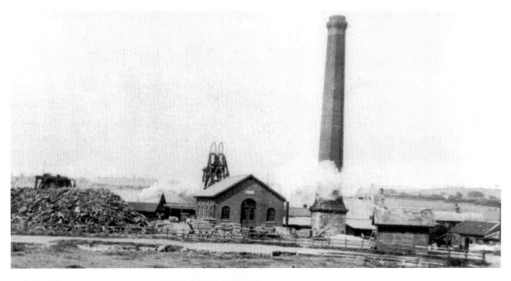

Above: Norwood Colliery, c. 1900. (*Vin Hopkinson*)

Left: Messrs Guest, Spooner and Parkin pose for the camera outside Dobson's farm, Rotherham Road, Killamarsh, on their way to the pit, c. 1935. (*David Thompson*)

Mr Birkbeck and Sheepbridge staff received a similar ovation, also Mr Longbottom, manager at Norwood. Other toasts were drunk, and the remainder of the evening was spent in songs, etc, most of them given in really excellent style.

Mr Simonite, Angel Inn Killamarsh, was the caterer, and great credit is due to him for the way in which the supper was served.

The Norwood Colliery is sunk for the purpose of obtaining hard coal.

The seam is nearly five feet thick and of excellent quality and will, no doubt, prove a very valuable property to the Sheepbridge Coal and Iron Company.

Very powerful machinery is already erected, and when the Colliery becomes developed it is expected the daily output will be from 600–700 tons.

The Midland Company are now constructing a railway to the Colliery, the set for which was obtained last session.

After the railway was constructed, it was further extended in the form of a branch line to the West Kiveton Colliery and on to Kiveton Park Colliery, for the Kiveton Park Coal Co. Ltd.

By 1871, the colliery was producing 4,000 tons per week and showing a good profit, but on 22 November of that year, a gas explosion killed George Barthorpe outright and badly injured many others by way of severe burns. Eight of these were so badly burned that they died shortly afterwards. Four of them had only been in the village about a year or so, and were living in a newly constructed row of cottages built by the colliery company on Sheffield Road.

Tragedies always put families in a state of shock, and this was no exception, but as usual they rallied round and pressed on with their lives. It is thought that the widows of brothers Enoch and Sam Lilley and Eligah Ralph, who were new to the village, may have returned to their place of origin. Thomas Hutchby's wife was left with two children, and opened up a grocery shop at Norwood. The family prospered and the son, Clarence Hutchby, went on to open a 'beer off' and a salt factory, which provided employment for other villagers.

These were the days when employers ruled with an iron fist, and housing for employees was at a premium. Consequently, widows were looked upon with very little compassion and were served with notice to leave. Only one year later, in 1872, 100 miners were taken to court over breaches in their contract agreement.

In 1916, the Sitwell seam was tapped at a depth of 1,055 feet, providing copious amounts of good-quality steam coal for many years.

Kelly's Directory of 1925 tells us that the colliery was now under the ownership of the J. & G. Wells company. The third seam, the Thorncliffe, was reached via a drift, which was some 360 yards south of the colliery. Coal was now being supplied to the steel industry, the railways and household customers.

Reserves eventually ran out, and the colliery was closed in 1943.

Billy Dobbs, Tom Jones, Stan Hornsby and Jack Walker, the wagon marshalling team, *c.* 1935. Shortly after the colliery opened in 1867, a yard labourer slipped and fell with his left arm on the rails just as a wagon was approaching. His arm was so badly injured that the surgeons were left with no choice but to amputate it. (*David Thompson*)

Mr Bramhall, the colliery hostler, with his pony and trap in Norwood pit yard, 1930s. (*David Thompson*)

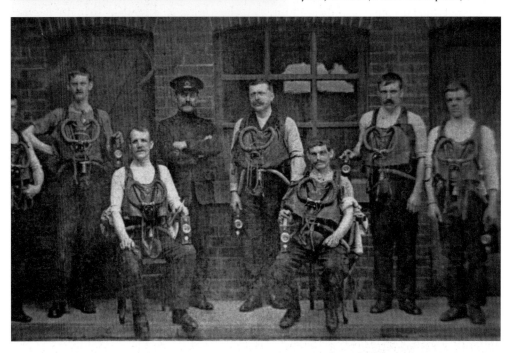

Norwood Colliery rescue team, mid-1920s. (*David Thompson*)

Norwood Colliery (Killamarsh)

Rotherham Road, Killamarsh, featuring Norwood Colliery in the distance, c. 1935.

The Angel Inn, showing just how close Norwood Colliery shaft was. Demolition had started, the winding ropes had been removed and the top part of the pit chimney had been removed, as can be seen in the centre behind the inn. (*Vin Hopkinson*)

Victory in Europe Day party for the children of Rotherham Road, outside Norwood Colliery canteen, May 1945. (*Author's Collection*)

West Kiveton Colliery

The West Kiveton Colliery was sunk by the Kiveton Park Colliery Co. in 1874 beside the Norwood Tunnel, on the Chesterfield to Stockwith Canal near Killamarsh. It had a wharf, which was fed by a tramway that transported coal tubs down to the canal side for tipping coal directly into the barges.

The colliery produced coal from the Top Hard seam at a depth of 480 feet, and took coal from the Thorncliffe seam and the much deeper Sitwell seam in the early 1900s. It went on to work well until its closure in 1931.

I can only find one record of an accident. It was recorded in the *Derbyshire Times* of 23 February 1883, and tells of an inquest at the Travellers Rest public house on a Benjamin Booth, who was hit by a lump of coal of approximately ½ cwt; it struck his left leg, which was broken as a result. On 13 January 1883 a Dr Robertson examined him at home after he complained of pain in his back, and found that he had congestion of the lungs. Benjamin Booth died two weeks later; the jury concluded that he had died from congestion of the lungs, accelerated by a fall of coal at the mine.

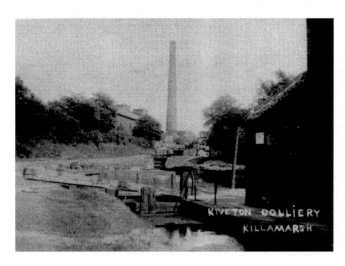

Above left: (David Thompson)

Above right: George Batterham with the Morris Commercial bus, *c.* 1927. (Author's Collection)

West Kiveton Colliery

En route from Kiveton Park Colliery to Killamarsh, passing under Norwood rail bridge, c. 1950. (*David Thompson*)

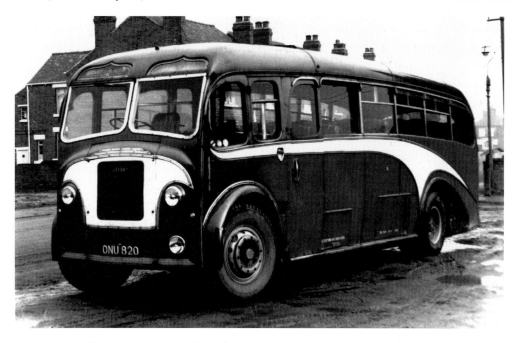

Grant & McAllin motor services of Beighton ran a service between Beighton and Kiveton Park Colliery. (*Robert Atack*)

Joseph Booth, who worked in the offices at the West Kiveton Colliery, and, along with his brother Fred, had a good understanding of business and an eye for opportunity, bought a second-hand lorry, and began a home coal delivery service for the miners after Fred learned to drive. They soon realised that a good many miners who did not live in the immediate vicinity of the pit had to walk there, in some cases a few miles, which meant that they needed a rest before they could start work, and similarly after they had walked home at the end of the shift – of course, this was in all kinds of weather.

Joseph did a bit of market research, and the miners thought that it would be a great idea if a motor bus was able to ferry them backwards and forwards to the pit for a reasonable fare. The pit owners jumped at the chance to get their employees to the pit in good condition to start work, and said they would subsidise the fares if Joseph purchased a vehicle.

In 1921, Joseph bought his first bus; the venture proved to be an immediate success, and further vehicles were purchased. Donald Fisher of Beighton was set on as fleet mechanic in 1925. After a few hiccups, a service was started in 1927 to run from Killamarsh to Worksop; a small Morris Commercial bus was used to run this service, and local lad George Batterham was set on to be the driver. Donald Fisher became a partner in 1940, and the company became known as Booth & Fisher. It grew over the years to become one of the most prominent and well-respected local businesses.

After the Second World War, Booth and Fisher purchased a fleet of ex-RAF Bedford Utility buses with wooden slat seats to be used on the contracts to ferry the miners back and forth from the pits, which were now nationalised. The collieries using the service were Westhorpe, Kiveton Park, Renishaw Park, Ireland, Markham, Bolsover and Oxcroft.

At a public meeting in Worksop in 1769, the great waterways engineer James Brindley was given the task of designing and overseeing the building of a canal, which was to run between Chesterfield and West Stockwith, to sell and transport coal cheaper than the South Yorkshire pits on the South Yorkshire Navigation Canal.

His untimely death in the autumn of 1772 meant that he was not to see the completion of the task, and his clerk of works, John Varley, was given the job of resident engineer. In this capacity, he was expected to let contracts on the basis of competency and value for money, in order to get the job done professionally and on time. This may have been his downfall; it was said that he was in fact giving his family, including his father and two brothers, contracts on the job.

When Brindley died, Hugh Henshall, who was James Brindley's brother-in-law, was the contract surveyor; he was given the job of chief engineer and inspector of works, and in overseeing Varley's work, he uncovered poor workmanship in the Norwood Tunnel and malpractice in the letting of contracts. This could have been attributed to Varley, but was never proven. The controversy carried on in March 2009, when Rotherham MP Kevin Barron unveiled a plaque on the wall of the old school in Harthill to commemorate Varley's work on the canal (Harthill was his place of residence during construction).

The canal was completed in 1777, and proved to be a great asset to the local coal mining industry.

Apart from local carriers, who catered for the area's immediate needs, the greater majority of coal was transported by horse-drawn barge on the canal for almost seventy years. In 1800 the national output was 10 million tons.

The Chesterfield–Stockwith Canal, opened in 1777.

The Chesterfield–Stockwith canal at Killamarsh. (*D. Wain*)

The Old Boatman inn at Norwood Locks, c. 1900. (*Vin Hopkinson*)

By the year 1870, it is reported that some 100,000 tons of coal were being taken to London alone. The national output at this time was an enormous 65 million tons, produced by 220,000 personnel. The combined Yorkshire coalfields, including the Sheffield area pits, contributed approximately 12 per cent of the national output, as compared with the North East's 24 per cent. Domestic needs called for 21 per cent of output and none was required for electricity generation. When compared with 1980, there is a very sharp contrast; domestic consumption had dropped by 2/3 to only 8 per cent, and electricity generation demanded more than 2/3 of output, approximately 69 per cent! It is a point of interest, because during this time, Yorkshire was producing 29 per cent of output as compared to the North East's 12 per cent, which adequately illustrates how trends and availability alter over the years to cause a complete reversal of roles for the different coalfields.

Norwood Tunnel, c. 1880. (*David Thompson*)

Typical miner's house of the era. (*Ken Wain*)

Ironically, later in the 1870s, and for a further ten years, the coal trade expanded and produced the goods, but the demand yet again suddenly dropped, and coal that was fetching 22s 6d per ton had fallen dramatically in price to 9s per ton; this caused the corresponding lay-offs and great hardship among the miners and their families. Considering that £1 per week was a good wage, and that the rent for a two-up two-down cottage was 4s 6d per week, eggs were eight for 1s and milk threepence a quart, very little was left to spend on the niceties of life!

The year 1913 saw Britain's highest ever output, at a staggering 287,430,476 tons.

Transportation of coal from the outlying pits in the South Yorkshire coalfield into Sheffield's iron smelting industries was an expensive and arduous task in the early 1700s,

relying on the good old horse and cart! It was soon realised that the River Don would fulfil an urgent need if essential work was carried out to make it more navigable; this work was completed, and the river was eventually used for transportation of coal in 1734. This proved to be a great success for Sheffield's industrial users and the collieries alike.

James Brindley's Chesterfield to Stockwith Canal, to the south of Sheffield, was completed in 1777 and had an immediate impact on coal sales. On 4 June 1777, the first coal barge arrived on the canal through Killamarsh, proceeding towards the Norwood Tunnel for the first time. By the mid-1830s, 160,000 tons of coal had been transported to Sheffield from as far away as Elsecar to the north, and the Denaby district to the north-east, and a whole network of canals were made over the next half a century or so to take coal to Gainsborough for sale to the domestic markets.

In 1789, 42,379 tons of coal were transported by horse-drawn barge; by 1905, this had fallen to 15,408 tons.

Several thousands of pounds were spent repairing Norwood Tunnel, but a severe cave-in finally caused its closure in 1908.

Not to be outdone during the Great Frost of 1894, when everything was frozen over for three months, and the canal was frozen solid, coal was transported along the frozen canal by horse and cart! When the barges reached the entrance to the tunnel, the horses were unhitched and walked to a nearby stabling facility to wait for the barges to return; meanwhile the bargees would lay on their backs and treadle the barges through the tunnel, which was 2,890 yards long, so it demanded a great deal of energy to complete the task.

When travelling towards Chesterfield, the barges had to descend a flight of thirteen locks. At the bottom of the flight of locks was a sizeable inn, The Dog and Duck, which was renamed The Boatman Inn in the latter part of the nineteenth century. The inn lost its licence shortly after the closure of the Norwood Tunnel in 1908. The main reason appears to have been the anger of the proprietors of nearby West Kiveton Colliery at the amount of time being spent by its employees in consuming alcohol at the inn.

A tramway was constructed from Norbriggs Colliery, near Renishaw, down to the canal to increase the coal trade, as Brindley had estimated that the coal would sell cheaper than the River Don coal sold at Gainsborough.

Until alternatives could be sorted out, sometime after the Second World War, coal was carried down from Shireoaks Colliery.

The Chesterfield Canal Society's publication of 1986 pays lip service to the way in which the canal's part in local history has been virtually obliterated by infilling and housing development, which has been allowed to cover the canal bed through Killamarsh and almost as far as the Norwood Tunnel, with the exception of small stretches.

The area to the east of the Norwood bridge, dated 1833, leading into Norwood Woods has been developed by its now private owners to include three exceptionally high-class residences converted from the old Boatman Inn; the locks office has been demolished and a new luxury dwelling erected. The sawmill by the wharf, before the top flight of locks leading to the west end of the Norwood Tunnel, has been converted into another luxury home with additional substantial outbuildings.

Each property has its own pond, fed by overflow weirs by the lock side; it is a crying shame that the development was allowed to be carried out without the full

Horses were used to walk the towpath, and tow the barges along the canals. (*National Coal Mining Museum*)

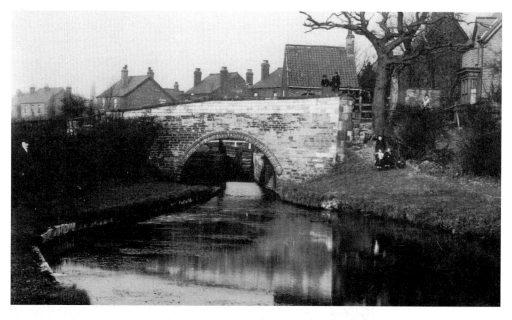

The canal at Killamarsh. Under the bridge can be seen the first lock in a series of thirteen climbing up to the Norwood Tunnel. The lock-keeper's cottage is behind the children on the bridge. At this time, the canal was only used by coal barges taking timber to and collecting coal from the West Kiveton Colliery, which closed in 1931. A few pleasure boats also used the canal. (*Dave Mathews*)

refurbishment of the flight of thirteen locks over this 1/3-mile stretch, which is considered by many, and quite rightly so, to be of great historical interest. Some of the lock sides were knocked in during 1964/5! A little bit of foresight and common sense on behalf of the Waterways Authority and the new owners would have saved these locks, and with a minimum capital outlay as compared with the cost involved in developing the residences, it would have added substantially to the value of the properties, both aesthetically and historically.

The old towpath is a public right of way, but motor vehicles are prohibited.

The canals were the mainstay of coal movement until the advent of the railways, which started in 1838 when a direct link line was put down from Sheffield to Rotherham, after which a rapid expansion programme was carried out throughout the South Yorkshire coalfield, with direct links to London, the ports and all the major cities. Sheffield was now well placed to tap the ever expanding worldwide export markets.

Sir George Sitwell, who was originally opposed to the idea of railways disfiguring his hitherto unspoiled landscapes, was soon to realise the folly of rejecting them, and the obvious advantages there were to be gained by his own companies in having priority access to a nationwide network of endless marketing possibilities. He soon withdrew his objections, and rails were laid across Killamarsh meadows by 1840.

The Manchester, Sheffield & Lincolnshire Railway was laid through Woodhouse Junction around 1845.

After the rail systems were linked together to form a national network, the demand for coal began to increase steadily, and more and more heavily mechanised deep mines were sunk to cope with not only the domestic markets, but the constant needs of the railways themselves. The developing local iron and steel industries, steam-operated agricultural tractors and road haulage traction engines, the Royal Navy, the Merchant Navy and the growing army of fishing vessels dotted around the British coast were all now heavily reliant on coal, and the steam era was well and truly established. The coal mining industry itself was soon to be using 50 million tons of coal per year for its own steam engines to wind the coal from the mines!

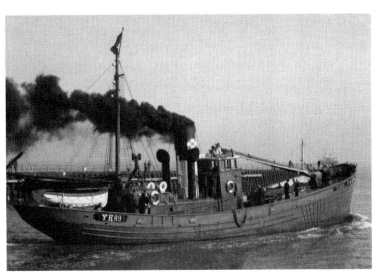

Lydia Eva, the world's last surviving steam-powered herring drifter.

Steam-powered fire engines and fairground equipment were now the order of the day, and the breweries were phasing out their horse-drawn vehicles in favour of steam wagons; coal was king!

London was expanding rapidly, and the capital's transport infrastructure was moving at a fair pace to keep up with the transportation of the city's working populace. Work progressed on the underground system until it was opened on 10 January 1863. The opening day was attended by approximately 40,000 people, who marvelled at the use of coal-powered steam engines running beneath the streets of London! The 3½-mile, eighteen-minute journey from Paddington to Farringdon took '2 hours and forty minutes' due to the number of people crowding the platforms wanting to ride on the trains; this created horrendous safety issues.

By this time, the coal industry and the iron and steel industry in and around the city of Sheffield were advancing at a rate of knots, and it will be noticed that there were now companies who had realised the potential of both industries and had begun to amalgamate to reap the rewards of their joint ventures:

Staveley Coal & Iron Co. Ltd.
Industrial Coal & Iron Co. Ltd.
Sheepbridge Coal & Iron Co. Ltd.
Askern Coal & Iron Co Ltd.
United Steel Collieries Ltd.

The railway companies were by now increasing their carriage of fare-paying passengers, and stations were springing up all over the Sheffield district. By 1903, the railways were consuming 18 million tons of coal; the coal trade was booming. Express trains were travelling to London and other major cities throughout the country.

Disaster struck when, at 12.45 a.m. on 29 February 1908, a special emigrant express train travelling through Woodhouse Junction from Liverpool to Grimsby crashed into the rear of a coal train which was leaving the east junction from Birley Collieries; it resulted in two deaths and one serious injury. The coal train guard, Mr Arthur Rowley, was killed instantly when the express, which was travelling at approximately 30 mph and carrying 300 passengers, ploughed into the rear of the coal train. The driver of the first engine was Mr Walter Howell, and he was very badly injured and scalded. The fireman, Mr Harold Clark, was trapped under the engine for two hours before being released, and he died at the scene. Serious disruption was caused, and coal from Birley Collieries was held up.

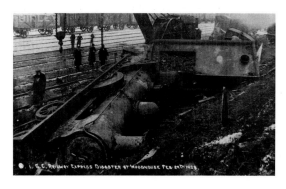

(Len Widdowson)

Steam

Steam power was introduced during the middle of the eighteenth century for all kinds of stationary engines, and also for motive power. By the year 1800, there were approximately 2,000 steam engines in operation in Great Britain, of which half were being used at the nation's collieries.

This was a ready market for millions of tons of locally mined coal. Indeed, the collieries' own boilers were consuming thousands of tons of coal to produce a decent head of steam to power the winding engines.

William Allchin started his business in Northampton in 1847. He manufactured all kinds of engineering and agricultural machinery, from small static engines with timber sawing benches to the much bigger traction engines for general agricultural duties, such as pumping and threshing operations.

John Fowler & Co. of Leeds started operations in 1861 and produced a whole range of different steam engines for home and abroad. They developed steam ploughing engines and started production in 1870, after which the company rapidly expanded into the traction engine and road locomotive markets. By the turn of the century, the company was employing in excess of 2,500 men in its Leeds steam plough works.

Fowler's was only one of the major producers of steam-powered vehicles, which illustrates the growing demand for steam coals from the local collieries. George Robey & Co. of Lincoln also manufactured agricultural tractors, static engines and winding engines used at collieries for coal mining.

Steamrollers were used in the 1890s for road construction, two of the most famous of the manufacturers being Wallis & Steevens of Basingstoke and Aveling Porter of Rochester. These machines were used right up until the early 1960s by most county councils until they were replaced by diesel-powered machines. The much heavier road locomotives were used for hauling heavier and longer loads on the nation's newly constructed highways. Along with Fowler's, Charles Burrel & Sons Ltd of Thetford were the leading makers of this type of engine; they were also used by fairground operators for the haulage and on site operation of their equipment.

The nationally acclaimed haulage contractor W. E. Chivers & Sons of Devizes set up their business in 1864 and had depots throughout the country. They grew rapidly and were recently referred to as the Eddie Stobart of the 1920s in the monthly steam and vintage vehicle publication *Old Glory*; they used in excess of 200,000 tons of coal per

year. Sheffield was well catered for by the company, who had rather a large fleet of steam-powered traction engines and wagons that were housed in the old Olympia Garage on Bramall Lane, all fuelled by locally mined coal. They also had a fully equipped workshop for the repair and maintenance of their fleet in Sheffield. During a two-month period in 1920, in one contract alone the company had transported almost 2½ million building bricks from a brickyard on the outskirts of Sheffield to building sites in and around Sheffield and Leeds.

Sheffield steelworks used steam-powered lorries for internal transport, and wagons manufactured by Sentinel, Garrett, Fowler and Foden etc. were also widely used by the breweries for the transportation of beer to local hostelries. These vehicles were used by all and sundry well into the 1950s.

This period of steam revolution was a boon to continued coal production in Sheffield; thousands of tons were consumed every week in fuelling the vehicles required to keep the nation on the move.

Burrell ploughing engine at Rother Valley Country Park. (*Alan Rowles*)

Steam 147

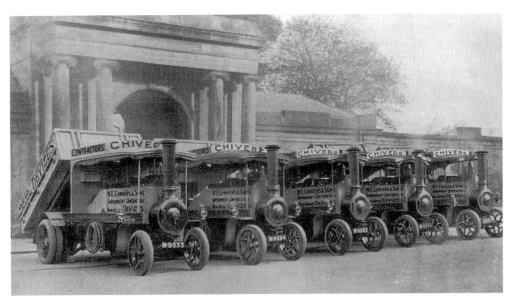

W. E. Chivers' fleet of steam tippers outside the botanical gardens, Sheffield. (Old Glory *steam magazine*)

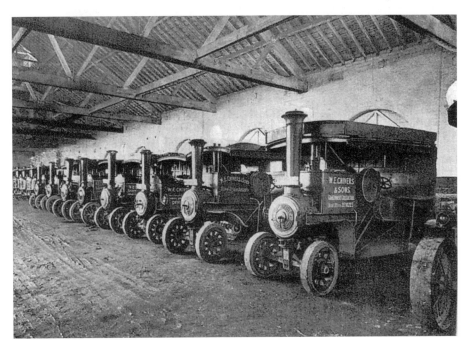

W. E. Chivers' Olympia Garage, Bramall Lane, Sheffield. (Old Glory *steam magazine*)

Stephenson's *Rocket*.

The Lancashire Fusilier, engine number 45407, on a special excursion after refurbishment, passing through Dronfield, October 2011. (*Ken Wain*)

Tornado, the latest steam engine to be built in Great Britain, seen in 2008. A1 Class engine *Tornado* has an output of 2,700 hp. It carries 5,000 gallons of water and has a coal tender capacity of 9 tons. It burns 52 lbs per mile, approximately 44 miles per ton, 396 miles per tender full! Try to imagine how many millions of tons of coal were used daily by British railways during the steam era.

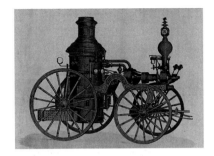

Early prototype single-cylinder steam pump. (*Ted Mullins*)

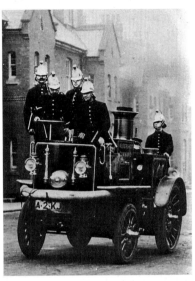

Self-propelled steam pump with crew, en route to tackle a fire. (*Ted Mullins*)

Wortley Top Forge yard near Sheffield, showing both steam-powered vehicles and a diesel-powered roller in the foreground, *c.* 1980. (*Ken Wain*)

YORKSHIRE ENGINE COMPANY LIMITED

A Subsidiary Company of the United Steel Companies Limited

MEADOW HALL WORKS · SHEFFIELD

Builders of Steam & Diesel-Electric Locomotives

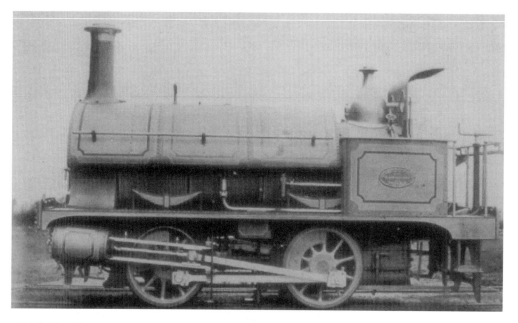

(*Sheffield Archives*)

In 1900, the national coal output had risen to 240 million tons, of which 50 million were exported. The coal mines were not only supplying steam coal for the nation's railways, but also for the workhorses that were used throughout the country for everything from ploughing to sawing wood in the agricultural industry, and road rollers and road locomotives with cranes for lifting materials used in the laying of the country's roads. General road locomotives were used for the transportation of goods. Showmen used engines to pull around the equipment and provide power for the operation of the rides and general lighting from the engine-mounted dynamos.

After the invention of the steam locomotive, and the opening of the Stockton–Darlington railway line, the railways expanded rapidly. They were operated by several companies and were used nationwide to carry all manner of goods and passenger services. They were eventually nationalised and run by British Railways, and they consumed many millions of tons of coal.

The insurance companies soon realised the importance of steam, and developed horse-drawn steam pumps to attend fires at their customers' premises. If you had no insurance, there were no firefighters to deal with it! After a number of years and needless loss of life and property, local council brigades were set up.

Sheffield's only steam locomotive manufacturer, Yorkshire Engine Co. Ltd, was established in 1865 and based at Meadowhall. Its first engine was made in 1866, and the company produced 789 steam railway engines over the next 100 years with a very healthy export business.

The company's first order with the coal mining industry was for three 0-4-0ST standard gauge engines for the 6th Earl Fitzwilliam in 1869.

The engines were each given a name:

Works number YE118, *Victoria*.
YE119, *Milton*.
YE120, *Wentworth*.

Orders were soon coming in at a steady trickle from all over the South Yorkshire coalfield:

Kiveton Park Colliery 1.
Wingerworth Iron 2.
Darfield Main Colliery 1.
Featherstone Main 1.
Hoyland Silkstone 1.
Waleswood Colliery 1.

All these engines were colliery shunting engines built to the same specification.

Coal consumption went up, as the company went on to supply not only many of Sheffield's iron and steel producers and general manufacturing companies, but also the nation's railways. Coal was on the move.

CHESTERFIELD AREA COLLIERIES

Apperknowle and Unstone Collieries

Apperknowle Colliery was opened in 1840 by G. Wright and operated until just after the turn of the century.

During the colliery's life cycle, it had four different owners and up until this time it was doing very well; however, it was now faced with falling trade, and coupled with inhibitive costs the pit was forced to close in 1869.

By 1870 it was reported that 296,000 men and boys were employed in the industry and were producing 110 million tons, a fantastic achievement considering the technology that was available at the time.

The pit lay dormant for five years, and was then reopened by Gill & Co. and operated from 1864 to 1876 until it was taken over by Havenhand & Allen, who ran it for a further year.

They had little success with the colliery, and after a somewhat hit-and-miss lifespan, it was finally taken over by the Unstone Coal & Coke Co., who had rather more success with it but were eventually forced to close it in the early 1900s, after unsustainable losses.

In the same area could be found many of the smaller pits, little drift mines occupying just one or two fields, e.g. Sharpe & Jason's Highfield Colliery, Sharpe's Sicklebrook Pit, and Swift & Mellor's Snowden Lane Pit. These were all working in the second half of the nineteenth century.

H. Rangeley & Co.'s Unstone Colliery was opened in 1854; there was one properly constructed adit into the mine, which was completed in 1869 and set into a hillside on the south side of the village.

A row of six double brick-lined coke ovens was sited within no more than 30 yards of the entrance to the pit; these were also set into the hillside and each one had a chimney that vented through the oven roof into the woodland above. The coke ovens between them produced 6 tons of coke every three days. Each oven held 3 tons of coal and took three days to burn, making 1 ton of coke!

Coal production was cut back to 200 tons per day, because the hauliers were charging 5s a ton to take the coke to Sheffield by horse and cart.

A railway branch line was constructed in 1869 to serve the colliery and take the coke to the steelworks in Sheffield; this was much quicker and cheaper. Coal for domestic use was delivered by horse and cart.

Because of the surface water running down the hillside, the colliery was always working in wet conditions, and to this day the mine workings are still being continually pumped out. The water runs through a submerged culvert, and is discharged into the River Drone. The water is ochre in colour due to iron deposits in the pit.

The Unstone Coal Company ran the 'Barrow Rat' pit, and by the turn of the century had the Unstone Little Pit, which operated until the beginning of the Second World War in 1939. Even the smallest of these collieries had their own coke ovens and supplied the table blade manufacturers of Sheffield and the local scythe makers of Troway and Ridgeway. James Rhodes' Coal Aston Colliery was working the Silkstone seam from 1867 until its closure on 5 December 1874, and the second and larger pit, the Summerley Colliery, was also working the Silkstone seam. This only lasted thirteen years, from 1871 to 1884, a premature end for a colliery that boasted expensive equipment, including a large single-cylinder steam beam engine. It was said that the Dronfield Silkstone Pit was also working at this time and that by 1879, ⅔ of the population were working at the pit. The Dronfield Monkwood Colliery was sunk by J. C. Plevins in 1862; the company advertised in the *Derbyshire Times* on Saturday 22 October 1864 to local colliers:

Good Stallmen can have constant employment at Monkwood Colliery, near Barlow, and can have houses at the Colliery if they wish.
Apply to the Steward at the Colliery.

(Ken Wain)

Coke oven entrances. (*Ken Wain*)

Open coke oven, showing a pile of ashes, and the burning of the inner lining of bricks. They have remained in this condition since they were abandoned in 1895! (*Ken Wain*)

The chimney exhaust outlet in the centre of the oven roof is clearly visible. (*Ken Wain*)

Entrance filled in, showing the coping stone dated 1869. (*Ken Wain*)

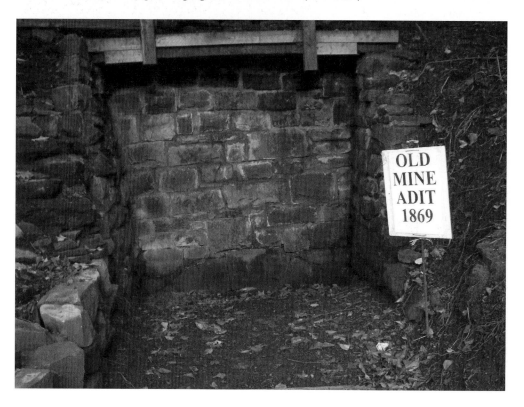

The remains of Monkwood Colliery spoil heap, near Barlow, 2012. (*Peter Storey*)

Right and below: In recognition of the men who worked in the coal mining industry and in the manufacture of steel in and around the Dronfield, Coal Aston, Apperknowle and Unstone districts, the Friends of Dronfield Station have installed a pit tub, sitting on steel rails, at the top of the Station Approach as a memorial. (*Ken Wain*)

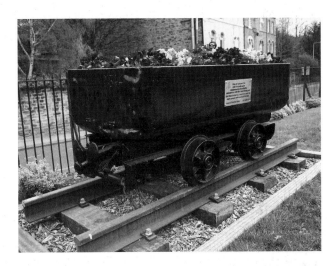

They operated the colliery until 1865. It became the Monkwood Colliery Company in 1866. After being taken over by a relative, C. H. Plevins, in 1880, it was run successfully until its closure in February 1898.

Cottam No. 2 (Pebley Pit), known locally as Peggers Pit, just 1 mile to the east of Barlborough, operated for thirty-two years from 1896 to 1928, its remaining reserves being taken by Renishaw Park Colliery.

Remarkably, a row of miners' cottages are still in use today in the lane leading up to the pit. Remains of the spoil heap are clearly visible, and the old lamp cabin has been converted into a luxury home.

Cottam No. 1 pit was sunk in 1799 and worked until 1886.

Kelly's Directory of 1835 lists mines of coal, lead, and iron working in the vicinity of Chesterfield.

Coal masters at the time are given as being:

Richard Gillett, Brampton Moor.
Sir Henry J. J. Hunloke, Wingerworth.
John Pearce Limb, Tapton.
Benjamin Smith & Co., Adelphi Wharf.

Other pits listed in the area are:

Rusk Pit	Blair Brothers.
Hazel Pit	1909–1914.
Westfield Sough	1830–1878.
Glebe	1835–1868.
Park Hall Drift	1895–1908.
Hazlewell.	
Knitaker Hill.	
Barlborough Common	1811–
Hollingwood	1865–1894.
George Tomlinson, Newbold.	

The local coal dealer was Robert Wearmouth of Soresby Street, Chesterfield.

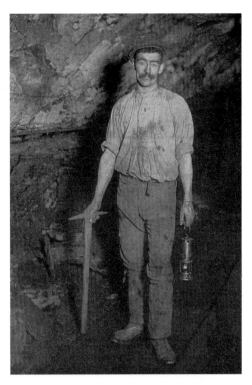

Old postcard.

Early twentieth-century hand-painted pub sign at Unstone near Chesterfield. (*Ken Wain*)

Barlborough Colliery

Barlborough No. 1 Colliery was sunk in 1873 by the Staveley Coal & Iron Company.

In October 1893, the colliery owners elected to lower the miners' wages. The Clowne Southgate and Barlborough miners held a meeting at the Anchor Inn at Clowne, where a Mr C. Johnson proposed that the miners should not accept any reduction in their wages and urged them to abide by the decision of the mineworkers' federation. Mr S. Woodhead said that they were prepared to wait until the New Year before giving in to the owners' demands. The owners relented.

The No. 2 pit was sunk some twenty-three years later, in 1896, on Broughton Lane at nearby Clowne.

The company's agent, Mr D. N. Turner, announced the closure of the No. 1 pit on 3 September 1921, due to heavy losses, putting 850 men out of work, after the pit had worked for forty-eight years.

The No. 2 pit remained in operation for twenty-three years, and closed in 1928, just a year before Clowne Southgate Colliery, the combined effect causing a terrific blow to the local employment scene.

North East Derbyshire Collieries of the Nineteenth Century

Alfreton Colliery	1886–1968.
Blackwell (A) Winning Pit	1872–1969.
Cotes Park	1850–1963.
Clay Cross No. 2 Pit	Known to be in existence in 1850.
Grassmoor Colliery	1875–1950 (later to be used as a training gallery for underground workers).
Hartington Colliery, Staveley	1879–1930 (later used as a pumping pit for Ireland Colliery, Staveley).
Hardwick Colliery, Holmewood	1870–1968.
Ireland Colliery	1874–1900s.
Markham Colliery, Nos 1, 2 & 4	1882–1994.
Morton Colliery, Nos 5 & 6	1863–1965.
Pleasley Colliery	1883–1983.

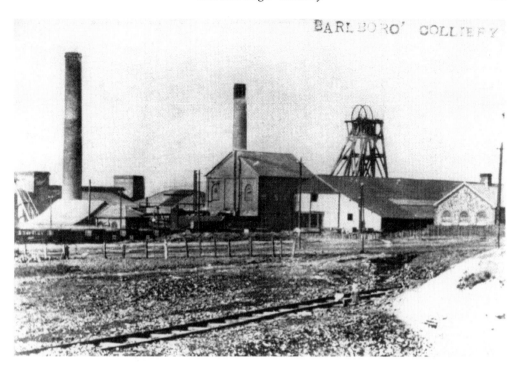

Old picture postcards of Barlborough Colliery, c. 1920.

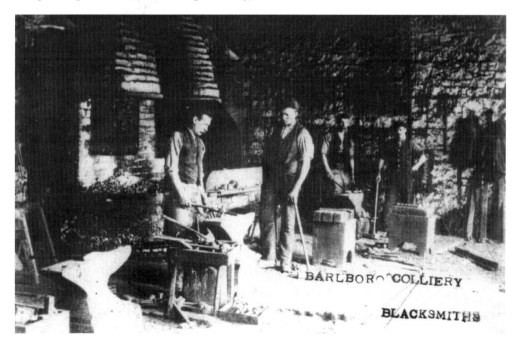

Manners Colliery, Ilkeston 1877–1949.
Shirebrook Colliery 1896–1993.
Glapwell Colliery 1882–1974.
Tibshelf Colliery Nos 3 & 4 1870–1939.
Parkhouse Colliery 1866–1962.
Ramcroft Colliery 1916–1929; 1939–1966.
Langwith Colliery 1878–1979.
Avenue Collieries, Nos 9 & 11 pits Opened 1881 and 1857, respectively.

Accidents during the latter part of the nineteenth century and the first half of the twentieth century:

Date	Event
10 June 1861	Clay Cross Colliery. Flooding killed twenty-one men.
24 March 1898	St Johns Colliery, Staveley. Underground fire.
20 October 1904	Boythorpe Lane Colliery. Underground explosion.
6 April 1919	Oxcroft Colliery. Underground explosion killed six men and injured seven.
10 January 1928	Wallsend Colliery, Newbould. Underground explosion.
19 November 1933	Grassmoor Colliery. Underground explosion killed fourteen men with fourteen injured.
21 January 1937	Markham Colliery. Underground explosion killed nine men and injured two.
15 February 1937	Winterbank Colliery, South Normanton. Underground explosion killed eight men and injured three.
10 May 1938	Markham Black Shale Colliery. A horrific underground explosion killed seventy-nine men and injured forty-nine others.
1940	Morton Colliery. Roof fall entombed two men for forty-one hours. They were found to be dead when reached by rescuers.
18 June 1946	Markham No. 4 Colliery. Five men were killed when a haulage rope snapped!
1949	Glapwell Colliery. Accident underground resulted in the death of one man, with twenty-seven injured, some seriously.
10 April 1951	Denby Hall Colliery. A serious roof fall killed five men.

(NUM)

Clowne Southgate Colliery

Southgate Colliery Company was formed in 1875, and the shaft was sunk in 1877, the first sod being cut by Miss Bowden of Southgate House.

The twin steam winding engines produced by James Farrer of Barnsley were installed in 1887.

The company also owned collieries at Shireoaks, Steetley, Harry Crofts near Anston, and Whitwell.

The pit was soon producing good-quality manufacturing, household and hard steam coals at a rate of 600 tons every day by a workforce of 400 men.

The first man to be killed at the pit was Rufus Mew, in unknown circumstances in 1878.

The pit chimney was built beside the boiler house in 1890 to take away the flue gases and exhaust from the steam winding engines.

A cage accident in 1911 took the lives of three men, named as Bunday, Wild and Marlow; a further nine men were seriously injured in the accident.

The colliery went on to have a very productive life, until 18 March 1920, when a fire destroyed the No. 1 engine house; this caused serious disruption, as men were laid off and production suffered greatly.

The pit was soon to resume normal working and went on working for another six years until the miners' strike of 1926.

Shortly after the strike, it soon became evident that lack of maintenance, combined with geological movement and water seepage, during the strike was to become a major problem, and challenged the continued life expectancy of the colliery.

The pit was eventually closed on 17 January 1929 as a result of flooding from the nearby workings of the old Oxcroft mine.

An inspection of the mine revealed that two pit ponies had perished in the flooding, but no further loss of life was recorded.

It was reopened for a short time in 1955 to connect to the Creswell High Hazels seam, but the exercise was never completed, and the shafts were filled in and capped by the NCB in 1961.

Even though technology had improved to allow for more efficient means of pumping and mines drainage, many of the smaller local collieries were to close due to similar circumstances, with uncontrollable ingress of water.

Fire and water are everyone's good servants but, as this very well illustrates, they are bad masters, and can destroy the employment and economic stability of whole communities within the mining industry.

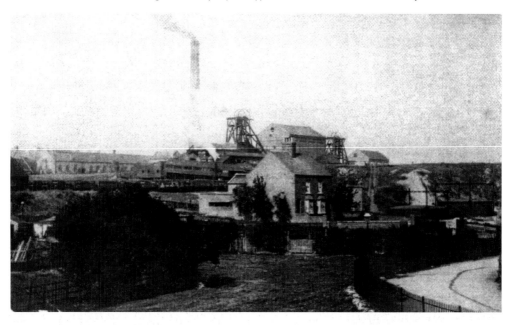

Southgate Colliery, c. 1900. (*Dave Mathews*)

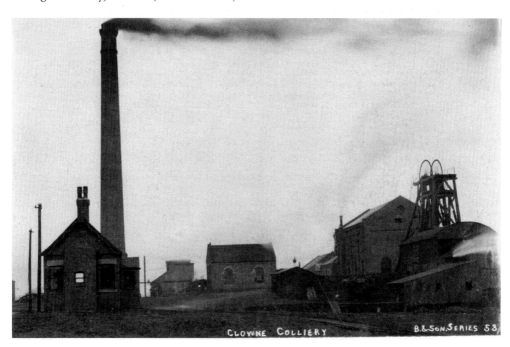

Early photograph of Clowne Southgate Colliery, c. 1890. (*Dave Mathews*)

Shunting engine *Alexandra* at Clowne Southgate Colliery, c. 1920. (*Dave Mathews*)

Southgate Colliery lamp room staff with four young boys before going on shift, c. 1900. (*Dave Mathews*)

CHESTERFIELD AREA COLLIERIES (NORTH EAST DERBYSHIRE)

Arkwright Colliery

The Staveley Colliery Company set up the Arkwright Colliery Company, which was trading under the name of S. E. Short & Co., S. E. Short being the company chairman of the Eckington-based J. & G. Wells coal company. The co-founders were Rex Ringham, John Hunter, and Harold Kirk.

The two 500-yard Arkwright drifts were driven in 1938 to take coal reserves which had become difficult to extract for the nearby Markham Collieries.

After only two years, the drifts were extended down to the Calow Main Colliery workings, and during 1943/44 the colliery had started working the Sitwell Seam, to be followed shortly afterwards by the First Waterloo Seam.

It was decided in 1940 to sink a shaft 21 feet in diameter at a depth of 220 yards into the Deep Soft Seam, which would be called the Arkwright No. 2 Colliery, and seek to provide ventilation for the Ireland Colliery workings.

The cutting of the first sod by Staveley Coal Company Chairman Mr D. N. Turner was done on 17 August 1945.

This would be the turning point for the colliery in terms of being able to extend its operations into the Top Hards Seam, and arrangements would be put in place for the use of the most up-to-date methods of mining; the shaft diameter would allow for the largest mine cars available, to cope with the envisaged extra production. The engine house was built, and the electrically operated winding engine was installed, but after seven years of shaft sinking, which was carried out by a local building company instead of specialist shaft sinkers, they had only progressed to 90 feet deep.

The NCB decided in its wisdom to fill in the shaft, demolish the buildings and transfer all the winding equipment to a Leicestershire colliery! By this time the colliery was already turning coal from the Top Hard Seam, which ironically was worked out by 1953.

In 1954, the Mineworkers Pension Scheme erected pit head baths.

Extra manpower was required to work the First Waterloo Seam, and men were transferred from Bonds Main Colliery at Staveley, which had closed earlier in the year, increasing the production to 625,000 tons by 1968.

£25,000 was spent in 1972 on driving a third drift for the purpose of working four more coal faces in the Waterloo, Second 11S and Low Main seams. Two ventilation fans were situated at the top of the new drift to circulate the mine workings, as the original

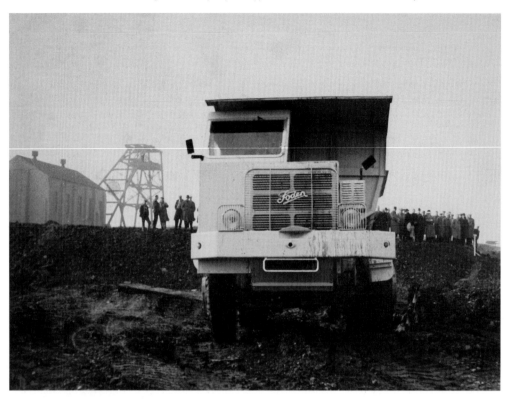

In December 1953, the NCB agreed to test heavy-duty dumpers at Arkwright, seen here watched by the manufacturing company and NCB officials. (*Peter Storey*)

Calow Main drifts were now in a state of bad repair and had to be abandoned.

By 1975, the production had reached a sizeable 750,000 tons, and progressing, but the miners' strike of 1984/5 scuppered any hope of linking the colliery underground to Markham.

After a very successful working life, the colliery was closed in 1988, three years ahead of the original plans.

Arkwright Town was found to be suffering the effects of continual methane gas seepage to such an extent that it led to a decision by the NCB and Derbyshire County Council to demolish the whole village, which belonged to the NCB. All the houses, shops and amenities were relocated across the road.

High Moor Colliery

High Moor was the last colliery in the Sheffield area to be opened by the NCB. It was a drift mine in the High Moor district of Killamarsh, and part of the NCB's North Eastern Division Bolsover No. 1 Area.

The colliery was less than ¼ mile from the old Comberwood Colliery, and ¼ mile from the Newman Spinney gasification plant. The No. 1 drift was opened out in 1953 at around the same time as the coronation of Her Majesty Queen Elizabeth II, and served by a single-rope, electrically operated Pickrose haulage system, which was sited at the top of the drift and used for the transportation of materials and coal, first produced in 1957.

The driving of the drift progressed very quickly, and an electrical substation was soon installed to supply electricity to the first districts of the mine, which were equipped with the very latest in mining technology available at the time. A trunk conveyor system was soon to be installed in the drift for the transportation of coal up the drift and into a large bunker, which was on stilts to allow a gravity feed for the coal to be deposited into lorries waiting underneath to take it away. Even though the pit was troubled with water problems from the very beginning, it was soon producing copious amounts of good-quality coal. It did so well in its first five years of working that it was dubbed a virtual gold mine by the chairman of the board, Mr J. Bowman. The pit was to become a great provider for the local community. However, the local inhabitants were soon complaining about the noise and the filth that was being deposited on the roads, due to the hundreds of lorries that were employed to remove the coal from the colliery site. The pit was never served by the railways.

The pit carried on for several years without any real drama, until 1985 when Arnold Crowder died of a broken neck when he was hit by a lump of rock falling from the roof.

In January 1989, a disaster was narrowly avoided when ten men were trapped underground by a roof fall. The colliery manager, Mr Hardy, immediately went underground with a team of rescuers, who worked with their bare hands and eventually broke through the rubble and brought out the men uninjured. Two further drifts were driven as part of the colliery's expansion; large roadways were built underground to facilitate the use of diesel-engined EIMCO coal loading vehicles. Further working of reserves towards Harthill and Kiveton Park was soon to lead to the underground linking of High Moor and Kiveton Park collieries in December 1989, when it became

more economical to take out all the production from both collieries up the Kiveton Park surface drift.

Kiveton Park Colliery closed in 1994, followed by Highmoor in 2002.

Highmoor Colliery, 1994. (*Ken Wain*)

Underground Workers – Work Underground

In 1939, when the Russians and Germans invaded Poland in a pincer movement, it was a forgone conclusion that the Poles would be mown down and defeated very quickly. The Russian and German armies were highly mobile and technical, and numbered nearly 2 million men; Poland's army was ill-equipped and mainly equestrian. This turned into a massacre of great proportions, and hundreds of thousands of prisoners were taken and interned or shot without mercy. All the Polish officers who were captured were shot. General Wladislaw Eugeniusz Sikorski was the commander in chief of the Polish armed forces; he fled to France, became the prime minister of Poland in exile and set up the Polish resistance movement.

Henryk Sikorski, a relative of the general, had studied hard for a good education, and learnt to speak seven languages fluently. Along with a friend, he enlisted in the movement and they were issued with German uniforms under assumed names, with papers to match. They had to infiltrate the German lines and sabotage the railways and strategic military installations.

After lots of successful missions, in which they destroyed many ammunition trains and equipment that would have been essential for the German war effort, they were eventually captured and interned in the infamous Stalag Luft III prison camp, which was at Sagan in Poland, scene of 'The Great Escape', which was used for captured Air Force personnel.

By coincidence, the mother of the German officer who interrogated them was in fact Polish. The American army was advancing towards Stalag Luft III, and the German officer, in an extraordinary fit of leniency, in exchange for their Polish eagle badges, arranged for them to escape.

He told them that the Americans were very near, that they were moving out and that prisoners would be shot. After the escape, Henryk and his friend met up with the Americans, who gave them uniforms and food; they joined the American Air Force and stayed with them until the war was over, when they were offered American citizenship. Instead, they came to England with other Polish nationals that they had met, and helped get the country back on its feet, working in factories and the coal mines.

Henryk and his friend had a little money, and spent it exploring the country before they found work in a factory in Lincoln. A friend told them that there was work at Shireoaks Colliery near Worksop, where they would earn more money. They joined them and stayed for a while.

A group of them decided to work at Renishaw Park Colliery. Some of them, along with Henryk, moved to Westhorpe Colliery. Henryk soon integrated very well, with his personality and language skills, and went on to be a supervisor, training new recruits into the industry. After a short spell, Henryk moved on to Highmoor in the 1950s until his retirement.

No one ever knew his true story until his daughter Maria recently told me, and gave me permission to publish the facts about what happened seventy years ago in March 1944.

Henryk. (*Maria Sikorski*)

Henryk Sikorski, second from right on the back row, with his friends at Shireoaks Colliery. (*Maria Sikorski*)

At Highmoor Colliery, 1950s. (*Maria Sikorski*)

Above: General Wladislaw E. Sikorski. (*Maria Sikorski*)

Right: The Sikorski coat of arms. (*Maria Sikorski*)

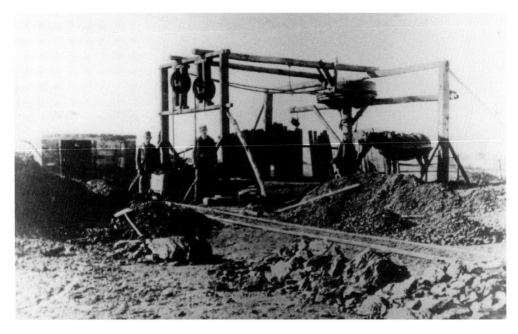

Two photographs of the old Highmoor Colliery at Killamarsh, which operated between 1831 and 1909. The top photo shows the bowler-hatted owner, Mr Greensmith, standing at the top of the shaft, from which coal was raised in a large bucket by means of a horse-operated Jenny Wheel. The bottom photograph shows the remains of the pit chimney in a later period. (*Vin Hopkinson*)

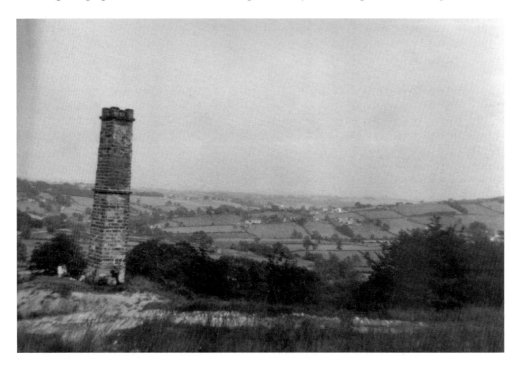

Westhorpe Colliery

The J. & G. Wells mining company of Southgate, Eckington, who already owned the Norwood Colliery and Holbrook Colliery at Halfway, purchased land in 1922 to sink a pit below Westhorpe Green, between Killamarsh and Spinkhill.

The first sod was cut on St Patrick's Day, 17 March 1923, by Mrs Fanny Greensmith, wife of the colliery company's general manager, and the sinking was completed in 1924 to a depth of 149 yards.

Coal from the Parkgate, Thorncliffe, Deep Soft and Chavery seams were wound via two single-deck cages of two-tub capacity, powered by a hefty George Robey steam winding engine, which was manufactured in Lincoln and boasted two double acting cylinders, with a steam pressure of 145 psi. The winding drum was semi-conical and controlled by twin vertical post type spring-loaded hydraulic brakes. It was installed at the colliery by the company at a cost of £3,000, plus £70 for the hire of a skilled supervisor to oversee the operation.

The colliery did very well during its first two years, but then fell foul of the 1926 strike, when great damage was inflicted on all the local collieries, due to neglect and lack of maintenance during the strike. Afterward, the pit soon bounced back into production, providing the local community with much needed worthwhile employment.

The year 1928 saw further exploration into the Deep Soft Seam, which worked successfully for twenty-three years.

In 1940, a delegation of Chinese mining engineers visited the colliery to see the Longwall method of mining.

Westhorpe was taken over by the Tinsley Park Colliery Company in 1941, but after only three years it changed hands again and came under the control of the United Steel Companies. The J. & G. Wells Company were then to become part of the Rothervale Collieries group.

The old Norwood Colliery was closed in 1943, and many of the staff members were deployed to Westhorpe. In August of the same year men were also set on from Holbrook Colliery, which had started to wind down its operations. The remainder of the Holbrook men were sent to Westhorpe in January 1944, when the pit finally ceased to wind coal.

In 1947, when the pits were nationalised, the government invested millions into the coal industry, and the National Coal Board was born.

Output from the pit at this time was 351,334 tons, with a manpower contingency of 1,027.

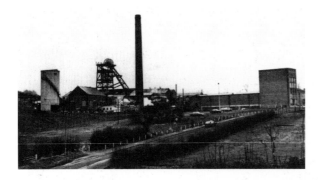

(Malcolm Jones)

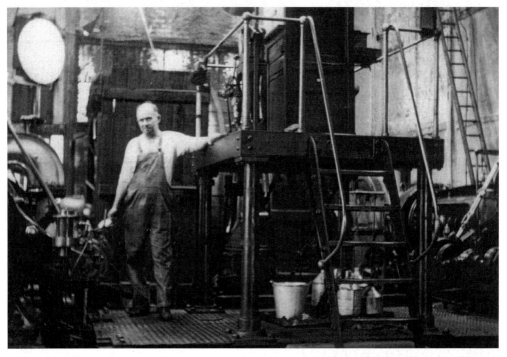

Above and next page: Westhorpe Colliery engine driver Mr Robert Emmett Chawner, c. 1930. (*Vin Hopkinson*)

The miners' lot was dramatically improved by the introduction of better methods of safety and healthcare.

Mr George Walker was installed as the manager at this time, and became the second-longest-serving manager at the colliery, behind Mr H. Kendall (the colliery had eleven managers during its lifetime).

He and his undermanager, Mr George Bradshaw, became a formidable team to be reckoned with, and achieved a lot for the pit (saleable output of 563,617 tons, with a workforce of 1,299 men in 1958, two years before his retirement in 1960).

Two drifts were driven at a gradient of 1:4 from the Deep Soft Seam into the Thorncliffe Seam in 1949, and passed through the Parkgate Seam, which started production shortly afterwards, in 1951.

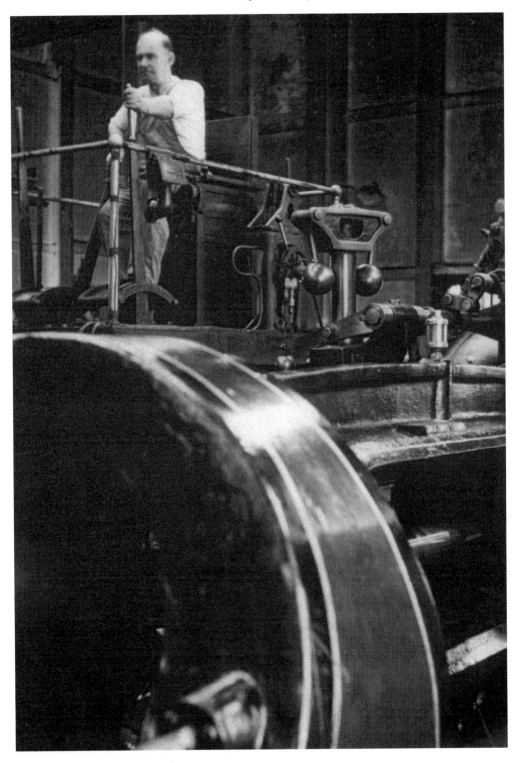

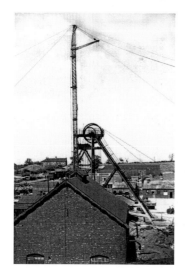
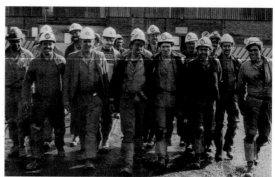

Above left: Installation of the new steel-framed headgear, 1949. (NCB)

Above right: V53's record-breaking team. (NCB)

Below: (NCB)

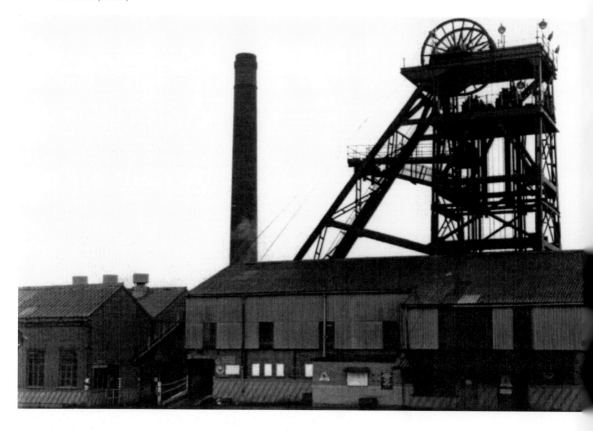

By 1949 the manpower was 1,053, and new pit head baths and a fully equipped medical centre were built at the time of erecting the new steel headgear.

A new man riding system was installed in the Deepsoft Seam at this time.

After only two years, in 1953, production finished in the Parkgate Seam.

Meco Moore coal cutters were introduced in the early 1950s.

Westhorpe and Holbrook collieries were linked underground, providing a secondary escape route for either colliery in the event of an emergency.

Ventilation of Westhorpe was provided by the Holbrook shaft until 1955, when the Westhorpe 1:3 surface drift was completed, and a massive ventilation fan was installed at the top of the drift. A submersible pump installed at the bottom of the Holbrook shaft kept Westhorpe clear of water up to the time when Westhorpe had its own pumps installed. The first armoured face conveyor was installed in 1957, closely followed by Shearer power loaders, Trepanner coal cutters and hydraulic-powered roof supports throughout the pit. A 300-tonne coal bunker and loading point were built in the pit bottom in 1959, making the pit fully mechanised.

The drift down into the Chavery Seam was started in 1968, and coal was produced for the first time in 1971 to coincide with the closing of the Deep Soft Seam, followed by the phasing out of the Thorncliffe Seam in 1972. The 1.15-m Chavery was the last coal-producing seam at Westhorpe Colliery.

Explosion

There was an unusually dramatic incident at the colliery on a bleak wintery March night in 1964 — an occurrence which resulted in the death of one of the London Underworld's top "jelly" experts.

The London-based criminal, known as "The Expert" because of his special knowledge of gelignite, was trying to blast his way into the Westthorpe explosives store; his nefarious activities being covered at the time by a driving blizzard. Unfortunately for him his plan went wrong and all the explosives in the store, about 700 kilos, were blown up.

The brick and concrete store was totally demolished and the would-be thief killed by the blast.

Fortunately no-one else was injured although debris was flung more than 450 metres away, crashing through the roofs and windows of nearby houses. In some cases the damage was so severe that the occupants had to be temporarily evacuated.

Above left: George Robey steam-winding engine, manufactured in Lincoln in 1923. (*Ken Holland*)

Above right: Excerpt from a British Coal publication, with regard to Westhorpe Colliery, 1984.

Right: Driving the new surface drift in 1953. (*NCB*)

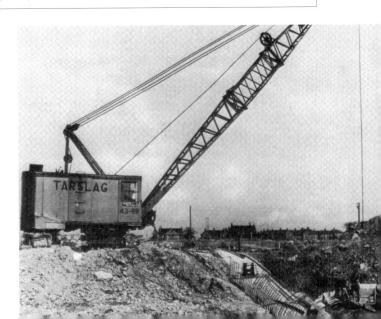

Westhorpe pit bank, 1950s. (*NCB*)

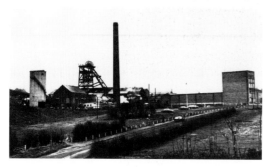

View from Spinkhill end. (*Malcolm Jones*)

Day shift going home. (*Malcolm Jones*)

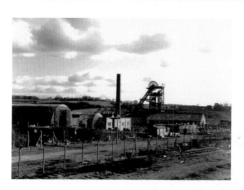

Above left: View from stock yard. (*Malcolm Jones*)

Above right: Keith Horner, electrician; Gordon Clayton, fitter; Ken Wain, electrician; and Keith Staples, welder, *c.* 1958. (*Ken Wain*)

Westhorpe Pit Yard During Demolition, 1985

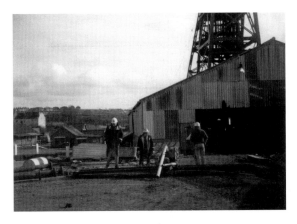

Pit bank from screens. (*Ken Holland*)

Pit yard from the top of the headgear. (*Ken Holland*)

Office block from pit bank. (*Ken Holland*)

Holbrook was demolished in the late 1950s, and a civil defence exercise was carried out on the colliery surface, using volunteers and local members of the St John's Ambulance Brigade to take part as casualties and rescuers among the rubble of the newly demolished buildings. Local GP Dr Charles Lipp officiated.

The colliery always had a good production record, good money was earned, and in the 1950s the pit was known locally as the 'money pit' or 'the pit with the golden wheels', with colliers earning just over £10 per week!

Westhorpe turned out a record tonnage of 603,828 tons in 1970/71, with 743 men under the management of Mr H. Heeley. However, in November 1981, what was thought to be the all-time record of output was established when V53's face workers, working in the Chavery Seam on a treacherous 1:4 gradient, produced 10,695 tonnes in one week. In September 1982, a weekly output of 18.54 tonnes per man shift was achieved.

Barely twelve months later, they shattered their own record by producing a massive 11,495 tonnes. This output could not be matched by any other coalface in the industry's national production league, and remained unbeatable for the next year!

The pit's production dropped to 509,465 tonnes in 1974, and the manpower to only 683 men. The manager at this time was Mr J. White. Poor-quality Chavery coal and geological faults led to the announcement of closure during the miners' strike of 1984, ending another six decades of local mining history.

Local groups tried to establish a rail link from the colliery site to the Rother Valley Country Park, but were unsuccessful. It was revealed in February 2013 that the new HST2 high-speed train from London to Leeds is planned to wend its way between Killamarsh and Beighton through the Rother Valley Country Park to Fence, Treeton and Tinsley on its way to the new Sheffield station at Meadowhall, before completing its journey to Leeds. Work is not planned to start for twenty years, so by this time the plans may well have been changed.

Most of the colliery buildings were then demolished, but the engine house and its contents were left intact, until in 1999 the George Robey steam winding engine was removed from the site and taken to the old Barrow Hill engine sheds near Staveley, as a museum piece, and with the hope of eventually getting it back under steam. Since this time it has been found a new home at Pleasley, near Mansfield.

Renishaw Park Colliery

When Renishaw Park Colliery was sunk in 1860 by the J. & G. Wells Company, there were two shafts, each sunk to a depth of 265 yards, approximately 600 yards apart, into the Silkstone seam.

The pit produced good-quality household, steam and coking coal, and employment for the local populace and the village of Renishaw was expanding at a fair pace at this time.

The colliery did well in the first twelve years of its life, having a workforce of 850 men, but fate lent a hand when, in January 1871, the pit suffered a major disaster, an explosion in which twenty-five men lost their lives, along with two boys. It is recorded that a further twelve employees were injured, and that most who perished were gassed, some with severe burns.

Although the men were issued with safety lamps, the explosion was caused by firedamp, because of the flame of a candle igniting the gas, but it was also known that it was the practice of some men to open their safety lamps.

The manager was told by the mines inspector that, to prevent these occurrences from happening again, severe measures must be taken!

Those who lost their lives in this tragic disaster were:

Aaron Arthur
John Alcock
Mark Barber
Ephraim Billam
John Bolsover
? Breeze
Enoch Briggs
John Catley
Francis Clarke
John Cutlet
John Ellis
Thomas Goodwin
George Hall
William Larkin

Thomas Lloyd
George Lowe
Ben Martin
Thomas Pearce
? Portas
Thomas Richardson
John Rhodes
Matthew Savage
John Thorpe
David Wainwright
Robert Watson
George Webster
William Wood

These accidents were all too common during this period, and whole communities suffered as a result. In this instance, nineteen women were widowed, with 151 children under the age of twelve and no income, making them totally destitute. The colliery owner, Mr Wells, made a donation of £200 to the relief fund.

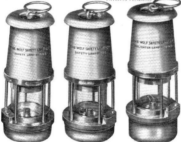

Wolf Flame Safety Lamp advert from a 1940s trade publication.

Renishaw Park Colliery

(J. Russon)

(J. Russon)

The Derbyshire coalfield at that time had 130 pits, which produced 5,360,000 tons, with 16,405 men and boys.

The pit was beginning to settle back into normal production when there was a fall-off in the coal trade; this resulted in a layoff of some 600 men, with the consequent hardships being borne by their wives and families.

Discontent among the local mine workers and the mine owners had always been to the forefront as a result of poor working conditions; requests to lower the wage rates during the periods of low demand were thrust upon them, even though the owners stockpiled thousands of tons of coal from previous production, which they used to cash in on during the periods of higher demand.

In 1893, a strike was called against the owner's demand for a lowering of wages; this spread throughout the other mining areas and lasted for four months.

Great poverty was endured, and the usual deployment of the military to quell the miners' anger and pent-up emotions was put into action in several areas, including Orgreave Colliery near Handsworth.

At J. & G. Wells' Holbrook Colliery near Killamarsh, a situation ensued whereby imported blackleg labourers were trying to load wagons when several hundred miners rioted against them and had them besieged within the engine house, which was being bombarded by all manner of missiles. This continued until the police arrived in from Sheffield and other outlying areas, and were able to disperse them.

Not content, the same men had, within a couple of days, made an attack on the nearby Hornthorpe Colliery near Eckington, where they set free two fully loaded wagons and sent them hurtling down the colliery link line and onto the main line. But for the actions of a local signalman, who realised what was happening and that a London-bound express train was approaching, it would have caused a major rail disaster.

After the exertion of all this energy, the miners were eventually starved back to work, and as usual, suffered the humiliation of accepting the employers' terms. Because of similar situations throughout the local coalfields, the Notts. & Derbys. Miners' Association was formed at a meeting in the George Inn at Eckington in 1885. The South Yorkshire Miners' Federation was founded in 1858. The Derbyshire area of the National Union of Mineworkers erected a commemorative plaque in June 1963 at the George Inn to celebrate the formation of the original association.

Renishaw Park Colliery was closed in 1914 because of serious flooding, but was producing coal again in 1929, due to the unstinting efforts of Mr Reg Horrocks, a mining engineer who was working at Earl John Fitzwilliams' Elsecar Colliery at the time and who accepted the challenge of ridding the colliery of its water problems. His hard work paid off as a result of pumping out nearly 10 tons of water per minute for over five years, his work not being effected by the strike of 1926! (Compare this with the 450 gallons per minute using Newcomen's steam-powered pumping engine of 129 years before.) However, this was to be only a short reprieve, due to a further incursion of water in 1932. Yet again, a flood was miraculously avoided because of the exemplary efforts of Horrocks's men.

The colliery was taken over by the National Coal Board after Nationalisation in 1947 from its owners at that time, Furnace Hill & Renishaw Park Collieries Ltd, the manager being Mr R. J. Detchon, with a workforce of 572 men.

A surface drift was opened in 1951, with a second one in 1977 to speed up the transportation of coal to the surface and into the screening facilities.

In 1981, there were 590 miners employed at Renishaw Park, and the colliery had a yearly output which was in line with the NCBs 'Plan for Coal' of some 450,000 tons.

The 1984/85 miners' strike brought about great hardship within the local community, and most of the children attending Renishaw primary school were on free school meals because of family incomes being so low. The school governors opened up the school canteen to cater for those families who were suffering hardship. Even though the pit kept up with the Board's production requirements, and great effort was extended by all concerned, it lost £21 million between 1983 and 1987, and was closed on 6 April 1989 without any great ceremony.

Tom Baker

Tom Baker of Killamarsh, an old neighbour of mine who spent his working lifetime in the local pits from the age of thirteen, gives us a glimpse into his life story:

Tom left school at the ripe old age of thirteen, and after weeks of searching for employment, was eventually set to work as a pony driver at J. & G. Wells' Renishaw Park Colliery for the princely sum of 1s 7d per ten-hour shift.

When he was seventeen in 1907, he moved on to the Renishaw Station Pit, doing the same job for 3s.

He had only been there for one year when he was badly injured as a result of the paddy train that he was travelling on underground being derailed; he suffered several broken ribs and a badly gashed head, and was trapped by his left leg, which was only hanging on by threads.

It was a major exercise to release him, as the roadways were so small and in very bad condition. Tom was in severe pain, but there were no painkilling injections available at this time. His mates eventually stretchered him out of the pit and took him to Renishaw station, where they put him on a train and took him to Chesterfield.

Still on the stretcher, he was unceremoniously carried through the streets to the Royal Hospital, where his leg was surgically amputated.

He was sent home in October 1908, and lived for five years on the measly sum of 10s a week.

After his father complained, he was eventually given a job in the power house; this again was relatively short-lived, because the pit had to close due to flooding.

War broke out in 1914, and Tom went on to work at Hornthorpe Colliery in the lamp room.

Tom had already had a chequered life at the pits, and it was to carry on. After the end of the 1921 strike, Hornthorpe Colliery was closed, and Tom was on the move yet again. This time he was on his way to Norwood Colliery at Killamarsh, where he stayed until it closed during the Second World War in 1943.

He finally moved to Westhorpe Colliery, working in the lamp room again until he tragically had another accident, slipping and breaking the kneecap on his other leg. This brought about his retirement in 1951.

Tom thought that it was this accident that cost him his other leg, which was amputated in 1973 as a result of it turning gangrenous at the age of eighty-one years.

Tom was a staunch union supporter and a local councillor for many years, and Killamarsh Parish Council honoured his name by dedicating a street name, 'Baker Drive', to him after his death.

This was a man who gave his all for the industry and his family, and his story can no doubt be repeated throughout the whole mining industry.

The Markham Collieries at Duckmanton

In 1882, the Staveley Coal & Iron Co. took a thirty-six-year lease on 5,000 acres at the Sutton Estates from William Arkwright, and sank a shaft into the Blackshale coal seam.

This was to become the Markham No. 1 pit, and by 1885 it was producing large amounts of coal. The Markham No. 2 pit was sunk in 1886 to a depth of about 500 yards into the Deep Soft Seam. Other coal seams worked by the collieries were Top Hards, High Hazels, and Top Waterloo.

Markham Colliery was connected underground to Ireland Colliery, and was the official escape route for either colliery in an emergency situation.

(*Alan Hill*)

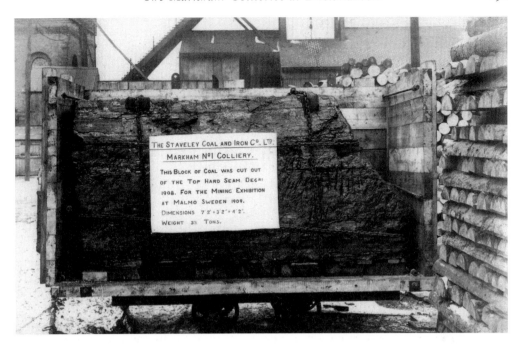

Markham No. 1 Top Hard coal became world-renowned for its steam-raising qualities, and this lump was cut in December 1908 for the mining exhibition in Malmö, Sweden, in 1909. It weighed 3½ tons. Advertising at its best!

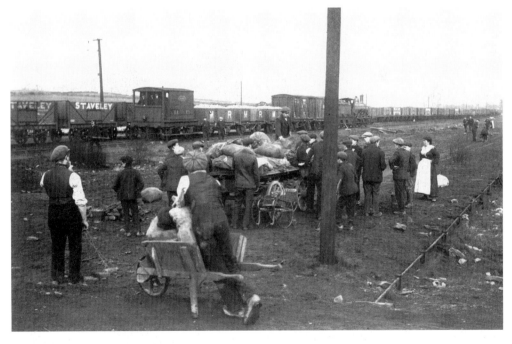

Coal pickers at Markham during the 1912 strike. (*Dave Mathews*)

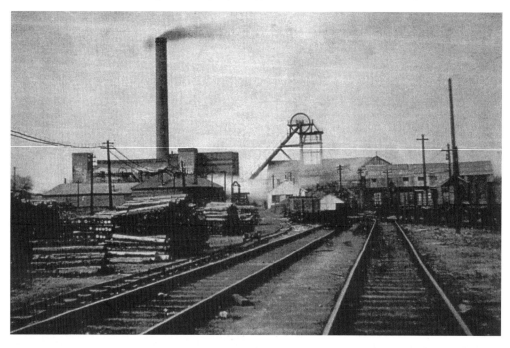

Markham Colliery, 1920s. (*Dave Mathews*)

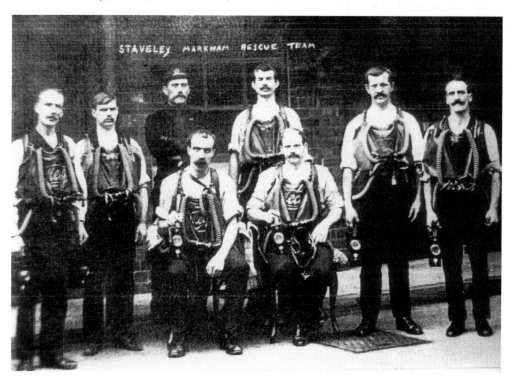

Markham Colliery rescue team, 1920. (*Dave Mathews*)

In 1933, Mr H. Kirk was the Markham Collieries Complex General Manager, taking in Markham No. 1, No. 2, and No. 4 collieries. He had a total manpower contingent of 2,550:

No. 1 pit had 1,000 men underground and 200 on the surface.
No. 2 pit had 900 men underground and 200 on the surface.
No. 4 pit had 200 men underground and 50 on the surface.

Markham Collieries were at the forefront of good working practices, but still had their share of serious accidents, resulting in horrific injury and loss of life.

On 21 January 1937, an underground explosion killed nine men and badly injured two others at the Markham No. 1 Pit. The explosion on the East District No. 2 unit of the Blackshale Seam was caused by an ill-fitting cover on the switch controller of a coal cutter, which allowed sparking to ignite an accumulation of gas. The nine men who died in this accident were listed as:

Edward Bagguley, aged thirty-four. Stallman.
Leonard Cadywould, aged twenty-one. Cutterman.
William Caulwell, aged forty-eight. Stallman
Joseph Furiss, aged twenty-eight. Stallman.
Ralph Marsden, aged forty-one. Stallman.
Charles Moreton, aged twenty-nine. Cutterman.
Frank Roddy, aged twenty-nine. Cutterman.
Wilfred E. Slater, aged thirty. Stallman.
Edmond Smith, aged twenty-nine. Stallman.

By 5 July 1937, the Top Hard seam was worked out, and the Top Waterloo and High Hazels were abandoned.

The following year saw mechanisation well established, and 60 per cent of Markham's coal was now undercut by Anderson Boyes' electric coal cutters. The colliery was doing well, still working the Blackshale seam from the original shaft sinkings.

At the time of the death of the 9th Duke of Devonshire, when the country was troubled by the possibility of war with Germany, and only sixteen months after the 1937 explosion, Markham Colliery suffered a further explosion in the Blackshale seam. It was at 5.30 a.m. on Monday 10 May 1938, just as the night shift was ending.

The night-shift men were on their way to the pit bottom when they heard a loud thud, followed by a blinding cloud of dust which bowled them over like tenpins. The ferocity of the explosion rendered many of them unconscious, as they were thrown against girders, roadway supports and conveyor equipment, etc.

The Blackshale coal was very soft, and while it was being worked it produced literally tons of coal dust, which was loaded into tubs and sent out of the pit. The dust was thick on the roadway floor and, when you walked through it, it would run like quicksilver around your feet. Lots of full tubs of it were waiting in a roadway to be taken to the

pit bottom when a coal dust explosion occurred. Twenty-eight-year-old Duckmanton miner, Richard Pitchford, stayed at home that day, suffering from the effects of gas while working in the Blackshale, and the man who took his place was sadly killed in the explosion.

The official enquiry concluded that it was caused by some of the tubs running down an incline and colliding with an electrical junction box, causing sparking, which in turn brought about an explosion of coal dust as it billowed out of the tubs when they smashed into each other in the roadway. Seventy-nine men and one pony were killed, with severe burns, terrible injuries and carbon monoxide poisoning. Some of these men belonged to the same families, bringing double tragedy to their wives and mothers within the local communities. Professional rescue teams from Chesterfield, Mansfield and Ilkeston were joined by local colliery teams from Markham, Ireland, and as far away as Warsop and Langwith. The men were taken down the pit and confronted with sheer carnage while trying to effect a rescue. Dead and injured men were found among derailed tubs and twisted metal girders, along with the dead pony. Fires and dense smoke hindered the operation, which eventually took about sixty-five hours to complete.

The dependants of the deceased rejected a suggestion that there should be a mass grave, and funerals were held at Duckmanton, Clowne and Barlborough at the same time, on Monday 14 May.

The following is a list of the thirty-five men who were injured in the accident:

Joseph Bagshawe, aged twenty-seven. Belt turner.
Henry Banner, aged forty. Timber drawer.
George Bluff, aged fifty. Timber drawer.
Jesse Boden, aged twenty-nine. Belt turner.
Samuel Bray, aged forty-one. Timber drawer.
John Brown, aged fifty-six. Timber drawer.
Thomas Bullock, aged forty-four. Timber drawer.
Alec Clarke, aged forty-three. Timber drawer.
Henry Clarke, aged twenty-six. Stallman.
Olivery Clarke, aged thirty-nine. Timber drawer.
Thomas Clarke, aged fifty-seven. Timber drawer.
Desmond College, aged twenty-eight. Ropeman.
William Cuttle, aged thirty-six. Timber drawer.
Ronald Davis, aged forty-five. Timber drawer.
Thomas A. Edwards, aged thirty-four. Shot firer.
William Evans, aged sixty-one. Timber drawer.
Thomas Fox, aged sixty-one. Timber drawer.
Thomas Grainger, aged thirty-four. Contractor.
James Greaves, aged forty-three. Timber drawer.
Samuel Hartshorn, aged twenty. Haulage hand.
Arthur Hodgkinson, aged forty-three. Contractor.
Joseph Kirk, aged thirty-five. Road layer.

Donald Linathon, aged thirty-six. Timber drawer.
Joseph Marsden, aged thirty-seven. Contractor.
Kenneth Monks, aged twenty-nine. Belt turner.
Walter Oakden, aged forty-three. Deputy.
Horace Poyser, aged forty-two. Timber drawer.
Charles Quail, aged twenty-four. Stallman.
Robert Belt Roberts, aged twenty-three. Turner.
Frederick Singleton, aged thirty-five. Belt turner.
George Slack, aged forty-nine. Contractor.
Albert Smith, aged fifty-six. Contractor.
James Smith, aged twenty-five. Belt turner.
Thomas Smith, aged forty-nine. Timber drawer.
William Stevenson, aged twenty-seven. Contractor.

News of the explosion tugged on the nation's heartstrings and all kinds of fundraising activities took place to boost the coffers of a relief fund that was set up for the dependants. Famous personalities, including music hall performer George Formby, were doing concerts to raise money. After several months the fund had reached a massive £50,000.

The seventy-nine men who died in the accident are as follows:

Henry Alberry, aged forty-six. Contractor.
James Allen, aged twenty-five. Contractor.
Leonard Atkin, aged fifty-three. Contractor.
David Bann, aged fifty-four. Contractor.
Albert Bell, aged thirty-three. Road layer.
Walter Bluer, aged forty-one. Ripper
Charles Bown, aged twenty-seven. Contractor.
John Henry Bradford, aged forty-six. Ripper
Arnold Bray, aged thirty-four. Ripper.
Samuel Bray, aged twenty. Haulage hand.
Herbert Brough, aged sixty-three. Shot firer.
Arthur Brown, aged eighteen. Pony driver.
John Thomas Brown, aged twenty-six. Timber drawer.
Cyril Buckley, aged forty. Contractor.
Arthur Carter, aged forty. Deputy.
John William Commons, aged forty. Contractor.
George Cowley, aged forty. Contractor.
George Davidson, aged fifty-one. Contractor.
Walter James Frost, aged forty-seven. Contractor.
Alfred Furness, aged thirty-nine. Road man.
Alfred Garland, aged fifty-two. Timber drawer.
Joseph Geary, aged fifty-five. Dataller.
Ambrose Grainger, aged forty-one. Road repairer.

John William Grainger, aged forty-nine. Road repairer.
Robert Henry Grainger, aged twenty-one. Road repairer.
Bernard Gregory, aged thirty-four. Timber drawer.
Robert Gregson, aged thirty-six. Contractor.
John William Hadley, aged thirty-two. Timber drawer.
Joseph Hardy, aged thirty-seven. Contractor.
Herbert Hargreaves Snr, aged forty-eight. Contractor.
Herbert Hargreaves Jnr, aged twenty-seven. Contractor.
Leslie Hargreaves, aged twenty-three. Contractor.
Wilfred Haywood, aged thirty-six. Ripper.
Arthur Henson, aged forty-five. Ripper.
Joseph Hibberd, aged fifty-one. Timber drawer.
Clarence Hill, aged twenty-nine. Belt hand.
Henry Hudson, aged twenty-six. Gate end man.
Lawrence Jacklin, aged twenty-eight. Contractor.
George Henry Jackson, aged forty-three. Contractor.
Enoch Jones, aged thirty-three. Haulage hand.
Thomas Jones, aged forty-nine. Contractor.
Leonard Keller, aged twenty-six. Belt turner.
Samuel Kerry, aged twenty-eight. Haulage hand.
Rowe Kirk, aged sixty. Contractor.
Alfred Lamb, aged twenty-six. Road layer.
Harry Lavender, aged thirty-nine. Ripper.
John William Leivesley, aged forty-six. Deputy.
Joseph Lilley, aged thirty. Road repairer.
Felix Lenathan, aged forty-eight. Contractor.
Stanley Lodge, aged forty. Belt erector.
Arthur May, aged fifty-nine. Contractor.
Frederick Monks, aged sixty. Timber drawer.
John McConnan, aged thirty-two. Rope greaser.
Clarence Cyril Palmer, aged thirty-nine. Contractor.
Colin Gee Pemberton, aged thirty. Belt hand.
George Edward Pether, aged thirty. Ripper.
William Pickering, aged twenty-four. Haulage hand.
Mark Richards, aged thirty-one. Ripper.
Albert Ernest Rodgers, aged nineteen. Haulage hand.
Arthur Roper, aged sixty-one. Contractor.
James Stanley Rowland, aged thirty-four. Contractor.
Samuel Edward Salt, aged forty-one. Deputy.
William Sherwin, aged sixty-four. Engine driver.
Clarence Silcock, aged forty-two. Ripper.
Robert Simms, aged fifty-seven. Contractor.
Frank Smith, aged twenty-six. Belt trimmer.
Frederick Taylor, aged fifty-three. Contractor.

Harry Taylor, aged thirty-two. Belt erector.
Herbert Wale, aged forty. Timber Drawer.
Benjamin Wallace, aged twenty-nine. Road layer.
William Wilkinson Watson, aged fifty-eight. Contractor.
Denton Whelpdale, aged thirty-nine. Contractor.
William Edward Whelpton, aged thirty-two. Rope greaser.
Redvers Baden Whitehead, aged thirty-seven. Shot firer.
George Whitley, aged forty-three. Ripper.
Matthew Williams, aged thirty-six. Contractor.
Robert Henry Woods, aged twenty-two. Haulage hand.
Thomas George Yates, aged thirty-eight. Timber Drawer.

All these men died from carbon monoxide poisoning, and some suffered from serious injuries and burns.

> For never again will the village street.
> Echo to the sound of their tramping feet.
> 'The Toll of the Mines', Mrs A. Gambling.

Walking Home. (NCB)

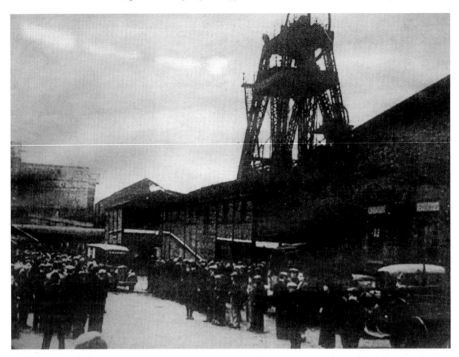

The scene at the Markham Colliery pit head in 1938, when seventy-nine men and one pony were killed in a coal dust explosion on Monday 10 May. Thirty-five men were also injured by the explosion. Relatives and friends are seen waiting for news of their loved ones, and ambulances wait to take the casualties.

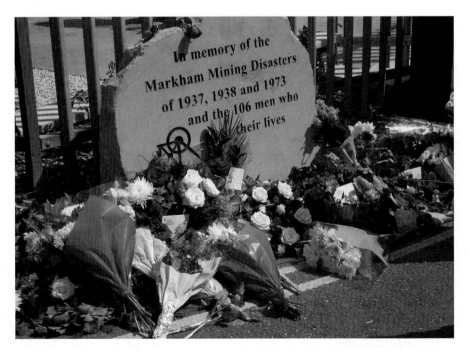

Memorial unveiled on 30 July 2013 in memory of the miners who lost their lives in the three disasters at the Markham Collieries.

In 1937, the writer George Orwell wrote a vivid insight, into the lives of the miners working underground, after he made a visit to a mine and witnessed first-hand the conditions in which they worked. He made the point that he himself, and indeed all those not concerned with coal mining, did not have the faintest idea how these people worked, or the conditions they suffered. People knew that the coal that their coal merchant delivered to them came from the pit, but, because the miners could not be seen, 'out of sight, out of mind' was the norm, until a serious disaster hit the headlines, bringing them into the public eye. During these times, they were shown great compassion, but were not fully understood by the masses.

Although not as eloquent a writer as George Orwell, having worked in the industry myself for thirty-eight years and listened to the stories from my family members, who worked in the pits for many years before that, I will explain as well as I can the miners' working day at this time.

Albert, the 'knocker-up', would get up early in the morning, about 5.00 a.m., get himself ready, pick up his snap tin and bottle of water, and walk down several streets of terraced houses leading to the pit.

He would systematically knock on people's doors and windows, 'knocking them up' – a human alarm clock!

The men would leave home and walk the ½ mile or so down to the pit together, their clogs rattling on the cobbled streets like machine guns, waking up the stragglers.

Duckmanton Central Workshops. (*Ken Wain*)

Once at the pit, they would go to the lamp cabin for their lamps; some were Davy lamps carried by the deputies and shot firers, who also carried cumbersome, heavy, handheld battery-operated electric lamps, which were charged to last a full shift. The miners and general workers just had the electric lamps. In the early 1940s, a new type of lamp was introduced, which was worn on the miners' caps. The lamp batteries, which weighed about 4 lbs, were carried on their belts around their waists. When they picked up their lamps, they also collected two brass tokens with their pit number on.

They would then go to the pit bank ready to get into the cage to be lowered down the shaft and into the pit.

After handing one of the tokens to the banks man, they would get into the steel-framed cage twelve men at a time, packed like sardines in a tin, with the steel mesh curtain lowered in front of them to prevent anyone falling out and toppling down the shaft. The cage was approximately 9 feet long, 6 feet high and 3 feet wide.

After signalling the engine driver to lower down the cage, the banks man would take the tokens to the lamp cabin and put them on to a peg board to indicate that the men had gone into the pit; the men would retain the other one and hand it to the banks man when they returned to the surface; two tokens on each peg on the board indicated that everyone had returned safely from the pit. If any were missing, an immediate search was instigated to find the missing man!

Once the engine driver received the signal to lower the cage, he would take off the brake and start the steam-powered engine, allowing the cage to drop at an alarming rate to lower the men down the shaft. The speed was such that you felt as though you would hit the roof of the cage, and your stomach fairly ached with a sickening feeling. You could see the bricks of the shaft lining flying past, and hear the guide ropes clattering and the air hissing around you. The driver would put on the brakes, and the cage would be retarded so quickly that your knees would bend, and if you were not holding onto the handrail on the side of the cage, you would end up on the floor.

At this stage of the journey it felt as though you were a yo-yo, bouncing for a while until you gently settled into the pit bottom; then the onsetter would lift the curtain for you to leave the cage.

That was only the beginning; you would then start the journey to your place of work, which could be anything up to 3 miles from the pit bottom. Some pits were lucky and had the facility of a man riding train, hauled by a steel rope coupled to an electric winch, which was able to take you part of the way. However, that in itself was very hazardous, because of air pipes, twisted girders and broken wooden roof supports that were hanging down over the roadway, and which could cause serious injuries if you didn't duck down at the right time to avoid colliding with them. Derailments were also commonplace. Others were not so lucky and had to walk all the way; rails for the coal tubs were usually laid the full length of the roadway, supported by wooden sleepers along which the miners would strive to walk, the others closely following behind. If, as was usual, a sleeper was missing and someone inadvertently lost their footing and fell, it caused the others to fall on top of each other. Utter chaos. If full tubs of coal were being hauled along the roadway at the same time, the men had to press themselves closely to the side of the road

and hope that they would not be hit by the tubs passing by. These men were also subject to the same overhead hazards as the men riding the trains, as well as probably walking through several inches of water or thick coal dust before reaching their work.

When they reached the end of the roadway, the men would sit down for no more than a couple of minutes for a drink and to gather their tools to take on to the coalface. They had a small space to crawl through by the side of the conveyor belt that was loading coal into the tubs at the end of the roadway to enable them to access the coalface.

Once they arrived on the coalface, they were met by a band of shiny black coal with a roof of rock above it where it was separated from the coal. They were on their hands and knees, usually in an area that was barely more than 4 feet high, and they remained that way for the rest of the day, apart from fifteen minutes for a 'snap break', or when they had to relieve themselves; on these occasions, they tried to find a secluded area for a little privacy, but bear in mind there were no toilets underground.

The men agreed not to eat oranges or onions on their break, because the smell was taken by the air intake on to the coalface, where, because of the cramped conditions and restricted airflow, the smell would linger, causing discomfort. Normal body functions still had to be carried out in the same conditions.

The shot firers had to drill holes in the coal and fill them with explosives; the miners would then retire to a safe place, and the shots were fired, bringing down the coal and leaving behind clouds of choking coal dust and the reek of dynamite.

The men would then position themselves between the coalface and the rubber face conveyor that was running directly behind them; there was probably one man every 5 yards along the length of the coalface. They were kneeling facing the coal, thrusting their shovels into it and throwing it over their left shoulder on to the moving conveyor. Because they were on their hands and knees, they could only use the strength of their arms to fill the shovels, whereas if they had been standing upright, they would have been able to use the additional strength of their legs and knees to put pressure on the shovel.

Tons of coal were moved every few minutes until it was time for the next round of drilling and shot firing to bring down the next strip of coal for filling on to the conveyor. This was continued throughout the working day.

At this time there were no safety helmets, and they would wear cloth caps, offering very little in the way of protection for their heads.

Hot and humid conditions meant that the men were constantly running in sweat, with coal dust sticking to their bodies almost like glue; they would usually only wear a thin pair of pants and a belt to carry the lamp battery.

When the men finished their stint, they would crawl back along the coalface to the roadway, where they would retrace their steps back to the pit bottom, encountering all the same obstacles that they found on their way – small wonder that they would be exhausted by the time they arrived home. A lot of these men would sit in a chair and fall to sleep while they were waiting for their wives to boil water and fill a tin bath. This was usually beside the fire in the kitchen in full view of the other family members, and

his wife would dutifully wash his back for him. He would dry himself and look as if he had had a few rounds in the boxing ring, with black rings of coal dust around his eyes. His next priority would be to have a meal and then sleep for a couple of hours, after which he would go to the pub for a few pints before seeing his wife and going to bed ready for the next day.

On 8 September 1945, William Edward Unwin, aged forty-nine, was killed when he was run over by tubs. Wilfred Polldening died, aged forty-two, on 15 February 1946, as a result of falling over a rail on the surface. William Clifford, aged fifty-nine, was crushed by a hoist on the surface on 17 October 1949. Insufficient roof supports causing falls of roof were still the cause of many fatalities throughout the British coalfield, with Markham suffering four of these accidents during the period 1945–1951:

3 March 1949, Sidney St John S. Smith, aged forty-six.
11 May 1950, John Stevens, aged sixty-two.
14 February 1951, Fred Thompson, aged sixty-five.
3 March 1951, William Pressley, aged forty-four.

On 18 June 1946, just six months before Nationalisation, another fatal accident occurred when a haulage rope snapped, killing five men at the time of the accident; another died from his injuries two days later. The deceased are named as:

Arthur Barley, aged forty-one.
Alfred Carter, aged forty-seven.
Frederick G. H. Powers, aged thirty-six.
Walter William Gettings, aged thirty.
Ebenezer Whitworth, aged thirty-six.

John William Usher, aged forty-nine, died from his injuries two days later, on 20 June.

In 1949, Markham No. 1, No. 2 and No. 4 pits had 2,741 men working between them under the management of Mr H. Wright, and were producing manufacturing, coking, gas and house coal.

They were now under the direction of the National Coal Board's East Midland Division, and the Top Hard, Deep Soft, Blackshale, and Second Ell coal seams were worked at this time.

A training centre was set up for new recruits and apprentices, which catered for all the collieries in the area, some fifteen in total, the underground training being done at the nearby, recently closed Grassmoor Colliery, and the electrical and mechanical apprenticeships at Duckmanton Central Workshops.

The National Coal Board apprenticeship scheme was very thorough and lasted for five years, and, as well as the training at their own collieries and at Duckmanton Workshops, the apprentices were each given day release to attend their local technical colleges at Clowne or Chesterfield, where they would receive the necessary education for certification as electricians or mechanics at the mine. Some went on to take the National

and Higher National Certificates, which would eventually enable them to become colliery electrical or mechanical engineers. The apprenticeship scheme was the envy of other industries throughout the nation.

After Nationalisation, the Markham Collieries went on to work satisfactorily for the next half-century, turning large amounts of coal at a good profit.

This was soon forgotten when the colliery was again struck by a tragic accident at 6.30 a.m. on the Monday day shift of 30 July 1973. Men were being wound down the No. 3 shaft at the No. 2 colliery, and, as the cages had passed the midpoint in the shaft, Mr R. W. Kennan, the engine winding man, began to apply the brakes, which was normal practice. He said that he saw sparks under the brake cylinder and heard a bang, so he operated both brake levers, but to no avail. He realised immediately that there was no response, and hit the big red button to the right of the driver's seat as he had been trained to do in any emergency situation. This isolated the power supply, and the double-decker cage in which the twenty-nine men were riding plummeted to the bottom of the 392-foot-deep shaft at an estimated speed of 27 mph.

The result of this was sheer carnage, the bottom deck of the double-decker cage being compressed by the speed of the impact, completely crushing the men, although the top deck suffered little damage. The injuries to these men were so horrendous that they just cannot be described; they were completely mutilated. The men on the top deck suffered horrific injuries, too; their limbs were twisted and broken, some made worse by the second impact of several tons of 1-inch-thick steel wire rope, which dropped on top of them from the bottom of the cage that was travelling up the shaft when it was arrested in the headgear and the rope severed.

When rescuers reached the scene via another shaft, they came across complete devastation and found eighteen men dead; eleven others were critically injured, and were administered morphia to help ease their suffering. The rescuers had the unenviable task of extracting these people from the tangled wreckage and bringing them to the surface up the No. 2 shaft, and to speed up the operation some were carried down a steep drift to the No. 4 shaft, which was 700 yards away.

Wives and families had to be told that their loved ones were seriously injured or that they would not be coming home, a difficult task even for the hardest of men.

A public enquiry was held three months later, in October of that year, during which it was agreed that no person was to blame for the tragedy, and the winding engine man, Mr R. W. Kennan, was given a clean slate and told that he did exactly as his training had said. He was affected in such a way that he never returned to work.

Some of the eleven injured never returned to work either, and the few that did were found work on the surface. Several other underground workers followed suit, and would only ever work on the surface, such was the impact of the accident on their lives.

After the investigation was finished, it was agreed that metal fatigue on a brake lever was to blame, and brake levers were tested on an international basis as a result.

Ironically, it was stated that, if the power could have been maintained, there was a remote possibility that the system may have been able to slow down the cage slightly and avoid some of the deaths and injuries.

The eighteen men who died in the accident were:

Joseph Birkin, aged sixty. Face worker.
Clarence Briggs, aged fifty-two. Deputy.
Joseph William Brocklehurst, aged fifty-eight. Deputy.
Clifford Brooks, aged fifty-eight. Deputy.
Henry Chapman, aged forty-eight. Deputy.
Gordon Richard Cooper, aged thirty. Development worker.
George Eyre, aged sixty. Gearhead attendant.
Michael Kilroy, aged fifty-three. Development worker.
Jan Kiminsky, aged fifty-eight. Development worker.
Lucjam Plewinsky, aged fifty-nine. General worker.
Frederick Reddish, aged fifty-three. Development worker.
Wilfred Rodgers, aged fifty-nine. Face worker.
Charles Leonard Sissons, aged forty-three. Road repairer.
Frank Stone, aged fifty-three. Road repairer.
Charles Richard Turner, aged sixty. Deputy.
Albert Tyler, aged sixty-four. Back repairer.
Albert White, aged fifty-seven. Deputy.
William Yates, aged sixty-two. Development worker.

The eleven men who were seriously injured in the accident were:

Dennis Brothwell, aged forty-four. Development worker.
Frank Cowley, aged forty-three. Development worker.
Malcolm Joseph Cowley, aged twenty-nine. Development worker.
James Reddish, aged twenty-five. Development worker.
Graham Richardson, aged thirty-four. Heavy supplies worker.
George Dennis Stone, aged forty-one. Overman.
Harry Taylor, aged forty-seven. Development worker.
Terence Thornley, aged eighteen. Face trainee.
Terence Graham Vaughan, aged thirty-eight. Development worker.
William Henry Watson, aged forty-seven. Face worker.
Richard Wrobels, aged forty-four. Face worker.

Injured during the rescue operation was John Maxwell, aged thirty-five, a reserve face worker.

The aftermath of the Thatcher government's pit closure plan left great swathes of land with colliery spoil heaps and slurry ponds in a dangerous state of dereliction, and looking like Second World War bomb sites.

This, of course, carried on from the Aberfan disaster on 21 October 1966, when the pit tip

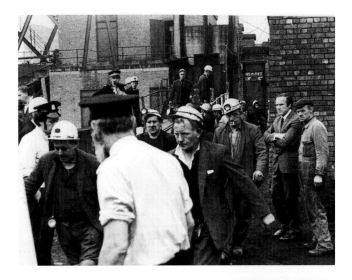

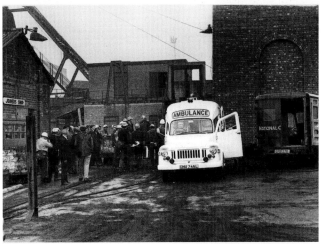

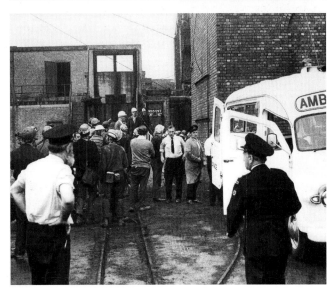

Sombre faces watch the rescuers bring out the casualties to the waiting ambulances. (*Sheffield Newspapers*)

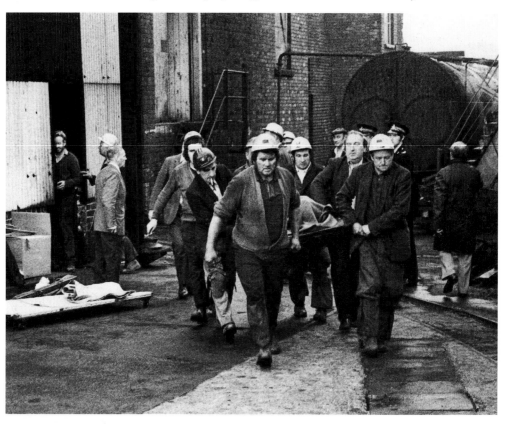

(*Sheffield Newspapers*)

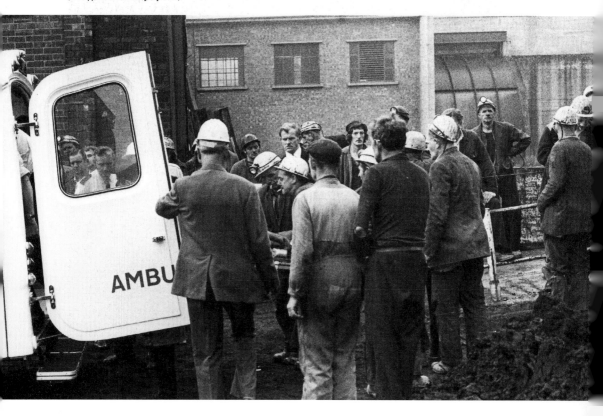

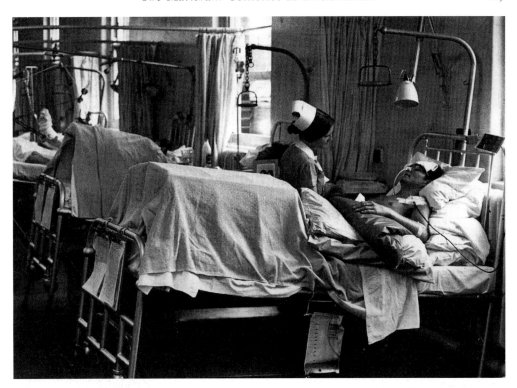

Survivors being treated on the Murphy Ward, Chesterfield Royal Hospital. (*Sheffield Newspapers*)

Funeral of one of the miners, 3 August 1973. (*Sheffield Newspapers*)

for the Merthyr Vale Colliery collapsed after becoming unstable through underground spring water and heavy rain on the surface, and caused 150 m³ of debris and slurry to travel down its slopes, inundating Pantglas school; 40 m³ of slurry killed 116 children and 28 adults.

The resultant Mines and Quarries Tips Act came into force in 1969, to make provision in relation to tips associated with mines and quarries; it prevents disused tips constituting a danger to the public. The NCB were then made responsible for making any disused tips in areas accessible to the public safe. Many local councils started up land reclamation schemes to address these issues, and after the pit closures lots of major site reclamation projects were under way nationwide.

The Ireland Colliery site in North East Derbyshire was part of a scheme by Derbyshire County Council and Chesterfield Borough Council which completely regenerated the whole area, culminating in the development of the Poolsbrook Country Park, which opened in March 1999, a facility that now benefits the local community and attracts visitors from far and wide. The park covers an area of 180 acres, including 85 acres of woodland, 42 acres of grassland and 23 acres of green water, making it the ideal place for innumerable activities, from cycling, walking and sledging to angling, canoeing, wildlife and birdwatching, and horse riding. There is a visitor centre, toilets and children's play area, with ample car parking, and a caravan park.

The regeneration of the old Markham Collieries complex, which is now known as Markham Vale, is being undertaken by Derbyshire County Council in a £77-million project. The head of the Markham Vale project, Mr Peter Storey, explains that the idea behind the project is to develop the site into a multifunctional site that will attract locally and nationally recognised businesses to the area, with the idea of creating 5,000 new jobs for local people, while at the same time making it aesthetically pleasing by the introduction of landscaped areas with woodlands, scrubland, lakes, walkways, bridleways and cycle tracks, done in such a manner as to enhance the local ecosystem and attract wildlife to the area. Great strides have already been taken; new businesses have established themselves and roads have been laid, with a new junction, 29A, on to the M1, making this a logistically sound proposition for businesses who need a high-speed link with their customers. By the same token, it will also be an incentive for visitors. When the project is completed, it will have transformed the original barren and unwelcoming wasteland into a thriving centre for business and commerce, and a parkland with unrivalled views across the lakes and newly landscaped conservation areas, for all to enjoy. A new Environmental Centre, with visitor information and conference rooms, has already been built, and is available for hire. The parkland is set in approximately 500 acres, and within this area the council also intends to keep alive the memory of the site's mining heritage; for this purpose £188,000 has been set aside for the development of a memorial to the miners who were killed in the collieries' disasters.

Internationally acclaimed artist Stephen Broadbent has been commissioned to design a forward-looking work of art, in the form of 100 2-metre-high steel figures, which will represent the miners who were killed. The artwork will be called *Walking Together* and the figures will be placed either singly or in groups of three or four

The Markham Collieries at Duckmanton

Markham Colliery winding wheel at Poolsbrook Country Park, on the old Ireland Colliery site. (*Ken Wain*)

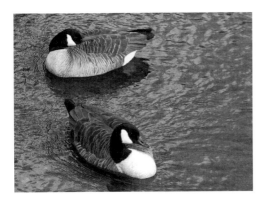

(*Ken Wain*)

along a trail leading from Duckmanton village to the site of the old Markham Collieries, where the new environment centre will be; this is symbolic of the miners walking together to and from the collieries on their way to work. Each of the figures will have several tags from different miners, each one representing individual miners' stories which can be accessed by your mobile phone or other handheld electronic devices, apps, or via the memorial website. Voices from the local mining areas relating to family stories may also be added, which will help to give a sense of community.

A Markham Vale Memorial Working Group was set up on 10 December 2012 to engage with people and groups, including the local schools within the communities connected with the Markham Collieries, to ensure that the memorial is given a life by stories from local people and will be owned by everyone within the community. Work is progressing at a fair pace, and the memorial was installed on 30 July 2013 for the 40th anniversary of the 1973 disaster, which saw eighteen miners killed and eleven seriously injured when a faulty brake lever allowed the cage to plummet to the bottom of the shaft. Another man died from his injuries on the following day.

Two of the steel figures were also installed outside the environment centre, and the remainder will be installed when further funding is secured.

The *Walking Together* memorial figures. (*Ken Wain*)

Opposite page: Photos supplied by Peter Storey, as donated by local people for the Markham Vale Project, showing their important contribution to local coal mining heritage. The Markham lads were soon breaking output records, and the British Coal Corporation announced a £33 million investment for the North Derbyshire pits. £6.5 million went to for Markham underground improvements and seam developments. Money was no object – even if it took £33 million to keep the miners happy. However, Maggie's pit closure plan was unstoppable. Markham closed in 1993/94, leaving millions of tons of prime coal.

Record Breakers

Only two years after the 1984/85 miners' strike, in the four weeks to 11 July 1987, Markham Collieries L206's 100-cm face turned 19.16 tonnes' output per man shift (1,184 tonnes per day). In the same period, L80's 170-cm face turned an output per man shift of 24.59 tonnes (1,483 tonnes per day). The new central area's output for the seventeen weeks ending 25 July 1987 was a massive 3,068,859 tonnes. L303's unit stripped 1.4 miles of coal on 10 December 1987, and L31's 1.01 miles of coal 20 February 1990. On 12 July 1990, the men of L407's unit were congratulated for stripping a record-breaking 1.07 miles of coal.

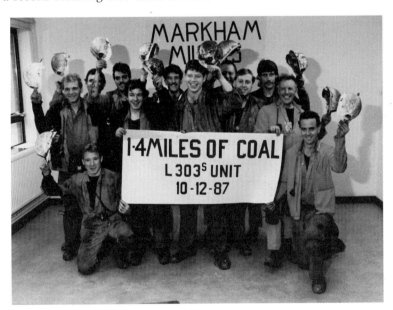

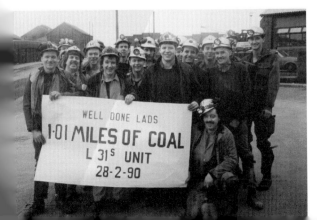

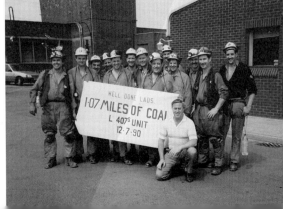

Orgreave Coke and Chemical Plant and the 1984/85 Miners' Strike

As a result of the two strikes by the nation's mineworkers in 1972 and 1974, which was the first time that the miners had resorted to strike action since 1926, they were commonly regarded as bringing about the fall of the Heath Government. In 1972, Britain's coal miners were among the lowest-paid manual workers in the UK. Pay negotiations between the National Coal Board and the National Union of Mineworkers broke down and the miners went on strike, which resulted in power shortages throughout the nation. The imposition of a three-day week brought 1.7 million workers to a standstill, and a state of emergency was declared on 9 February. The strike continued for seven weeks until the miners accepted an annual rate of increase of 21 per cent, plus five extra days' holiday and a restructuring of pay for eighteen- and nineteen-year-olds over the next two years.

The miners called for further action in 1974 and Edward Heath called a snap election in the hope that it would get the nation behind him against the miners, but it proved to be the downfall of the Conservative Government, with a resounding victory for Harold Wilson and the Labour Party.

The strike had been ongoing for sixteen weeks, but within forty-eight hours of Labour's victory it was ended, with approximately 260,000 miners accepting a 35 per cent increase, nearly double that which was on offer by the Heath Government, which brought them in line with other industrial workers.

The Conservative MP Nicholas Ridley, who had always held the view that the trade unions could get in the way of Conservative policy decisions, put together a report on all the nationalised industries, which outlined ways in which future vengeful Conservative governments would be able to fight and defeat major strikes within a nationalised industry. He was of the view that the trade unions had too much political power, which got in the way of market forces and had to be curbed. The 'Ridley Plan' was leaked to *The Economist* magazine in May 1978, giving the unions a distinct advantage in the event of any strike situation.

In 1981 there was the threat of further action by the miners due to a Government plan to close twenty-three pits. The miners said they should be kept open unless the supplies were exhausted or there were geological problems, and if this was not the case they would strike.

In 1982 the Government made an offer of 5.2 per cent in return for increased productivity, which the mineworkers' membership accepted. At this time, the NCB

were always pressing the miners for more productivity, saying that the price of coal had to be maintained or lowered to prevent their customers from buying abroad or converting to alternative fuels. We now know that this was an agreement between the Thatcher Government and the NCB to increase power station coal stocks, to be used in case of any future action by the miners, thus weakening their position and ensuring the Government's upper hand in the expected strike.

The Thatcher Government made Ian MacGregor the Chairman of the NCB in 1983 on a three-year contract, with a salary of just over £59,000 and a £1.5-million windfall in compensation for the US merchant bankers Lazard Frères, because they would be losing a senior partner for three years. This equates to £500,177 a year for three years for MacGregor to butcher the industry. Cheap at half price! On 6 March 1984, just one day after the South Yorkshire miners came out on strike, he said that previous agreements made after the 1974 strike were now obsolete and that he intended to close twenty pits, with the loss of 20,000 jobs. This meant that whole communities within the north of England, Scotland and Wales would lose their main source of employment.

The president of the National Union of Mineworkers, Arthur Scargill, said that the Government had a long-term plan to close over seventy pits and to destroy the industry, but the Government vehemently denied this claim. Margaret Thatcher endorsed a letter that was sent out to all NUM members by Ian MacGregor, telling them that Arthur Scargill was deceiving them, and that there were no plans to close any more pits than had already been mentioned.

Since the release of the National Archives files on 3 January 2014, showing the Government's Cabinet papers of 1984, it is patently obvious that Margaret Thatcher and Ian MacGregor deceived the miners by lying about MacGregor's plan to close seventy-five pits, which would mean the loss of 64,000 jobs over three years. They also ensured that no list of sites that would be closed should be issued. Sir Robert Armstrong, who was Margaret Thatcher's key advisor and cabinet secretary in 1983, denies a cover-up, but there is a record of a secret meeting held at No. 10 on 15 September 1983, headed SECRET: CMO, with an instruction for it not to be photocopied or circulated outside the private office, which was immediately disregarded when a copy was in fact given to Sir Robert Armstrong.

Those present at the meeting were Prime Minister Margaret Thatcher; the Chancellor of the Exchequer, Nigel Lawson; the Secretary of State for Energy, Peter Walker; the Secretary of State for Employment, Norman Tebbit; Sir Robert Armstrong, Cabinet Secretary; Mr Peter Gregson, Deputy Secretary to the Cabinet Office; and Mr Michael Scholar, Private Secretary to Margaret Thatcher.

The members of the meeting were told that the NCB's pit closure plan had gone better this year than planned; there had been one pit closure every three weeks, and the workforce had been reduced by 10 per cent. The new NCB Chairman Ian MacGregor now wanted to go further; he intended to close another seventy-five pits during the three years 1983–1985, and said there should be no closure list, but a pit by pit procedure. That would bring down the manpower to 138,000 from 202,000. The first sixty-four would reduce the workforce by 55,000 and reduce capacity by 20 million tonnes, then

a further eleven, with manpower reductions of 9,000, would bring a capacity reduction of a further 5 million tonnes.

The document says the plans for pit closures and subsequent job losses were discussed, and that the effect would be that ⅔ of Welsh miners would become redundant, ⅓ of the miners in Scotland would also lose their jobs, and almost a half of those in the North East of England. Half of the South Yorkshire miners would also be axed, along with almost half of those in the South Midlands. The worst of those affected would be those in the Kent coalfield, which would be completely closed down. The last paragraph of the document read, 'It was agreed that no record of this meeting should be circulated'!

One week later, another document, written by a senior civil servant, suggested that the same small group of people should have regular meetings, but that there should be 'nothing in writing which clarifies the understanding about strategy that exists between Mr MacGregor and the Secretary of State for Energy'. In other words, an official cover-up of the true facts.

If this document had been made public during the strike, Margaret Thatcher's credibility would have been dealt a devastating blow, because of the blatant lie tailored to discredit the miners' leader, Arthur Scargill, and turn the nation against the miners. It is also recorded that at the beginning of these Cabinet meetings, oral exchanges were also entered into, and were never recorded although they were central to the points under discussion. This, in my opinion, amounts to subterfuge, with the intention of withholding information that would damage their fight to win at all costs.

At this time and for many months before, the Government had taken the decision to stockpile millions of tonnes of coal at all the coal-fired power stations, so as not to have a repeat of the situation in 1974, when a lack of coal resulted in major disruption to power supplies, which almost brought the country to a standstill. They even went to the lengths of buying fields adjacent to the power stations to provide additional stocking facilities. Most of this was prime agricultural land and would have commanded a high price, but money was not a problem.

Bringing Ridley's plan into action, the Government orchestrated the movement of coal from some of the collieries' own stockpiles, along with coal from collieries that were still working and producing coal, primarily in the Nottinghamshire Coalfield. Picketing had little or no effect on the exercise, and Ridley used a heavy police presence to deter the miners; he also ensured the use of non-union labour in his choice of haulage contractors. Even though the rail workers mounted some action against moving coal stocks, it had little impact. Rail bosses sent home, without pay, those refusing to move coal. One signalman near Worksop acted alone in refusing to allow coal trains to proceed along his stretch of line, but he was soon replaced and reprimanded.

Not only did the Government stockpile coal and import millions of tonnes from around the world in the face of action by the dockers, who imposed restrictions on unloading imported coal, they were able to divert the coal ships to smaller coastal ports and wharves, along with some inland waterway ports, such as Goole. They also colluded

with the Central Electricity Generating Board in secretly converting some of the power stations to burn heavy oil as an alternative, keeping the power workers on side by whatever means to ensure the continuance of supply.

Money was no object, and public spending was allowed to spiral upwards like never before; there was no cost that could deter this onslaught on the miners, their industry, and the nation's trade unions. There was no restraint on Government spending on policing and power station conversion, costing billions of pounds; to Margaret Thatcher and her Government cronies, it was money well spent to achieve their twisted aims. They would stop at nothing. They were expert at keeping in the background, and letting MacGregor and his counterparts unfold the forthcoming decimation of the industry. Lies, deceit and cowardice were to the forefront from the beginning to the bitter end.

Within just four days of the announcement by British Coal that Cortonwood Colliery was to close, although no vote was taken, 55,000 miners rallied to Arthur Scargill's call to strike against the Thatcher Government's pit closure plan, and the yearlong struggle for the miners' livelihood began in earnest. The strike began in South Yorkshire on 5 March, and the national strike started one week later on 12 March, involving some 180,000 men. The day of 15 March saw the strike's first casualty. Yorkshire miner David Jones died on the picket line at Ollerton Colliery in North Notts. On the following day the Notts miners voted against strike action, and three weeks later on 11 April the National Association of Colliery Overmen Deputies and Shotfirers voted 7,638 to 6,661 for the strike. However, NACODS rules meant that no action could be taken due to a ⅔ majority being required.

On 4 May a massive demonstration took place at Harworth Colliery involving some 10,000 pickets with only small amounts of ill temper.

Because of the gathering momentum of the strike, and the mounting support nationally for the miners, the trade unions arranged a series of one-day strikes in Yorkshire, Humberside, and South Wales to show their support.

On 29 May, 7,000 miners went to picket Orgreave Coke and Chemical Plant. Violence erupted when they were confronted by a large contingent of police with batons and riot shields. This led to eighty-two arrests, and sixty-nine people were injured. The police arrested Arthur Scargill the following day for 'obstruction'! The day of 5 June saw the untimely death of Kellingley Colliery miner Joe Green; Joe was picketing at the Ferrybridge power station when he was crushed to death by a lorry.

Because of the importance of the Orgreave coking plant in the supply of raw materials to the steel making industries, the impact that the curtailment of supplies would have on the industry and the inevitable effect of this on the nation's economic outlook in general, the Orgreave coking plant was soon to become a major area of picketing activity. The protestors tried to stop incoming coal stocks and the supply of coke to these industries during the 1984 miners' strike, to try and bring the strike to a hasty conclusion.

Sadly this was not to be, and the Orgreave saga was one of the bloodiest in this unfortunate last-ditch stand by the miners to try and save their industry from extinction.

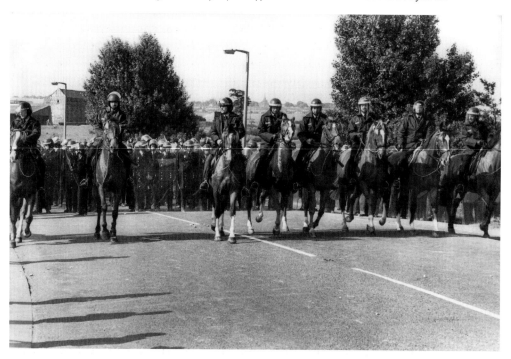

(*Sheffield Newspapers*)

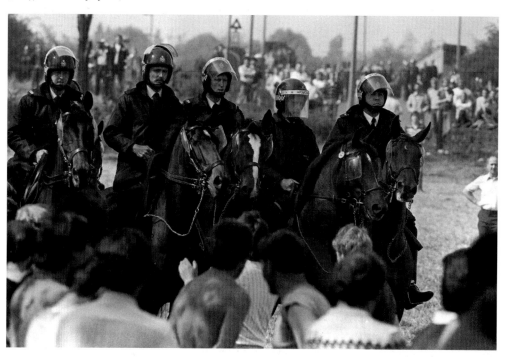

(*Sheffield Newspapers*)

It was Monday 18 June 1984, now known to many as 'Bloody Monday', the day when all reason was blown in the wind. It seems as if this was the day when the police decided to teach the miners a lesson they would never forget, and tried to end the dispute with sheer terror, force, and intimidation. It was patently obvious that the police knew there was going to be a mass picketing exercise at Orgreave on this morning, proving that the Government's intelligence services had been doing their 'homework' and infiltrating the ranks. Miners had been complaining for weeks previous about so-called strangers asking pertinent questions, then mysteriously vanishing. On seeing the amount of pickets and police, one could only assume from the very beginning that some sort of military-style exercise was being orchestrated and that there were going to be some violent clashes.

The pickets felt uneasy, because, contrary to previous treatment when attending an area for picketing, the police were showing them where to park and directing them to an area in the field across from the Orgreave Plant. The lorries were lined up several hundred yards away, waiting for the order to go into the plant. They started to go in at about 8.30 a.m., at which time the pickets surged forward to try to talk to the drivers, but it was all in vain and the lorries just drove past as instructed by the police, taking no notice of the pickets.

Directly after this, the police ensured that the pickets had been corralled into an area bounded on three sides by police with large riot shields. Some officers were accompanied by dogs. At 8.45 a.m., the police line in front of the pickets separated to allow the mounted police through; they started a cavalry charge against the pickets, who were assembled in the field, and hit out at them while knocking some down like tenpins, causing them to flee in all directions. At 9.30 a.m., the police decided to repeat the action, and were now accompanied by the riot squad, who ran amok and started to lash out at people who were doing no more than standing watching what was going on. Anyone who did not run away was regarded as a threat to the officers, and many were arrested; one photographer was hit by a baton while trying to record the scene. It is reported that a senior officer said, 'At the body not the head.'

This incited more action from the pickets, who started tearing up fences and using them as barricades, which they saw as the only way of protecting themselves against unnecessary police violence. Stones and bricks were then hurled at the police, and the ensuing confrontations resembled that of some medieval battlefield, some of the threatened pickets further risking their lives by fleeing over a fence and down an embankment on to the railway line.

Arthur Scargill, the mineworkers' leader, arrived on the scene and was able to bring some semblance of order for a short while. The battles continued well into the afternoon, neither side wishing to be humiliated, and things were made worse when Mr Scargill was injured, having allegedly been struck by a riot shield. The Government later claimed that he received his injuries by falling down a railway embankment, but several witnesses claimed to have seen the incident. Another one of the miners who had blood pouring down his face was sent to hospital for treatment, along with Mr Scargill. Word had got out to the press and the television media regarding the confrontations, and after their arrival on the scene, when they were filming Mr Scargill, things seemed to miraculously quieten down somewhat. This

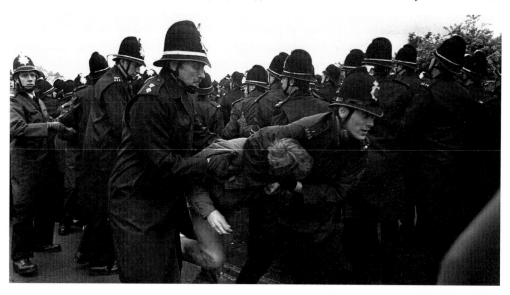

Above: Police started using snatch squad tactics, singling out individuals, as is shown by this photograph of the time. (*Sheffield Newspapers*)

happened on a regular basis when the media were present. At the end of what could only be described as a bloody awful day, both sides were licking their wounds, with eighty-two injured and more than ninety arrests! On 26 June, BBC Radio 4 reported that Arthur Scargill was claiming to have received leaked information that coal stocks were now standing at only 15 million tonnes. He said that the CEGB and the Government were preparing to present plans for emergency measures to Parliament for the introduction of power cuts on a rota basis, as they approached August and September. The Government decided to play down the claim, and made no attempt to reply, hoping that the miners would cling on to false hopes of early power cuts bringing the Government and the NCB nearer to capitulation.

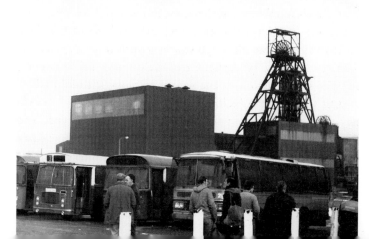

(*Peter Storey*)

July and August saw escalation of picketing, with an emphasis on the Notts pits, where ex-breaker's yard armoured buses were taking men into work, the non-union drivers being paid £1,000 a week for running the gauntlet – money no object. After supposed conciliation talks failed in early September, the TUC became involved in the dispute on 15 September, some six months into the strike. This was the day on which Margaret Thatcher met in secret with her Chancellor, Secretary of State for Energy, Secretary of State for Employment, Cabinet Secretary, Deputy Secretary and Private Secretary, along with NCB Chairman Ian MacGregor, who spelled out his plans for closing seventy-five pits, with 64,000 job losses over three years! Five months later, NACODS revealed the results of a second ballot – 82 per cent of its members were in favour of strike action. Margaret Thatcher's 'Three Stooges' – Messrs Walker, Tebbit and her American-imported hatchet man, Ian McGregor – put forward so-called peace formulae, designed to lure the miners back to work on better pay and conditions, with no mention of pit closure plans, the ACAS conciliation service or the NUM. The day of 10 October saw the talks break down yet again, and the NUM was fined £200,000 for contempt.

On 24 October, NACODS called off the strike planned for the next day. On 25 October, the court ordered that £200,000 of NUM assets were to be seized for not paying the £200,000 fine for contempt. The day of 30 November brought the untimely death of taxi driver David Wilkie, who was killed by a concrete block dropped from a bridge as he was driving a miner to work. Two of the striking miners were later charged. On 11 December 1984, strike breaking Nottinghamshire miners formed a breakaway union, the Union of Democratic Mineworkers, and set up its headquarters at Berry Hill Lane in Mansfield, with a membership of just over 25,000. Its principal officers at the time were Roy Link and Neil Greatrex. What they and their membership did not realise at the time was that they were being duped by the Thatcher Government into thinking that, because they were still working and keeping the power stations supplied, and because all the Nottinghamshire pits were classed as long-life pits, their jobs would be safe. It must be right because the Government said so!

During December 1984, much to the Government's dismay, such was the worldwide strength of feeling for the miners' plight that food parcels, clothing and toys were shipped in from all over the world to ensure that the miners and their families were cared for over the festive period. January 1985 brought a steady trickle of strike-weary and cash-strapped mineworkers back to work, causing ill feeling among former friends and breaking up families, with much infighting and back-stabbing. The TUC's plan for ending the strike was rejected by the NUM delegate conference, and NUM members were now streaming back to work. Picketing, although still vehement in some places, is now regarded by some as akin to Custer's Last Stand. On 27 February the Government was rubbing its hands together as the NCB announced that more than half of all NUM members were back at work. On 1 March, the NUM area conference called for a return to work; a special delegate conference was held at Congress House in London. The delegates voted narrowly, 98 to 91, to return to work on 5 March, one year to the day from when the strike began.

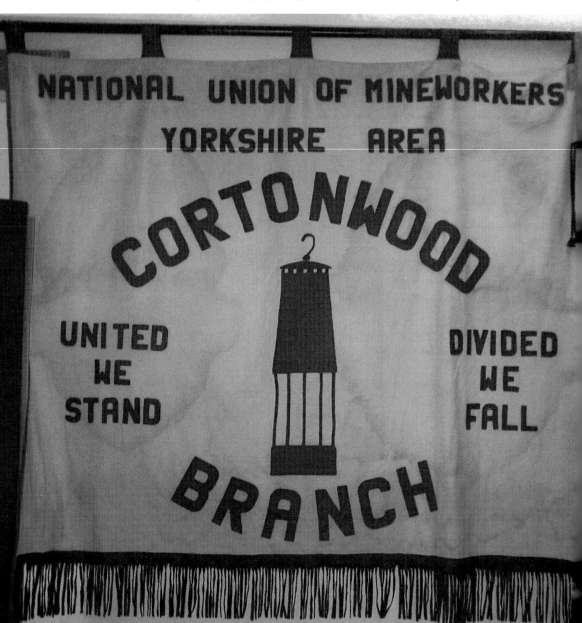

The miners of Cortonwood Colliery proudly marched down the road to the pit, carrying the NUM banner, which was emblazoned with the words 'United we stand Divided we fall'. Had the Nottinghamshire miners stood with them, who knows what the outcome would have been? They were accompanied by the colliery band, and cheered along by their friends and families. Alas, this was to no avail, and the colliery never worked again; it was officially closed on 25 October 1985.

Not content with sealing the fate of the British steel industry, the decimation of the mining industry, as predicted by Arthur Scargill, had now begun. In the remaining ten months of 1985, twenty-five pits had been closed (one pit every two weeks)! This left millions of tons of prime coal sealed beneath our feet. We are literally sat on it; isn't it ironic that we as a nation are now importing about 40 million tons of poor-quality coal every year to generate approximately $1/3$ of our energy requirements, mostly from China.

The cost to the British taxpayer of the 1984/85 strike fiasco was a massive £8 billion, and the policing activities in South Yorkshire alone amounted to £55 million, showing the determination of the Thatcher Government and British Coal's imported American hatchet man Ian MacGregor to bring down the miners, and decimate the industry and all its contracted manufacturers and suppliers. The total cost of all this in lost jobs and closed industries to the British economy, which is at its lowest for years, is incalculable!

The NCB's research establishment at Bretby was well on the way to completing years of work to burn coal cleanly and efficiently, thus protecting the environment and ecosystem for future generations. The technology to bring this about would have brought hundreds of millions of pounds into the British economy in wordwide sales.

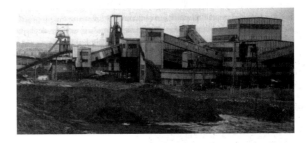

Cortonwood Colliery, c. 1980. (Alan Hill)

The offending tee shirt.

The fluidised bed research establishment at Grimethorpe Colliery near Barnsley, which cost £20 million and was jointly funded by the UK, the United States of America and the Federal Republic of Germany, was the most advanced clean coal burn scheme in the world. British Coal, in its wisdom, decided to close the facility after the strike, and the Swedish company ABB Carbon picked up the gauntlet, perfected the system and sold full-scale plants in Europe and the United States of America; it even has outstanding orders from Japan and Czechoslovakia.

Let's not forget how the Government brought down the steel workers by using the same man and the same tactics. This was the man who was given a knighthood for the butchery of Sheffield's, and indeed the nation's, coal and steel industries. He said, 'I am not a butcher, I prefer to call myself a plastic surgeon, I try to rebuild damaged features.' MacGregor also angered the Yorkshire miners when he said they were less productive than women miners in the United States.

It was not long before the treachery of the Thatcher Government came into play for the UDM members. When the NUM were defeated in 1984, there were 170 collieries; one year later, twenty-five of them had been closed. By 1992, twelve of the twenty-five Nottinghamshire pits had been closed, but there were no compulsory redundancies and the miners were earning good money, thank you very much. Then came the crunch – the Government announced that a further thirty-one pits were to close, with the loss of another 30,000 jobs. This was the final nail in the coffin of the coal mining industry. Three of the remaining thirteen pits were to be shut in 1992, and seven more of the Nottinghamshire pits were to close between 1993 and 2004.

Mrs Thatcher's beloved strike breakers were no longer the flavour of the month. They had served their purpose and were now being given the same sadistic treatment as the NUM. UDM president Roy Lynk, who was presented with an OBE for 'Services To The Trade Union Movement' by the Thatcher Government, staged a one-man sit-in at Silverhill Colliery on 6 October 1992 after realising that he had been duped. A few days later he resurfaced and returned his OBE, and retired after Neil Greatrex was voted in as president.

Sixty-one-year-old Greatrex became a Trustee of the Nottinghamshire Miners' Charity, which ran the Phoenix Care Home for retired miners at Chapel St Leonards in Lincolnshire; on 3 April 2012, after a trial lasting two weeks, Greatrex was found guilty on fourteen counts of theft from the Nottinghamshire Miners' Charity. Sixty-year-old Mick Stevens was cleared of the same charges at the same trial. Birmingham Crown Court heard that Greatrex had committed the offences between 2000 and 2006; he was jailed for four years for the theft of almost £150,000. In his defence Greatrex said, 'I billed the care home for a new kitchen at my home in lieu of a salary, I thought that I was entitled to a reasonable wage and expenses for the work that I was doing at the home.' Judge John Wait heard that Greatrex was earning a salary of £67,000 in 1987, and told him that, as a trustee of the charity, he was not entitled to profit from his role, and that he could afford to pay for the work he was having done. It was calculated and dishonest greed. This is the man who spent over twenty years in the NUM before forming the UDM and speaking out against Arthur Scargill's tactics in the 1984/85 miners' strike.

Thirty years after the 1984/85 miners' strike, strength of feeling is still running high against Margaret Thatcher, the perpetrator of the infamous pit closure plan that decimated the coal mining industry. This culminated in throwing on the scrapheap many thousands of mineworkers and workers in other industries that were part and parcel of coal mining, tearing apart families and whole communities, while causing immense damage to the nation's economy.

The Chesterfield-based Derbyshire Unemployed Workers' Centre's Colin Hampton, while attending the September 2012 Trades Union Conference in Brighton, had a stall selling tee shirts depicting the eighty-seven-year-old ex-Prime Minister's name on a gravestone, and quoting, 'A generation of trade unionists will dance on Thatcher's grave.' Not all Derbyshire residents were of the same opinion, and after protests by Tory MPs proclaiming its insensitivity, the tee shirts were withdrawn from sale.

However, Toby Perkins, Tory MP for Chesterfield, said that, although he did not agree with the sentiments of the tee shirt, there were still a lot of people in Derbyshire who felt that they had been betrayed by the Thatcher Government of the 1980s, and who were still feeling the consequences three decades on.

Colin Hampton stated that the stall did a roaring trade, and he felt that Thatcher was at long last doing some thing for the unemployed by raising funds for them – he was selling the tee shirts to raise money, due to the present Conservative Government withdrawing funds from them two years ago!

MONDAY 7 MARCH 2013, THE BBC ONE O'CLOCK NEWS ANNOUNCED THE DEATH OF MARGARET THATCHER DUE TO A STROKE. THE FUNERAL COST THE BRITISH TAXPAYER AN ESTIMATED £10 MILLION!

Bibliography

A Coal and Iron Community in the Industrial Revolution, John Addy (Longmans).
Black Diamonds, Catherine Bailey (Penguin).
Memories of the Derbyshire Coal Fields, David Bell (Countryside Books).
Coal Mining and the Miner, H. F. Bulman (1919).
South Yorkshire Mining Disasters Vol. 1, Brian Elliott (Wharncliffe Books).
The Miners' Strike Day by Day, Brian Elliott (Wharncliffe Books).
Yorkshire Miners. In Photographs, Brian Elliott (Sutton Publishing).
'When Coal Was King' in *Derbyshire Times*, Clive Hardy.
The South Yorkshire Coal Field. A History and Development, Alan Hill (Tempus).
The Chesterfield Canal, Ryton Typing Service, Worksop (NCB).
Mining Days in Abram, F. Ridyard (Leigh, 1972).
A History of Gleadless, Pauline Shearstone (Unicorn Press).
South Yorkshire Pits, Warwick Taylor (Wharncliffe Books).
The Forgotten Conscript, Warwick Taylor (1995, 2003, The Pentland Press).
South Yorkshire People and Coal, Peter Tuffrey (Fonthill Media).
Yorkshire People and Coal, Peter Tuffrey (Amberley).